MAXIMUM RAD

the iconic covers of
THRASHER MAGAZINE

UNIVERSE

EDITOR IN CHIEF Jake Phelps
EDITOR AT LARGE Michael Burnett
MANAGING EDITOR Ryan Henry
CREATIVE DIRECTOR Kevin Convertito
ART DIRECTOR Dan Whiteley
ASSOCIATE ART DIRECTOR Adam Creagan
AGENCY DESIGNER Brent Gentile
MUSIC EDITOR Stanislaus Clemens
ASSOCIATE EDITOR Erin Dyer
IMAGING TECH Randy Dodson
SENIOR WEBSLINGER Greg Smith
VIDEO ROAM Preston Maigetter
ASSOCIATE WEB GURU Nicholas Lattner
ASSISTANT WEBSLINGER Jordan Joseffer
MOTION & WEB DESIGNER Tom Dunnam
INTERNS Matt Brouwer, Sami Naffziger

PHOTOS AND ART
Ryan Allan, Kevin Ancell, Kevin Baboot, John Bing,
Michael Blabac, Michael Blanchard, Block, Wesley Bocxe,
Torin Boyd, David Broach, Joe Brook, Chris Buchinsky,
Gomez Bueno, Michael Burnett, Suzanne Burns,
Erik Butler, Reg Caselli, Dom Callan, Dan Cavalheiro,
Ben Colen, Sean Cronan, Lance Dalgart, Lance Dawes,
Mark DeSalvo, Sean Dolinsky, Dave Duncan,
Matt Etheridge, Gary Fluitt, Nik Freitas,
Glen E Friedman, Jim Goodrich, Kenichiro Goto,
Bob Groholski, Mike Gulotti, Joe Hammeke,
Bruce Hazelton, Luke Hudson, Bryce Kanights,
Chuck Katz, Steve Keenan, Jim Knight, Joe Krolick,
Mark Madeo, Rex Marechal, Noah Martineau,
Scotty McDonald, Sonny Miller, MoFo, Gabe Morford,
Jody Morris, Joseph Muellner, Neck Face, Scott Needham,
Jeff Newton, Luke Ogden, Chris Ortiz, Matz Oscarsson,
Scott Pommier, Pushead, Craig Ramsay, Giovanni Reda,
Rhino, Rich Rose, Shane Rouse, Paul Schmitt,
Ron Schneider, Aaron Sedway, Scott Serfas, Sleeper,
Scott Starr, CR Stecyk III, Josh Stewart,
Daniel Harold Sturt, Nick Scurich, Kevin Thatcher,
Bill Thomas, Mike Tkacheff, Xeno Tsarnas,
Shonna Valeska, Geoff Van Dusen, Tony Vitello,
Robert Williams, Xeno, Dan Zaslavsky

WORDS
Brian Anderson, Steve Bailey, Michael Burnett,
Steve Caballero, John Cardiel, Quim Cardona,
Mike Carroll, Glenn Danzig, Chris Dobstaff, Pat Duffy,
Matt Field, Cairo Foster, Ethan Fowler, Fred Gall,
John Gibson, Jeff Grosso, Tommy Guerrero, Ryan Henry,
Peter Hewitt, Frankie Hill, Christian Hosoi, Rick Ibaseta,
Jesse Martinez, Lance Mountain, George Nagai,
Richard Paez, Jake Phelps, Andrew Reynolds,
Geoff Rowley, Andy Roy, Arto Saari, Keegan Sauder,
Sean Sheffey, CR Stecyk III, Chris Strople,
Justin Strubing, Ed Templeton, Kevin Thatcher,
Ernie Torres, Fausto Vitello, Shelby Woods

ADVERTISING DIRECTOR Eben Sterling
MARKETING DIRECTOR David Sypniewski
AD OPERATIONS MANAGER Michael Breslin
MARKETING & EVENT MANAGER Sally Vitello
SOCIAL MEDIA COORDINATOR Mike Hubert

PRESIDENT Gwynned Vitello
PUBLISHER Edward H Riggins
CHIEF FINANCIAL OFFICER Jeff Rafnson
GENERAL COUNSEL James M Barrett

WEBSTORE COORDINATOR Yolanda Rodriguez
MAIL ORDER/CUSTOMER SERVICE Chelsea Scanlan
PRODUCT SALES MANAGER Rick Rotsært
PRODUCT PROCUREMENT John Dujmovic
SHIPPING Derik Stevenson
ACCOUNTING MANAGERS Kelly Ma, Helen Fu
CIRCULATION DIRECTOR Richard Convertito
CIRCULATION CONSULTANT Joe Berger
ENGINEER Ely Agustin

First published in the United States of America in 2012 by
UNIVERSE PUBLISHING
A Division of Rizzoli International Publications, Inc.
300 Park Avenue South
New York, NY 10010
www.rizzoliusa.com

2012 2013 2014 / 10 9 8 7 6 5 4 3 2 1

Printed in China

ISBN: 978-0-7893-2432-0

Library of Congress Catalog Control Number: 2011937298

HIGH SPEED PRODUCTIONS
1303 UNDERWOOD AVE., SAN FRANCISCO, CA, 94124

WWW.THRASHERMAGAZINE.COM

CURTIS HSIANG 1963–2000 RUBEN ORKIN 1969–1999 PHIL SHAO 1973–1998

yan and Magenta and Yellow and key Black inks. In fact, these are merely colored dots printed on organic-based paper, yet they somehow manage to transcend from this mechanical minimalism into more than the sum of their CMYK parts. Their combined effect has a curious culminating purpose, which compounds over the ages into indelible portraits of specific attitudes inflicting themselves upon particular places and times. Herein is a compendium: 30 years' worth of *Thrasher* covers.

It is a history of the wrecking and reclaiming of environments. Of audacious leaps. Going bigger than big. Subtly sublime insertions and delicate debaucheries, and large, ludicrous assaults on contemporary mores. *Thrasher*, the chronicling source of these wicked assignations, is noteworthy in that it stands alone as the only long-standing, independently-operated journal of skateboarding. Rival titles around the world are controlled by publishing conglomerates rather than practitioners of the activity, but content trumps corporate concerns in *Thrasher*'s pages. The aftermath of many such battles is evidenced in this assemblage offering.

The archive as a comprehensive database is tweaked by the evolution of both its subjects and creators. All covers are art pieces of a sort—some quite literally. *Thrasher*'s inaugural offering in January 1981 was a pen-and-ink rendering done by its editor, Kevin Thatcher. Adept as a graphic designer, photographer, and writer, Thatcher was largely responsible for the early articulation of the magazine's wide-ranging aesthetic. Not so coincidentally, Kevin was a member of a sand-castle-building familial enterprise that was lionized in the San Francisco Chronicle newspaper by writer Herb Caen. Outsider artists to be sure, but none the less, the Thatchers were progenitors recognized by the Pulitzer Prize-winning scribe of Baghdad by the Bay's cultural elite.

Other artists of note created *Thrasher*'s finer moments, such as Pushead, who did the September 1987 edition. This masterpiece was done in his idiosyncratic personal style, which has adorned the sleeves of innumerable albums by musical progenitors such as Metallica, Misfits, SS Decontrol, FUs, Wasted Youth, Meatmen, and Destructors.

Robert Williams' August 1988 cover painting accompanied the artist's first major write-up outside the genre of comics. Williams' association with High Speed Productions has continued into the present, as he is a co-founder of the popular culture magazine *Juxtapoz*.

May 1994 featured one of Mark Gonzales' characteristically-oblique drawn statements: "Hey, Do I Look Like A Street Skater?" Gonz, who is one of skating's all-time legends and whose first photo in the mag was actually the cover of the November 1984 issue, now exhibits in international museums of note and has been featured in motion pictures such as *Gummo* and *Beautiful Losers*.

Gomez Bueno, the well-known Spanish conceptualist, did a portrait of Jonathan Bohannon for the September 1996 issue.

December 1984's cover was executed by Chris Buchinski, who went on to win three International Clio Awards for animation

"BEHOLD THE DOCUMENTS THAT CHANGED THE CULTURE"

and directing; to work as a courtroom illustrator for NBC; and to artistically collaborate on such films as *Sea Biscuit*, *the Green Lantern*, and *Hancock*, amongst numerous others.

Sonic artists like Mike Muir of Suicidal Tendencies, Glenn Danzig, and the groups Gang Green and Rancid have also graced the *Thrasher* cover. But what we mostly see here is a primary documentation of the leaders in movement who are dealing with the re-definement of the geometry of space. Their names include numerous legends: Alva, Adams, Hawk, Way, Burnquist, Bastien, Gator, Rowley, Caballero, Carroll, Mountain, Phillips, Reynolds, Antwuan, Speyer, Song, Cardiel, Peralta, Mullen, Guerrero, Hosoi, Blackhart, Agah, Wray, Anderson, Cole, Blender, Strople, Olson, Dill, Salba, Salazar, Groholski…

Decades of unique solitary achievement are depicted on these covers. The images are debuts of futuristic propositions that were often disguised as new maneuvers. Behold the documents that changed the culture. —CR Stecyk III

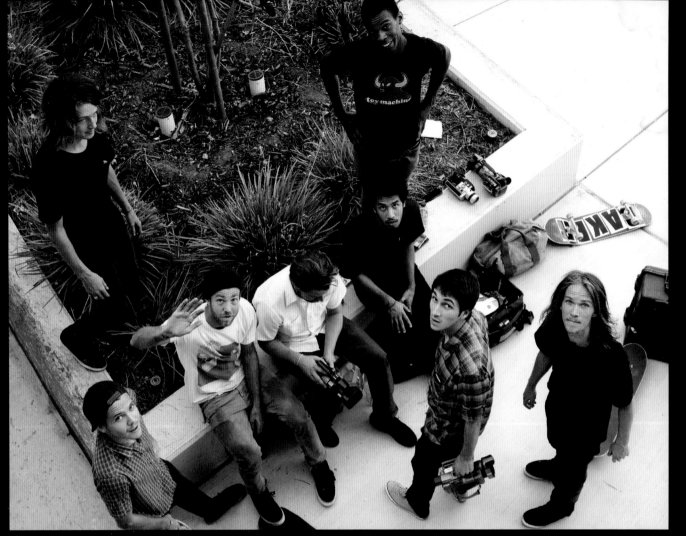

A series of photographs by editor-at-large Michael Burnett, culminating in Andrew Reynold's October 2010 cover.

HOW IT WORKS...

Say "1981" out loud. It may not have the same ring as "1969" or "Y2K," but the second year of the '80s was one of historical firsts: NASA launched the first reusable space shuttle, Columbia, that spring. IBM introduced the first personal computer. MTV was born that summer. But to start the year off, before any of these other events took place, a group of skateboard manufacturers in the Southeastern corner of San Francisco, CA were putting together the first issue of *Thrasher* magazine. Known simply as "The Bible" amongst skateboarders, *Thrasher* quickly became the most revered skate mag in the world. Skateboarding found a mouthpiece and imposed itself on the landscape because of it.

Deciding on a front for this Bible each month is the hardest part of what we do. We're looking for a photograph taken at that un-measureable instant, when the style and danger of skateboarding are best communicated visually. The process involves multiple decisions to be made, taking into account input from many different sources, like photographers, editors, publishers, advertising directors…even circulation consultants who we've never met. They're all hoping that the cover accomplishes a couple of things: We need to capture eyes at the newsstand, at the same time inspiring skaters with a stoke beyond imagination. What color should we make the logo? Does one color sell better than another? Do the cover lines and text distract from the skater and the trick? They might…but if those descriptive words aren't there, how will the average grocery store mag rack consumer be enticed to check out what else is inside? Is one of our advertisers counting on their skater being on the front, since he's got a huge interview that issue? Sure. But what if someone else had the crazier trick?

In the beginning, when The Mag cost one dollar, the cover of *Thrasher* was really built by hand, with X-Acto blades, Rubylith, cutting and pasting, line screen indicators, Stat cameras, and four sheets of film: Black, blue, red, and yellow. This process—where the inks are combined in different ratios to make every color on the page—is still used today. But now it may involve selecting a swatch on a screen or typing in a value via keyboard, rather than submitting physical pieces of art and film to a pre-press house. Up until 2009, most of our images were shot with medium-format or 35mm

"THAT UN-MEASUREABLE INSTANT, WHEN THE STYLE AND DANGER OF SKATEBOARDING ARE BEST COMMUNICATED VISUALLY"

cameras, and we still have a high-resolution drum scanner at our headquarters to convert processed analog images into digital files. But the quality of digital photography is the norm now, saving us valuable time in those short monthly cycles that seem to pass in just a few days—let alone the money saved at the film processor.

The end goal is always the same. A skater has busted a gnarly move, the sickest thing that's happened in 'boarding that month, a trick never done before at that specific spot. The photographer has captured the moment of maximum rad. We're proud to put it together and distribute it to the masses, inspiring riders around the world to Skate and Destroy.

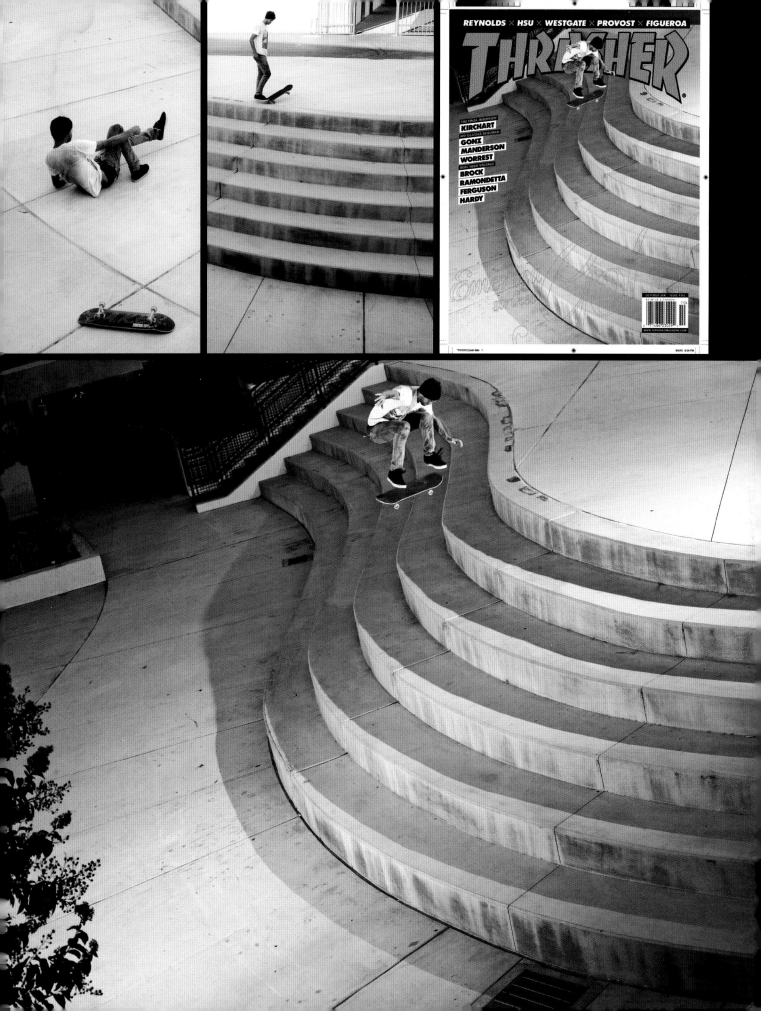

JANUARY 1981

As soon as we finished the first issue, we knew that we had come up with a winning formula. Everyone who skated knew *Thrasher* was made by skaters, for skaters, with no-bullshit articles, good photos, and in-depth, cutting-edge coverage of the industry from insiders' perspectives. As the word spread, I left my desk and hit the road. From the Midwest Melee to the Great Desert Ramp Battle to the Capitola Classic to Savannah Slammas I and II, the shit was on and we were showing the world what skateboarding was about. Everywhere we went people were stoked, and sure enough, skating proved that it wasn't just a trend; it was a sport that would grow to change the world. —*Fausto Vitello*

The illustration for the first cover of *Thrasher* was an old-style Proquil India pen and ink drawing that I did at, probably, 3:30 in the morning—pulling an all-nighter and scratching away at my little studio in Los Gatos, CA. It was actually done before the idea for *Thrasher* came about. It's heavy on the imagination—the influence for the skater, I guess you'd have to say, is a cross between me and Rick Blackhart. It kinda looks like Blackhart, but the guy in the illustration's regular foot, with the Nike hi-tops we were wearing at the time, the striped tube socks, striped shorts, and the long, flowing, surfy hair. There's that chunk of pool floating in the cosmos—it was just a tripper drawing I did when we were so into pools and weren't finding enough terrain to skate because all the parks were closing. Fausto and I were looking around for ideas for the first mag and said, "Fuck it. There's the cover right there." With the printing techniques at the time, it was easy. We weren't doing four-color printing yet. Hey, it was just like working on a comic strip.

It was all-skate, all the time back then. We thought about skating all the time. —*Kevin Thatcher*

01/81
Artwork: Kevin Thatcher

JANUARY 1981 $1.00

THRASHER

SKATEBOARD MAGAZINE ™

FEBRUARY 1981: **CHRIS STROPLE**

This was a private pool, right across from Pasadena City College. We probably had 20 or 30 pools running at the time. I took KT to 15 or 20 of them—but when he saw this one he said, "That's it!" He shot all of them that day, and came up with this photo. He thought it was a

"THE GUYS UP NORTH WANTED TO KILL KT AND BURN HIM AT THE STAKE!"

rad picture, even though I thought I'd done a bunch of other stuff that was a lot crazier—a bunch of airs and handplants—but he wanted a grind picture. The guys up north wanted to kill KT and burn him at the stake! It was a crazy deal: A SoCal guy gets the first skate photo on the cover of a NorCal mag. How about that? —*Chris Strople*

02/81 Chris Strople
Photo: Kevin Thatcher

Chris Strople expresses freedom and aggression
during a backyard session somewhere in Pasadena, CA.

FEBRUARY 1981

$1.00

THRASHER

SKATEBOARD MAGAZINE ™

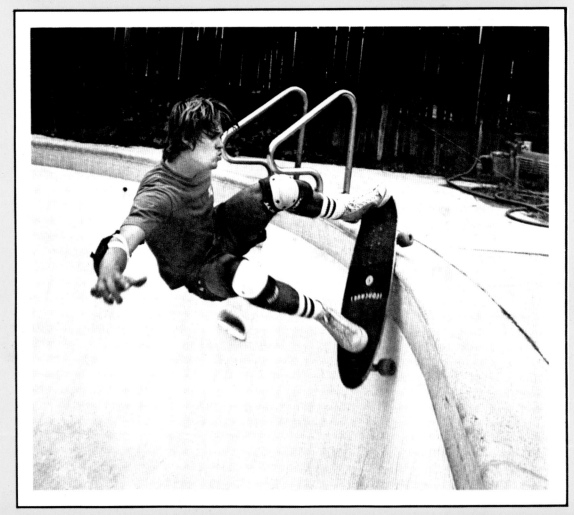

Losi was a great innovator. He gave us the modern lien to tail, the Smith grind, and this incredible thing: The fakie ollie foot plant. The dude invented all kinds of tricks, and he did it all on Connection trucks, which is just fucked! With those trucks, you'd lean right but turn left. The dude was an insane powerhouse. This 13-foot-deep pool was at Colton, before they built the Hollyday Bowl. That's all they had. Losi was on Variflex, and everyone on Variflex was a trick innovator. The fakie ollie had just come out, and footplants were all the rage, too. Allen tried to fuse the two, and all of a sudden *Thrasher*'s on the scene. We got it in the mail and were blown away. The fakie ollie was a brand new trick, and then this insane variation was on the front of The Mag? It looks strange nowadays, but try one… Try one! Losi did them consistently. We used to make him do them all the time. He'd just laugh and pop it off the coping perfectly. To *Thrasher*'s credit, they put Losi on the cover. He was a Variflex guy, and they were not down with the Varibots. He was a Down-South guy but Fausto and the boys were like, "Innovation—yeah! Let's put him on the cover." Losi is one of the greatest. He taught me how to be a man. —*Jeff Grosso*

03/81 Chris Miller
Photo: Jim Goodrich

The Badland's new blade, Chris Miller, lofting a bio frontside air during the competition at the Lakewood ASPO Contest.

04/81 Allen Losi
Photo: Rich Rose

Demonstrating amazing footwork, Allen Losi pops a fakie footplant ollie at Colton.

**05/81 Duane Peters
and Steve Caballero**
Photos: Kevin Thatcher
and Mike Gulotti

Always on form and forever attacking, Duane Peters' go-for-broke skating is the stuff of legends. Aggro sweeper re-entry, Whittier Pro/Am.

Steve Caballero's vertical skating is nothing less than phenomenal. Full tilt air, Whittier Pro/Am.

06/81 Mike Smith
Photo: Kevin Thatcher

Mike Smith lapping over the coping, edging out the competition at Colton.

MARCH 1981 $1.00

THRASHER
SKATEBOARD MAGAZINE™

L.A. SKATEPARK PARADISE

MODERN MOVES

ASPO AM CIRCUIT READY FOR '81

KONA CONTEST

APRIL 1981 $1.00

THRASHER
SKATEBOARD MAGAZINE™

L.A. PARKS Part II

DALLAS OLLIE AIR CONCRETE BARRELS

MAY 1981 $1.00

THRASHER
SKATEBOARD MAGAZINE™

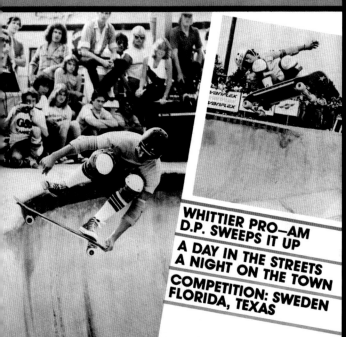

WHITTIER PRO–AM D.P. SWEEPS IT UP

A DAY IN THE STREETS A NIGHT ON THE TOWN

COMPETITION: SWEDEN FLORIDA, TEXAS

JUNE 1981 $1.00

THRASHER
SKATEBOARD MAGAZINE™

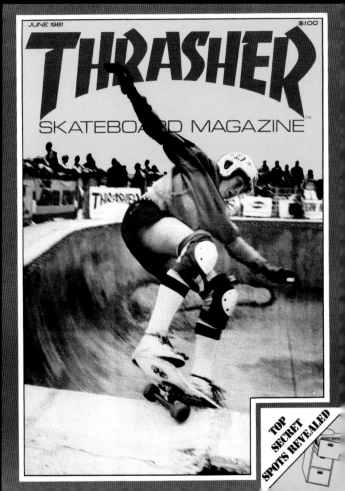

TOP SECRET SPOTS REVEALED

Steve Caballero, outtake from his September 1981 cover.

07/81 Mike Pust
Photo: MoFo

Mike Pust stalling a handplant at Hebert's
ramp in Calgary, Canada.

**08/81 Roger Hickey
and John Hutson**
Photo: Reg Caselli

Roger Hickey, quick on the draw in the
duel with John Hutson at Laguna Seca.

09/81 Steve Caballero
Photo: Kevin Thatcher

Steve Caballero holds on to win yet
another pro contest at the Variflex/Kona
Summer Nationals.

10/81 Top: Tony Hawk
Photo: Rex Marechal

**10/81 Bottom:
John Hutson and Paco Prieto**
Photo: MoFo

Top: Tony Hawk, rising amateur star,
during one of his typically bizarre re-
entries at Del Mar.

Bottom: John Hutson leads Paco Prieto
to the finish at Capitola.

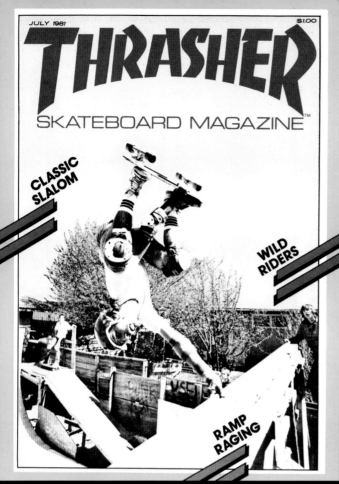

JULY 1981

$1.00

THRASHER
SKATEBOARD MAGAZINE™

CLASSIC SLALOM

WILD RIDERS

RAMP RAGING

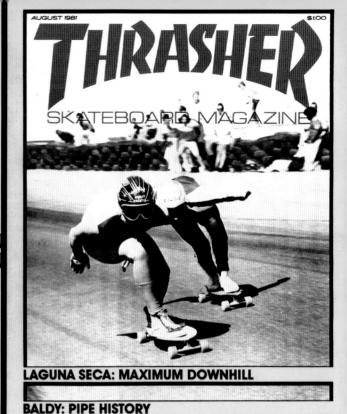

AUGUST 1981

$1.00

THRASHER
SKATEBOARD MAGAZINE

LAGUNA SECA: MAXIMUM DOWNHILL

BALDY: PIPE HISTORY

RAMP BUILDING

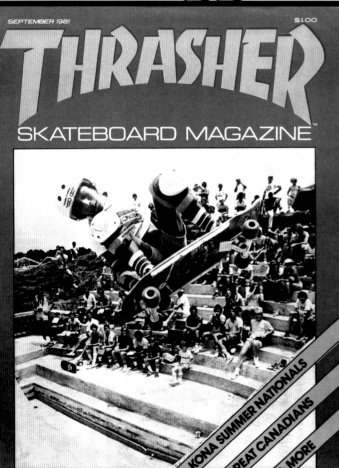

SEPTEMBER 1981

$1.00

THRASHER
SKATEBOARD MAGAZINE™

KONA SUMMER NATIONALS

GREAT CANADIANS

& MORE

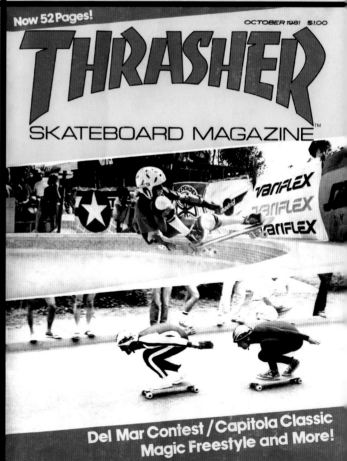

Now 52 Pages!

OCTOBER 1981

$1.00

THRASHER
SKATEBOARD MAGAZINE™

variflex
variflex
variflex

Del Mar Contest / Capitola Classic
Magic Freestyle and More!

DECEMBER 1981: STEVE ROCCO

Steve Rocco skating in the kitchen of a real estate salesman's open house somewhere in Los Angeles. Ever innovative, Rocco parlayed his home-invasion style of operations into the founding of *Big Brother* magazine and became one of the biggest skateboard manufacturers, via his brand World Industries. —*CR Stecyk III*

11/81 100-Percent Aggression

Aggression is a bi-product of *Thrasher* magazine. By skaters, for skaters, and all about skateboarding.

12/81 Steve Rocco
Photo: CR Stecyk III

Steve Rocco practicing freestyle in the kitchen of a certain prominent skater's mom's house.

01/82 Mike Smith
Photo: MoFo

The unpredictable Mike Smith getting lofty with a backside air in a 10+ Berkeley pool, on a recent visit to *Thrasher*.

02/82 Steve Caballero
Photo: MoFo

If there are 100 different ways to do ollie (no-handed) aerials, then Steve Caballero must know 101. Out of a fakie with total foot displacement on his own ramp.

NOVEMBER 1981 $1.00

THRASHER
SKATEBOARD MAGAZINE™

CAUTION: CONTAINS

100%
AGGRESSION

INSIDE...

1982 Calendar Inside
DECEMBER 1981 $1.00

THRASHER
SKATEBOARD MAGAZINE

DOWN SOUTH STYLE
San Diego County

INDOOR BOARDING
A Guide To Staying Dry

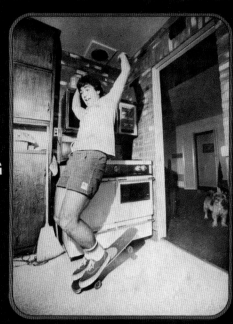

JANUARY 1982 $1.25

THRASHER
SKATEBOARD MAGAZINE™

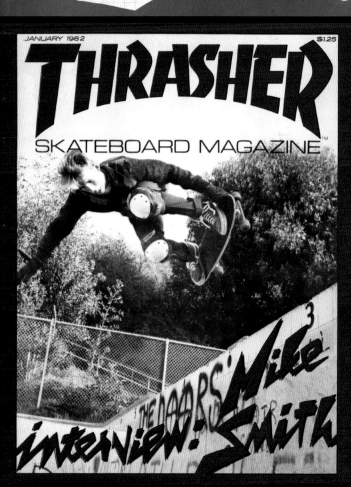

interview: Mike Smith

FEBRUARY 1982 $1.25

THRASHER
SKATEBOARD MAGAZINE™

INTERVIEW: STEVE CABALLERO

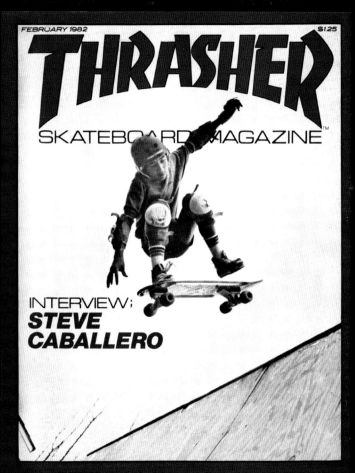

MAY/JUNE 1982: STACY PERALTA

This was a controversial view of the back of my Main Street studio. It featured an inebriated, passed-out local and Stacy Peralta skating. Some viewers felt we should have offered medical assistance to the downed individual. SP went on to directorial prominence, winning a number of prestigious awards, including multiple victories at Sundance. The "offended" went on to start *Transworld.* —*CR Stecyk III*

03/82 Duane Peters
Photo: Kevin Thatcher

"Wouldn't it be cool to drop into the pool from the slide?" It started out as kind of a joke, but quickly turned to reality when Duane Peters showed up at a Kitty pool session.

04/82 Street Scott
Photo: MoFo

An overcoated pedestrian strides by, oblivious to the suburban assault tactic of the street skater. Scott, driveway flyoff. Kansas St., Potrero District, San Francisco.

05-06/82 Stacy Peralta
Photo: CR Stecyk III

Stacy Peralta, interviewed this issue, freestyles before a laid-out local at one of the more famous of Dogtown's old hangouts.

07/82 Micke Alba
Photo: Glen E Friedman

Malba, interviewed this issue, blasts a high backside air over the round pool at Upland on his way to winning the first contest of the Rusty Harris Pro-Am Series, which is also covered in this mag.

MARCH 1982 $1.25

THRASHER

SKATEBOARD MAGAZINE

INTERVIEWS:
Duane Peters · The Damned

More HOT Ramps!

APRIL 1982 $1.25

THRASHER

SKATEBOARD MAGAZINE

GNARLY STREET ISSUE!

NO PARKING

CATALINA ISLAND

STREET SCOTT

MAY/JUNE 1982 $1.25

THRASHER

SKATEBOARD MAGAZINE ™

PRIVATE PROPERTY
NO TRESPASSING
NO LOITERING

DOWNHILL

VERTICAL

INTERVIEW:

STACY PERALTA

JULY 1982 $1.25

THRASHER

SKATEBOARD MAGAZINE ™

MICKE ALBA · UPLAND · TEXAS

AUGUST 1982: JAY ADAMS

Thirty years back, I remember it just like it was yesterday. Which is to say I've forgotten everything about that, too. Don't know the exact whys and wherefores, but it all coulda started down by Pico Creek at the Horizons West shop. A sloppy, three-foot south swell had blown out, and we were kicking it on Main Street with some Silver Satin and Kool Aide. Up walked Jay Adams, who'd been down a while with Polar Bear, slammed on some nonsense charges for something they didn't do. But a diligent investigator's actions got them both exonerated, and we were extremely surprised and elated to see Jay sprung.

I'd observed Adams' improvisations for years, dating back to his seminal riding in 1966. Kent Sherwood was at that time a co-worker of mine at Dave Sweet Surfboards in Santa Monica. And I was also a board wrangler for Kent and Ely Lea's rental concessions at the Ocean Park and Santa Monica piers.

Inculcated in the traditional Hawaiian water sports, Kent was a quiet, unassuming individual who radiated the arcane knowledge gathered in his youth on Waikiki Beach. Sherwood mentored his stepson's experimental ways: Building him equipment, teaching him the intricacies of surfing and skating, all while driving the kid's crew to different spots and adroitly photographing their progress. Jay benefited from this training, hanging in the laminating rooms of surf factories, riding Malibu Point, and skating in front of huge crowds on amusement piers. Somewhere in that ad-hoc industrial/social upbringing Adams absorbed the rudiments of composite materials construction, and a modicum of functional showmanship.

"ADAMS DESPERATELY NEEDED TO SKATE"

Like father, like son: On the North Shore of Oahu, Jay prospered for a time as the renowned Ding King, a repair technician widely sought out for his expertise. The US Congress eventually recognized Kent Sherwood for his technological achievements, and his Foam Matrix facility became a leader in the design and fabrication of critical structural components used on unmanned combat aircraft. Sherwood's company created the fins used on the Pegasus missile, which was the first winged vehicle to accelerate to over eight times the speed of sound.

However, on this sunny afternoon in 1982, none of the preceding had yet happened—Adams was thrilled just to be outside, and desperately needed to skate. So Jay and I borrowed a board from Nathan Pratt, along with one of Geoff Van Dusen's cameras. (Think it was a Contax 135 with a Carl Zeiss 18 millimeter lens, which was loaded with Ilford HP4 film.) Mike Scheliga drove us up through Ocean Park Heights, to the top of Centinela Hill.

Our goal was to hit it and quit it. The crowned sidewalks there had a clean, natural arc, overlooking the old Douglas Aircraft plant where they built DC-3s, jets, rockets, and the like. Being on the border there between SM and LA, enforcement efforts overlapped in this shared jurisdictional incident response zone. Patrol sorties were quick and simultaneous—PD units were common, but we scored a long, unobstructed session. Next we rolled the Santa Monica Airport banks, and then went to the Venice Pavillion for some sunset sliding.

That was a real good day. Just like all the rest. —*CR Stecyk III*

08/82 Jay Adams
Photo: CR Stecyk III

Jay Adams, ripping it up on the streets in a fashion
that only he can administer. Jay is featured this month
in a more than revealing, exploitive interview.

AUGUST 1982

$1.25

THRASHER

SKATEBOARD MAGAZINE ™

EXPLOSIVE! JAY ADAMS

WHITTIER PRO/AM

RAMP ACTION

OCTOBER 1982: RODNEY MULLEN

This cover of Rodney Mullen was the first time a magazine ever showed a picture of an ollie. Back then, thinking about making the board snap up and fly with you was too insane to comprehend—little did we know, but it would be the trick that would change the skateboarding world. Think about 28 years' worth of Shoe Goo, worn-out soles, blown-out leather, suede, and rubber, all in a big, burning pile… You get the picture. —*Jake Phelps*

09/82 Per Welinder
Photo: MoFo

Swedish freestyler in America,
Per Welinder, style and footwork at
Paramount RHS Pro Freestyle event,
covered this issue.

10/82 Rodney Mullen
Photo: MoFo

11/82 John Hutson
Photo: Matt Etheridge

Capitola King, John Hutson, down to
business and first across the finish line,
with Scott Wood drafting, at the
Capitola Classic.

Inset: Terry Orr
Inset Photo: MoFo

Calgarian skater Terry Orr at the
Canadian Amateur Championships.

12/82 Tom Groholski
Photo: Bob Groholski

Tom Groholski hovering over
his own backyard Rad Ramp in
North Brunswick, New Jersey.

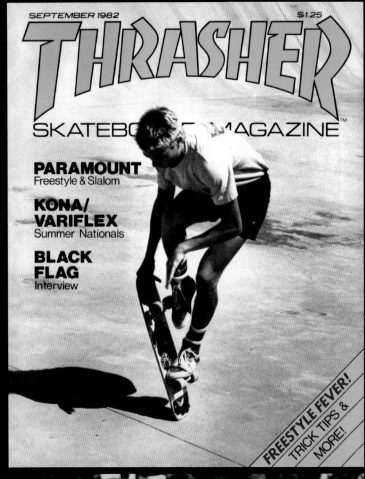

SEPTEMBER 1982 $1.25

THRASHER
SKATEBOARD MAGAZINE™

PARAMOUNT
Freestyle & Slalom

KONA/ VARIFLEX
Summer Nationals

BLACK FLAG
Interview

FREESTYLE FEVER!
TRICK TIPS & MORE!

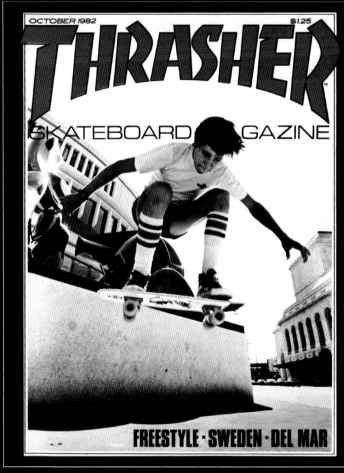

OCTOBER 1982 $1.25

THRASHER
SKATEBOARD MAGAZINE™

FREESTYLE · SWEDEN · DEL MAR

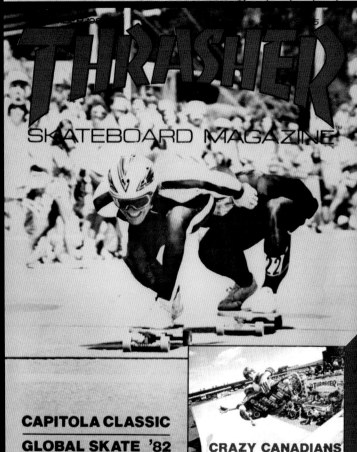

THRASHER
SKATEBOARD MAGAZINE™

CAPITOLA CLASSIC
GLOBAL SKATE '82

CRAZY CANADIANS

DECEMBER 1982 $1.25

THRASHER
SKATEBOARD MAGAZINE

RAMPS

POOL PARTY

PHOTOGRAFFITTI

CONTEST WRAP-UP

Arizona · Florida · Texas · Colorado

01/83 Lance Mountain
Photo: Glen E Friedman

Hovering over his home park, Lance Mountain works out in the tri-bowl at Skate City, Whittier, and works in the pro shop and concessions.

02/83 Bob Denike
Photo: Matt Etheridge

"One Wheel It" Bob Denike takes it to the literal extreme at an undercover skatespot in San Jose, CA.

03/83 Bill Ruff
Photo: Kevin Thatcher

Bill Ruff, interviewed in this issue, executes another backside air over the now closed Skate City Whittier keyhole during the Christmas Classic.

04/83 Micke Alba
Photo: Glen E Friedman

Micke Alba shoves himself into a handplant way up on the 12-foot high extension of the massive Palmdale ramp. A hardy crew of skaters, spectators, judges, and HBO people braved the rainy and windy conditions to attend the first pro backyard event of this kind.

JANUARY 1983 $1.25

THRASHER
SKATEBOARD MAGAZINE ™

INTERVIEW:
LANCE MOUNTAIN

RAMP ACTION
MILE HIGH

SO. CAL. AMATEURS
CASL/TURKEY SHOOT RESULTS

2ND ANNIVERSARY ISSUE

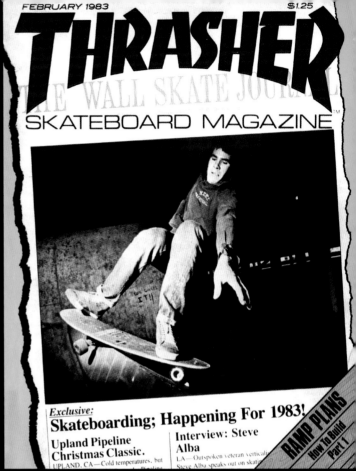

FEBRUARY 1983 $1.25

THRASHER
THE WALL SKATE JOURNAL
SKATEBOARD MAGAZINE ™

Exclusive:
Skateboarding; Happening For 1983!

Upland Pipeline Christmas Classic.
UPLAND, CA—Cold temperatures, but ...

Interview: Steve Alba
LA—Outspoken veteran vertical ...
Steve Alba speaks out on skate...

RAMP PLANS
How To Build Part 1

MARCH 1983 $1.25

THRASHER
SKATEBOARD MAGAZINE ™

**INTERVIEW;
BILLY RUFF**

**SKATE CITY
WHITTIER CLASSIC**

**TAKING THE
KILLER SKATE PHOTOS**

SKATE ROCK

APRIL 1983 $1.25

THRASHER
SKATEBOARD MAGAZINE ™

THE GREAT DESERT RAMP BATTLE

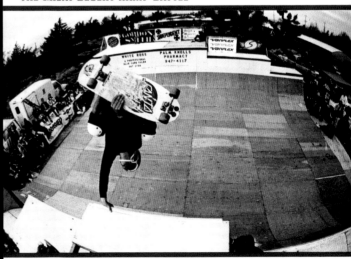

WILD IN THE STREETS **RAMP CONSTRUCTION** PART II

MAY 1983 $1.25

THRASHER

SKATEBOARD MAGAZINE ™

**DEL MAR
PRO/AM
SPRING
NATIONALS**

**EXAMPLE;
SAN JOSE**

**MODERN
SKATE
COMIX**

**PHOTO-
GRAFFITI**

**COMP
RESULTS**

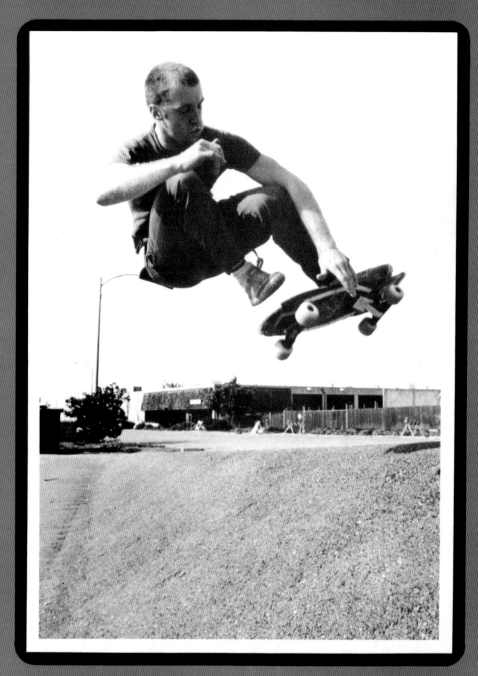

05/83 Garry Davis
Photo: Craig Ramsay

Pressing into and releasing a "boneless air" is skater/journalist extraordinaire Garry "Skate" Davis, at a new San Jose hot spot called "the sink."

06/83 Andy Kessler
Photo: Wesley Bocxe

Longtime New York City ripper Andy Kessler works the nose on a crisp and cool spring night with the NYC skyline as a backdrop.

07/83 Jay "Alabamy" Haizlip
Photo: Glen E Friedman

Operating with just the bare necessities—Levi's, high tops and a board—Jay "Alabamy" guides his skate with aggressive intensity across the love seat channel at a backyard in the wet/dry pool capital of the world, Southern California.

08/83 Steve Caballero
Photo: MoFo

While some of the other pros have been heard saying, "Well, at least we can go for second," Steve Caballero continues to rack up the most impressive contest record in vertical skateboarding history. Frontside channel plant.

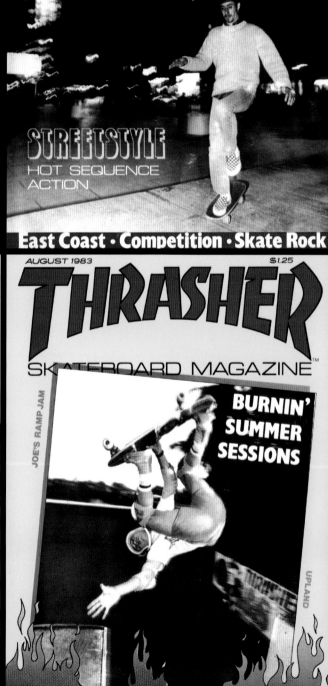

JUNE 1983 $1.25

THRASHER

SKATEBOARD MAGAZINE™

STREETSTYLE
HOT SEQUENCE ACTION

East Coast · Competition · Skate Rock

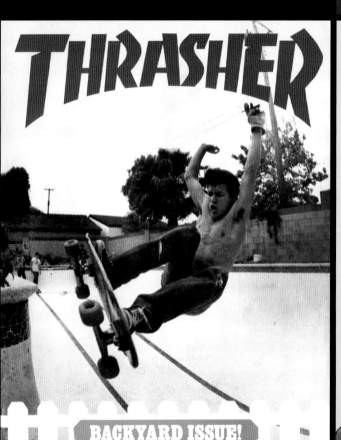

THRASHER

BACKYARD ISSUE!

AUGUST 1983 $1.25

THRASHER

SKATEBOARD MAGAZINE™

BURNIN' SUMMER SESSIONS

JOE'S RAMP JAM

UPLAND

09/83 Top Left: Mike McGill
Photo: Schmitt

Top Right: Craig Johnson
Photo: Jeff Newton

Bottom Left: John Gibson
Photo: Jeff Newton

Center: Jay Cabler
Photo: Jeff Newton

Bottom Right: The Gang
Photo: Jeff Newton

(Clockwise from top left) Mike McGill
flies high over the St. Pete ramp.
Craig Johnson visits the shallow end stair
canyon of a Knoxville, TN pool. Street
pushing through New York City. John
Gibson streaking at Joe Bowers' place
in Tennessee. (Center) Jay Cabler, loose
frontside edge out at Joe Bowers'.

10/83 Puker and Pat Clark
Photo: Glen E Friedman

Raucous and radical Toke Team
member Puker pumps a backside
air over ramp master Pat Clark at
the highly-ripped and well-skated
Annandale ramp near Washington, DC.

11/83 Rob Roskopp
Photo: Ron Schneider

"The Farmer" himself, Rob Roskopp,
steps lively at the "Midwest Melee" ramp
jam in Lincoln, Nebraska, as part of this
month's corny cover concept.

12/83 Big Steve
Photo: MoFo

Local Big Steve power grinds a
frontside across the death box
in a backyard LA pool.

SEPTEMBER 1983 $1.25

THRASHER
SKATEBOARD MAGAZINE ™

EAST COAST SUMMER TOUR
KONA · ST. PETE

RAD! RAMP ACTION

OCTOBER 1983 $1.25

THRASHER
SKATEBOARD MAGAZINE

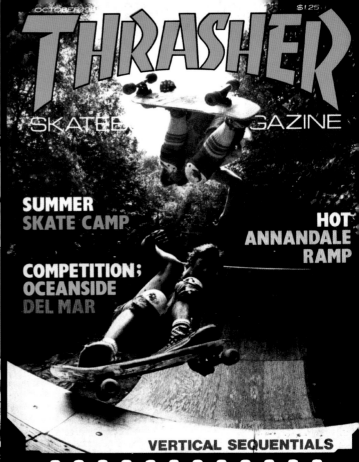

SUMMER SKATE CAMP

COMPETITION: OCEANSIDE DEL MAR

HOT ANNANDALE RAMP

VERTICAL SEQUENTIALS

NOVEMBER 1983 $1.25

THRASHER
SKATEBOARD MAGAZINE ™

100% PURE RAD · SERVE HOT

MIDWEST MELEE

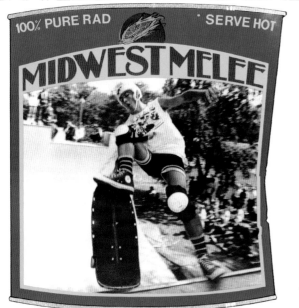

CAPITOLA CLASSIC · MIKE MC GILL

DECEMBER 1983 $1.25

THRASHER
SKATEBOARD MAGAZINE

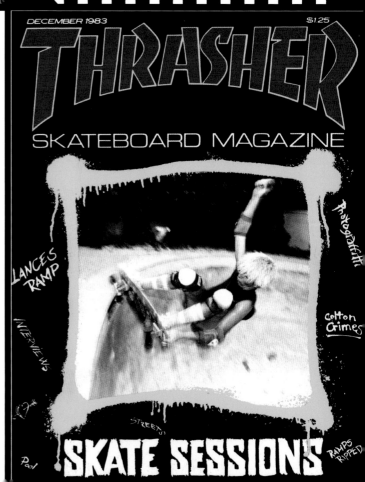

LANCE'S RAMP

INTERVIEW?

Photograffitti

Cotton Crimes

STREET

Pool

SKATE SESSIONS

RAMPS RIPPED

01/84 Rodney Mullen
Photo: Glen E Friedman

Vanguard freestylist Rodney Mullen
kicks it out at Kenter Canyon School
in Santa Monica.

02/84 Monty Nolder
Photo: Jeff Newton

Monty Nolder, gay twist over
the channel at the St. Pete Jam.

03/84 Mondo
Photo: Matt Etheridge

Gnarly Grinder, Mondo, tears one off at
the Playa del Rey ramp in West LA.

04/84 Bryce Kanights
Photo: Matt Etheridge

Lofting in a loft, Bryce Kanights, our
resident darkroom technician, paste-up
artist, photographer, and... Oh yeah!
Ripping skater, bones up on some
frontside air in a warehouse of banks
in Oakland, CA. Photo was snapped by
fellow staffographer Matt Etheridge,
who, incidentally, was responsible for
last month's Mondo grind cover shot.
And yes, Matt skates also.

THRASHER

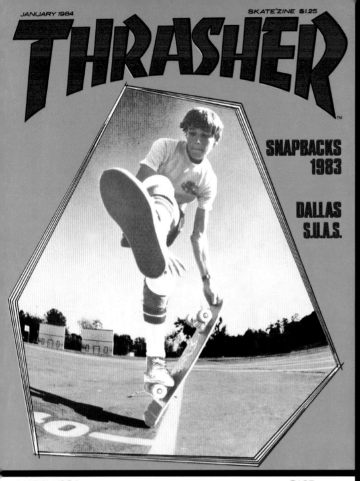

SNAPBACKS
1983

DALLAS
S.U.A.S.

THRASHER

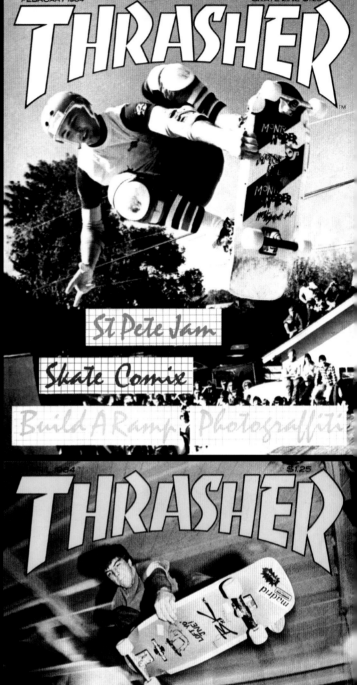

St Pete Jam

Skate Comix

Build A Ramp *Photograffiti*

THRASHER

GRINDING Style

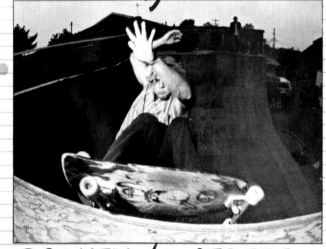

RODNEY Speaks STREET Sagas

THRASHER

A
Skater's
Guide To

AIR

Skate Rock · TSOL · McRad · Puszone

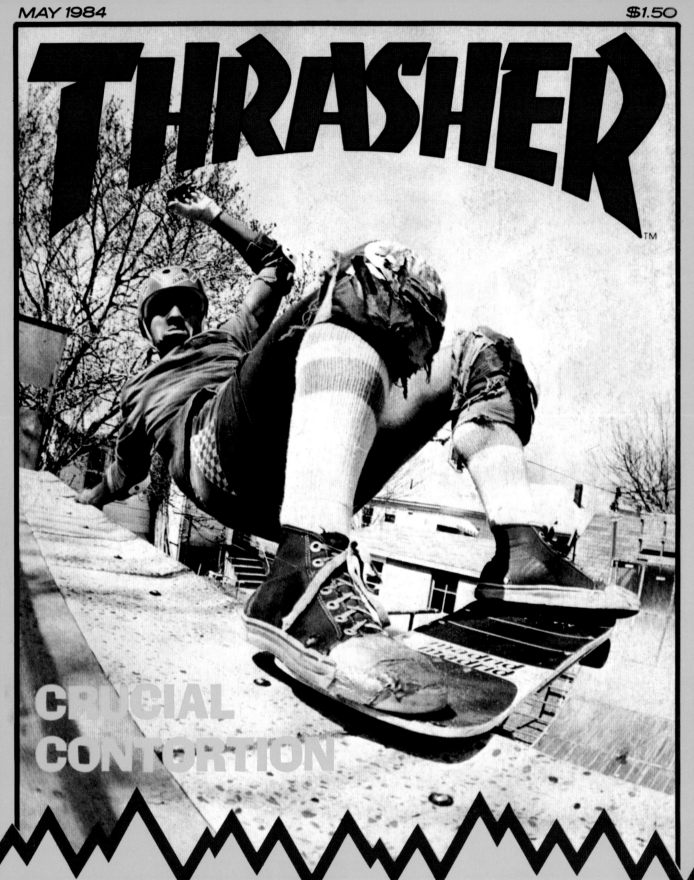

MAY 1984

$1.50

THRASHER

™

CRUCIAL CONTORTION

TONY ALVA; Life & Times

05/84 Chuck Treece
Photo: Glen E Friedman

Rad McShredder Chuck Treece contorts bodily and facially as he rolls out of the Groholski ramp in New Jersey.

06/84 Mark Rogowski
Photo: Kevin Thatcher

Mark Rogowski pushes a frontside lip lapper out onto the shallow hip of a deep kidney in San Jose. First color photo on the cover.

07/84 Tommy Guerrero
Photo: Kevin Thatcher

Boosting a "fast plant" over the corner at Fort Miley banks in SF is Tommy Guerrero. Before the railing.

08/84 Christian Hosoi
Photo: MoFo

Working high above the gnarled lip of the combi pool at Upland is Christian Hosoi, kickin' out a backside air.
Inset: Big Boy Biscuit thrusts a devilish grin at the crowd during a Skate Rock show at the Stardust in LA.

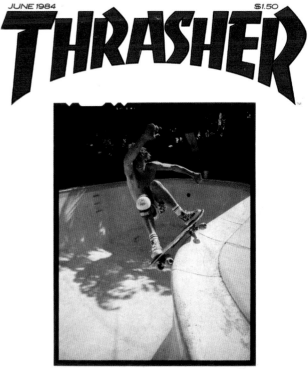

JUNE 1984 $1.50

THRASHER

POOLS · PIPES · PARKS

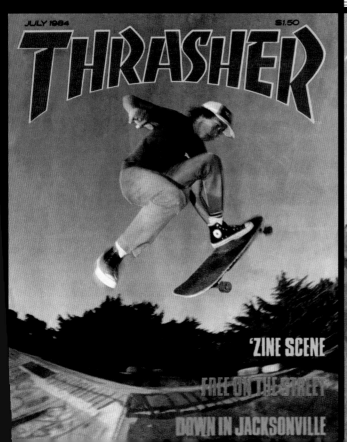

JULY 1984 $1.50

THRASHER

'ZINE SCENE

FREE ON THE STREET

DOWN IN JACKSONVILLE

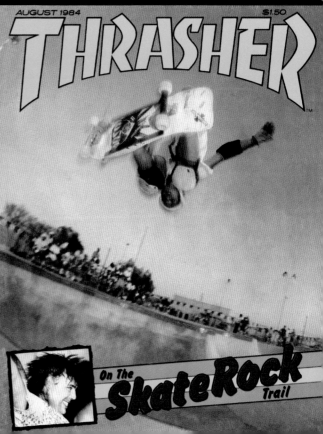

AUGUST 1984 $1.50

THRASHER

On The
Skate Rock Trail

SEPTEMBER 1984: NATAS KAUPAS

Ocean Park Boulevard wallride. This was the first image of
Natas Kaupas published in the magazines. —*CR Stecyk III*

10/84 Bob Denike
Photo: Gary Fluitt

Bob Denike lopes along on his skate
through the heartland of America.
Sunset photo by travel-mate Gary Fluitt.

Inset: Neil Blender
Photo: MoFo

Inset: Neil Blender rages at the NSA
Finals at Del Mar.

09/84 Natas Kaupas
Photo: CR Stecyk III

"Up against the wall," Natas Kaupas
powers away from a wall walk through
a 90-degree transition.

11/84 Mark Gonzales
Photo: MoFo

Amateur street radical, Mark Gonzales,
blasts through a boneless-type
maneuver at the Capitola Classic
'Street Thrash' event.

12/84 San Jose Navaho
Artwork: Chris Buchinsky

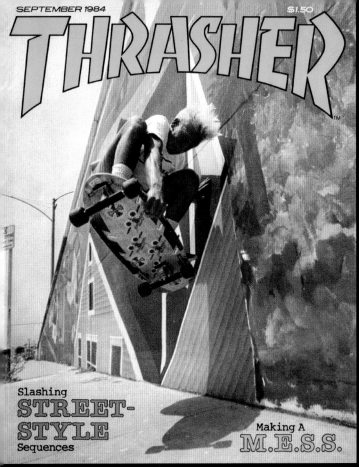

SEPTEMBER 1984 $1.50

THRASHER

Slashing
STREET-
STYLE
Sequences

Making A
M.E.S.S.

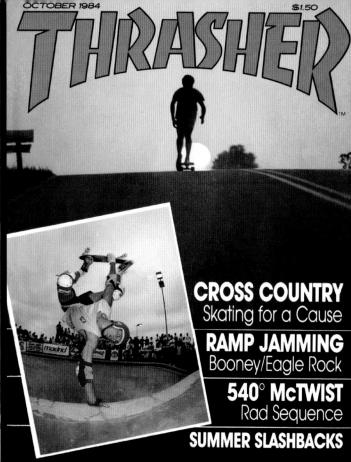

OCTOBER 1984 $1.50

THRASHER

CROSS COUNTRY
Skating for a Cause

RAMP JAMMING
Booney/Eagle Rock

540° McTWIST
Rad Sequence

SUMMER SLASHBACKS

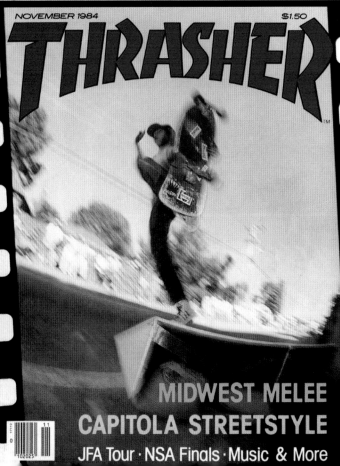

NOVEMBER 1984 $1.50

THRASHER

MIDWEST MELEE
CAPITOLA STREETSTYLE
JFA Tour · NSA Finals · Music & More

0 102025 11

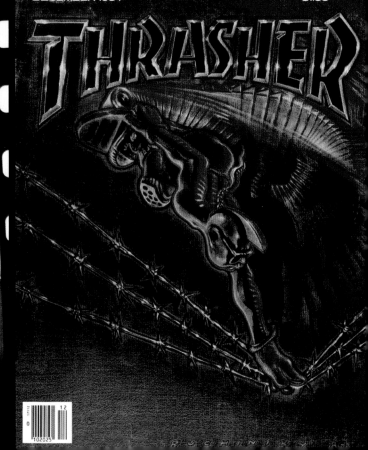

DECEMBER 1984 $1.50

THRASHER

0 102025 12

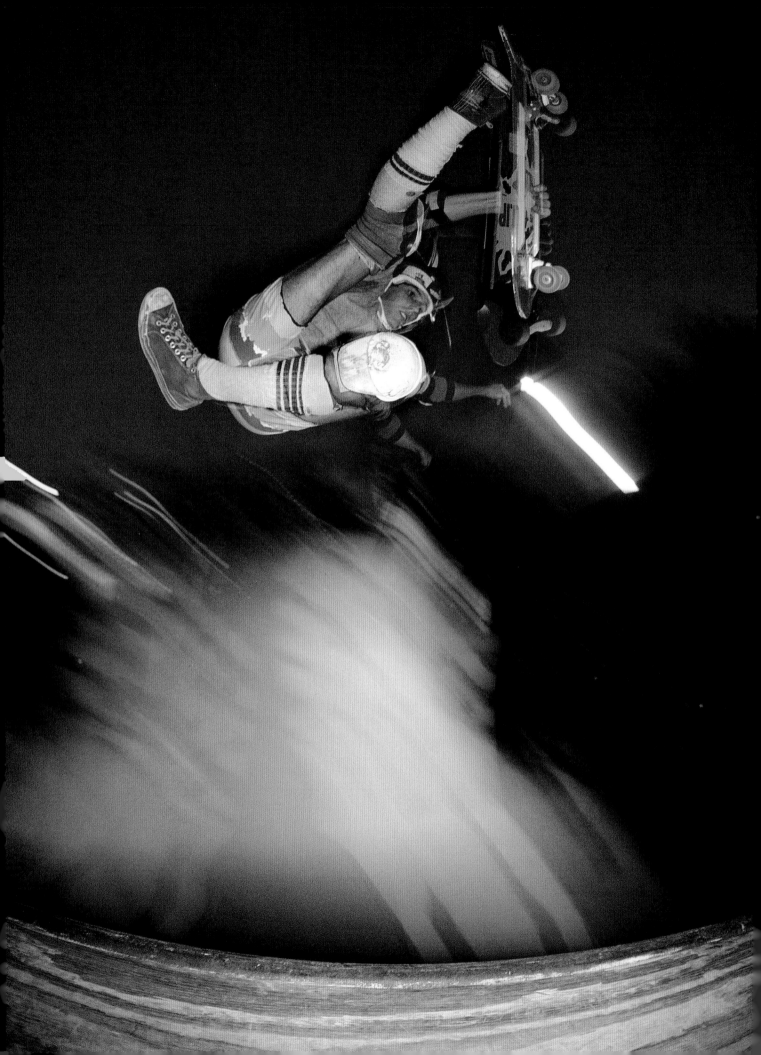

JANUARY 1985 $1.50

THRASHER

:DALLAS :MOTORHEAD :WORLD

JANUARY 1985: JEFF PHILLIPS

The boneless one was one of the first tricks I ever learned.
I couldn't ollie, so the boneless did the job of an ollie for me. At first
it was just a way to get up things like curbs or a way to jump down
some stairs. But when I learned it on transition, it became the way
that I could get the highest. After years of studying the boneless,
it's easy for me to say that Jeff Phillips had the best one ever. I can
remember my first time looking at this cover and thinking, "How
the hell did he get his body in that position!?" Nose pointed straight
down, foot tucked at the apex… And the photo looked like it was in
some crystal ball wrapped in cloth. Psychedelic! —*Peter Hewitt*

01/85 Jeff Phillips
Photo: MoFo

Absolute contortion by Jeff Phillips on
the Clown Ramp in Dallas. Boney cover
concept and photos by MoFo.

MAY 1985: JOHN "TEX" GIBSON

We were jolted awake by the loudest alarm clock we'd ever heard in our lives. It was still dark outside and it was freezing cold, but that's how we did it then—we had to sneak in to the pipe before the sun came up so no one would see us. We'd climb down the wall with a rope, get all of our stuff down there… We had to skate just to stay warm. Our original plan was to get in there and then go back to sleep until the sun came up—but there was no sleeping, because it was bone-chilling cold. So we started skating in the dark, doing fakies to get our blood going. Then the sun started coming up a little bit… Then a little bit more… And that's how KT's picture came about. The sun had just barely risen when he took the shot—the first photo of the morning; the first frame on the roll. —*John Gibson*

**03/85 Billy Ruff
and Neil Blender**
Photo: MoFo

Can you believe these guys are actually professional skateboarders? Billy Ruff and Neil Blender goofing off in a North County parking lot.

02/85 Neil Blender
Photo: MoFo

Neil Blender and a friend.

04/85 Christian Hosoi
Photo: MoFo

Christian Hosoi quivering in a full Andrecht flap-over on top of Joe's ramp.

05/85 John Gibson
Photo: Kevin Thatcher

High plains drifter John Gibson tests the altitude in a giant Texas pipe at dawn.

FEBRUARY 1985 $1.50

THRASHER

*NEIL BLENDER
LOOK AT LANCE'S

adventure·hidden lies·water

MARCH 1985 $1.50

THRASHER

INSIDE:
ACTUAL SIZE

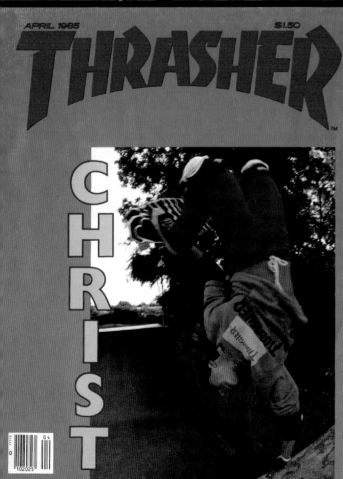

APRIL 1985 $1.50

THRASHER

CHRIST

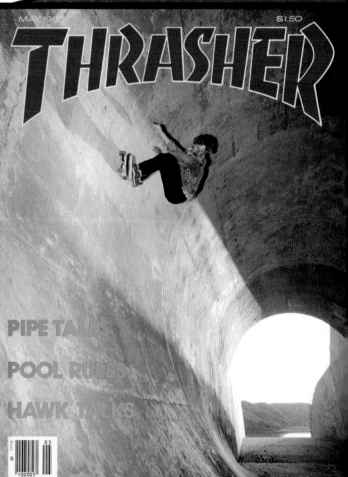

MAY 1985 $1.50

THRASHER

PIPE TALES

POOL RULES

HAWK TALKS

$1.50

THRASHER

™

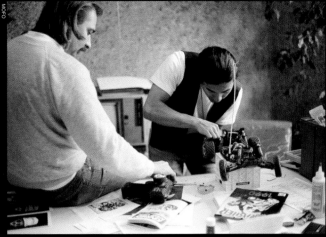

Thrasher founder **Fausto Vitello** and **Steve Caballero**, working on remote-control cars at the magazine's headquarters in 1990. Steve's January cover from that year is seen on the desk.

JUNE 1985: STEVE CABALLERO

You see the little things that are holding my braids together? They're tiny *Thrasher* stickers! This is the Jew Bowl in San Jose, at the Jewish Community Center. Frontside invert on the side wall. Out of all the covers I've had, this is my favorite, for sure: Hometown, little fake dreads in there... It's just an awesome cover. It was an honor.

This was when we were shooting video for *Future Primitive*. I was taking Stacy Peralta to all the spots in San Jose, and this was one that had just opened up. It was the first time I skated that pool. Making videos back then was a lot less stressful: It was just skating while the cameras were rolling, filming stuff that we already knew how to do. It wasn't like how it is now, where you're learning tricks and trying to progress as you're filming. Nowadays, everyone tries to film something that they *can't* do until they make it. At that time, we were just skating anything we could. This was when the parks closed, so I had my backyard ramp, and we skated ditches, and we tried to find

"YOU SEE THE LITTLE THINGS THAT ARE HOLDING MY BRAIDS TOGETHER? THEY'RE TINY THRASHER STICKERS!"

pools—trying to make a session happen wherever. To us, that was skateboarding. It wasn't like, "I wanna get something today, so I gotta call my photographer, my videographer, a couple friends, and we're going to get some business done." Ya know, we just skated, and that's what skateboarding meant to us back in the day. Now it's really business-oriented, and to tell you the truth, that kinda takes the fun out of it.

Especially with Powell, our stuff wasn't really based on photo incentives. We were paid well, so it wasn't like, "Hey, here's another 50 bucks for a cover!" would have mattered. We were getting pretty good royalty checks from our decks. This is actually before Vans— I am wearing Vans in the photo, but soon after that I was wearing other shoes like Converse and Nike. That's when we pumped up the Air Jordans and made those really big. Pumas, too. I remember going to buy 10 pairs of Pumas at Big 5; they were 10 dollars a pair. I spent $100 on 10 pairs of shoes—that's how desperate we were back in 1986 and '87. Then, in 1988, Vans rolls up: "Hey, we want you to ride for Vans again...and we're going to pay you now!"

"Sign me up!" —*Steve Caballero*

06/85 Steve Caballero
Photo: MoFo

Bursting off of our cover this month,
Steve Caballero is locked into a much dreaded
(and braided and tied) frontside handplant.
The pool, Jew-drop in San Jose, was bulldozed
as we went to press, but we all know, skating
can't sustain if the terrain remains the same.

JULY 1985 $1.50

THRASHER

™

0 17112

07

0 102025

MORE THAN EVER

07/85 Chris Miller
Photo: MoFo

Until he slammed himself out of
contention, Chris Miller was the one
to beat in Upland's Combi.

08/85 Lester Kasai
Photo: MoFo

Reflecting on a high backside air,
Lester Kasai floats above a freshly
white-washed Trashmore ramp during
the NSA No. 3 at Virginia Beach.

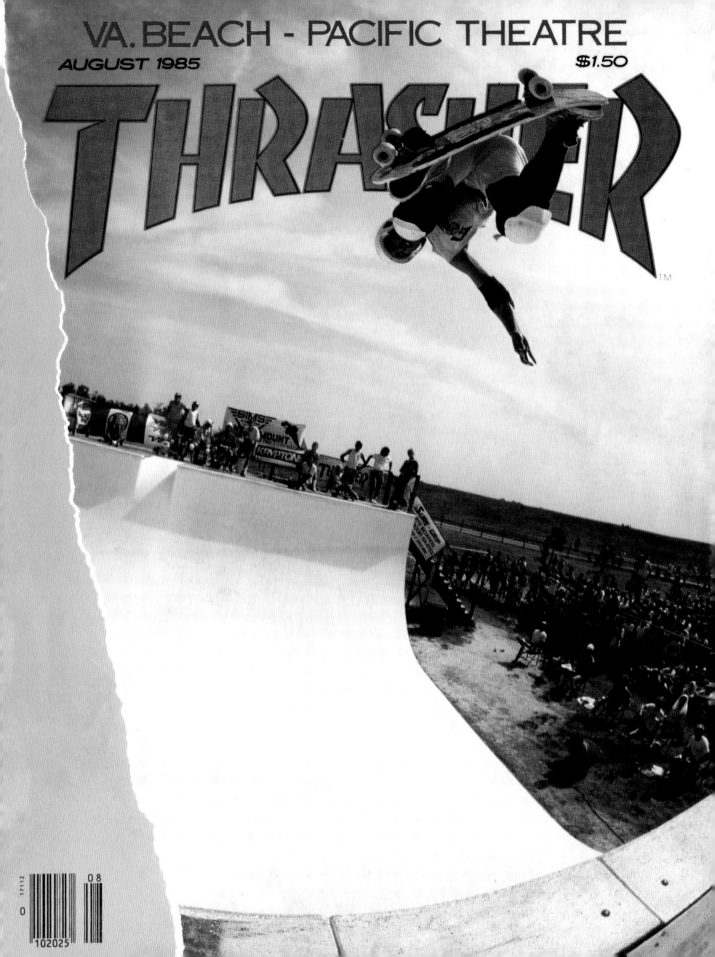

VA. BEACH - PACIFIC THEATRE

AUGUST 1985

$1.50

THRASHER
™

SEPTEMBER 1985: LANCE MOUNTAIN

"Mountain Juice." This must have been MoFo hooking me up for winning the Tahoe contest. It was in the woods, a backyard-type deal, and he must have thought that Jack Daniels fit with the backwoods/whiskey theme. He told me I got the cover and I was like, "Yes! The cover!"… And then I see that it's just a photo of me smiling in front of a Holiday Inn. Obviously, as a skater you're thinking, "Why didn't I get a skate photo?" This picture is actually from Dallas, and I don't think many people knew it was supposed to be a whiskey bottle…

"WHY DIDN'T I GET A SKATE PHOTO?"

I didn't know what it was at first. It was strange: Cab got a big skate photo for his cover. Hosoi got a big photo, skating. Chris Miller even got one…when he rode Indys instead of Gullwings. And then I got mine, smiling with my fang in front of a Holiday Inn. I don't think anyone thought I was going to do good at contests, let alone win one, so nobody took a photo of me. I didn't really practice—I'd just show up and take my runs—so unless they got a photo of me in those two runs, I was out of luck. They didn't think I was going to make the cut, so they wouldn't want to waste film on me. So when I *did* win?

"We should put him on the cover. What photo do we have of him?"

"Well, we've got this photo of him out in front of a Holiday Inn."

I think that's what happened. —*Lance Mountain*

09/85 Lance Mountain
Photo: MoFo
Inset: Lance Mountain. Mile High Victor.

10/85 Bruno Peeters
Photo: MoFo

Bruno Peeters, fakie ollie in Germany
on Claus' ramp.

11/85 Christian Hosoi
Photo: Mike Tkacheff

Auto pilot Christian Hosoi making
a head-high flyover above the
car at the Capitola Streetstyle Classic.

12/85 Dave Hackett
Photo: Shonna Valeska

In a New York state of mind. Like a
chameleon, Dave Hackett blends into
his surroundings while doing stylized
walkovers in the Big Apple.

01/86 Claus Grabke
Photo: Shane Rouse

Culture clashing, Claus Grabke
vaults an invert over the Iron Curtain
into Czechoslovakia to experience
a skating adventure.

OCTOBER 1985 $1.50

THRASHER

london
germany
and
sweden
infiltrated

europe

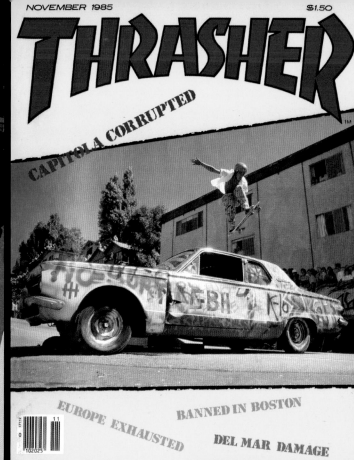

NOVEMBER 1985 $1.50

THRASHER

CAPITOLA CORRUPTED

EUROPE EXHAUSTED

BANNED IN BOSTON

DEL MAR DAMAGE

DECEMBER 1985 $1.50

THRASHER

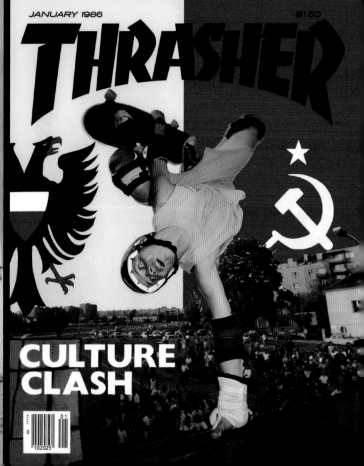

JANUARY 1986 $1.50

THRASHER

**CULTURE
CLASH**

APRIL 1986: TOMMY GUERRERO

Wallos is fuckin' gnarly, rough, and brutal. This was my first time there—we were in Hawaii for a demo tour that *Thrasher* and KT had organized. We went with a bunch of locals: Stacy Gibo, Billy Deans, Moblow, and that whole crew. I'd find whichever one of them was regular foot and follow their line so I wouldn't get broke. The tranny was tweaked—there were so many cracks and holes everywhere, but those guys had it dialed. They knew that you'd have to carve farther out on a specific wall so you wouldn't hit the huge crack at the bottom. Like when Mike McGill broke his truck in *Animal Chin*.

It's one of those epic spots. When we were "searching" for *Chin*, we thought it would be the perfect location: Pretty, tropical, and so forth. I was travelling a lot then, at 19-years-old. I'd turned pro in '85, and my board first came out in '86, so this mag was hot off the press. The board in the photo was my first pro model, but George Powell didn't like the graphic so he had it changed to the more recognizable one with the flames. I actually have this very board, the complete setup. It's thrashed. Ray Meyer, the freestyler—his brother found it last year outside his house and gave it to me. It's super beat because he'd done some freestyle on it, so the tail's chipped up and the trucks are cranked down. Crazy lookin'. EBay!

Thrasher has the best history. I remember when the first issue, the illustration of the layback on newsprint in the big format, came out. That was when skating was totally dead. That's when street skating started happening, right when the parks closed. Most of the parks were in the South Bay—Winchester, Milpitas—we didn't really have much up here, so we'd hop BART down there. Once they all closed, we were still gonna go skate. We'd grown up skating the hills, so when the parks closed, it was back to the hills again. —*Tommy Guerrero*

02/86 Allen Losi
Photo: MoFo

Veteran from Variflex, Allen Losi looks at his skating from an interview perspective.

03/86 Natas Kaupas
Photo: Kevin Baboot

Give a dog a skate and stand back. Natas Kaupas, "because it's there," lays back while involved in a different kind of demo.

04/86 Tommy Guerrero
Photo: Kevin Thatcher

Tommy Guerrero takes to the harsh tropical transitions of the infamous Wallos with a lien flair.

05/86 Lester Kasai
Photos: MoFo

Lester Kasai, hectic hangar frontside ollie at Hot Tropics Pro/Am in Mobile, AL.

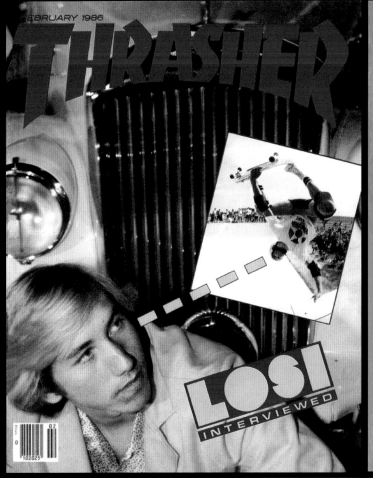

FEBRUARY 1986

THRASHER

LOSI INTERVIEWED

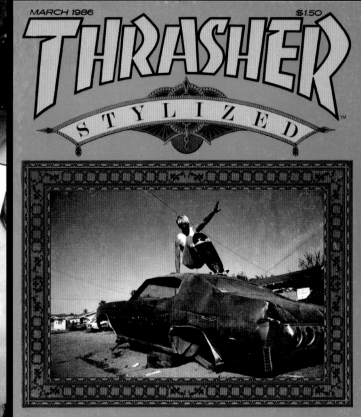

MARCH 1986 $1.50

THRASHER
STYLIZED

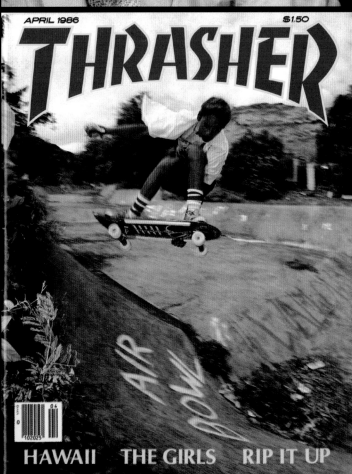

APRIL 1986 $1.50

THRASHER

HAWAII THE GIRLS RIP IT UP

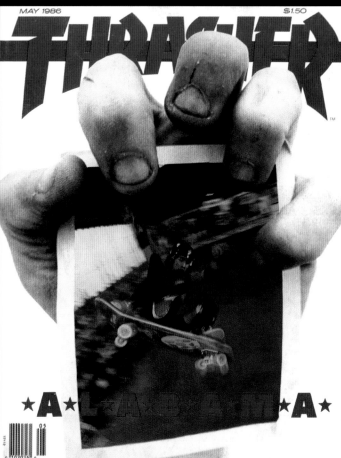

MAY 1986 $1.50

THRASHER

★A★L★A★B★A★M★A★

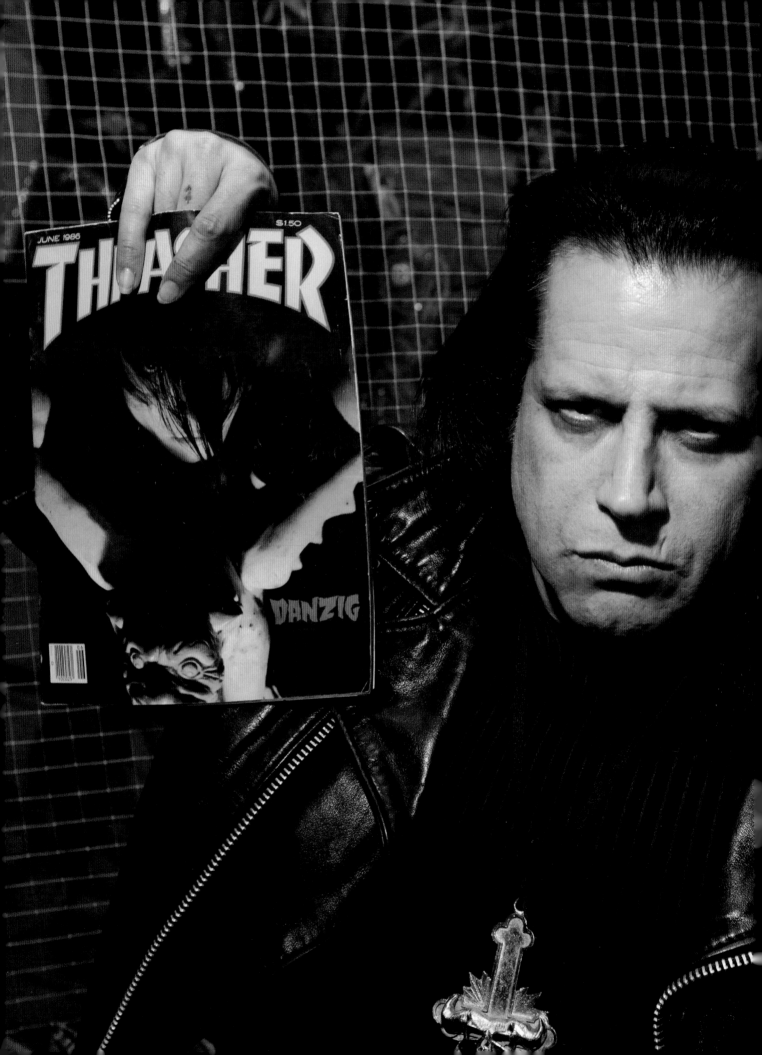

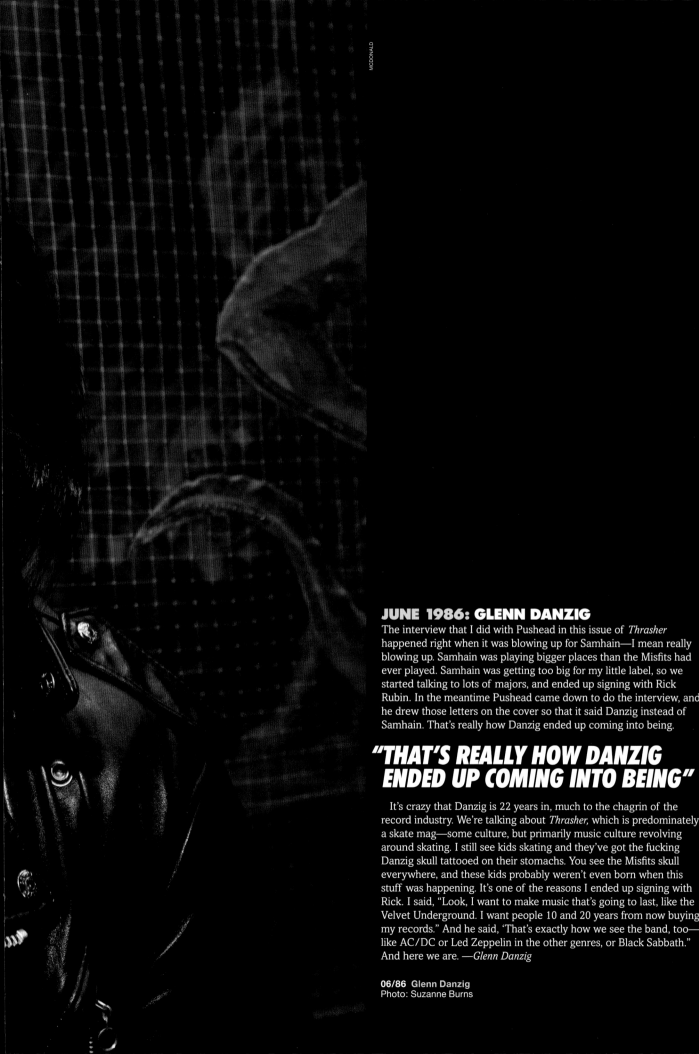

MCDONALD

JUNE 1986: GLENN DANZIG

The interview that I did with Pushead in this issue of *Thrasher* happened right when it was blowing up for Samhain—I mean really blowing up. Samhain was playing bigger places than the Misfits had ever played. Samhain was getting too big for my little label, so we started talking to lots of majors, and ended up signing with Rick Rubin. In the meantime Pushead came down to do the interview, and he drew those letters on the cover so that it said Danzig instead of Samhain. That's really how Danzig ended up coming into being.

"THAT'S REALLY HOW DANZIG ENDED UP COMING INTO BEING"

It's crazy that Danzig is 22 years in, much to the chagrin of the record industry. We're talking about *Thrasher,* which is predominately a skate mag—some culture, but primarily music culture revolving around skating. I still see kids skating and they've got the fucking Danzig skull tattooed on their stomachs. You see the Misfits skull everywhere, and these kids probably weren't even born when this stuff was happening. It's one of the reasons I ended up signing with Rick. I said, "Look, I want to make music that's going to last, like the Velvet Underground. I want people 10 and 20 years from now buying my records." And he said, 'That's exactly how we see the band, too—like AC/DC or Led Zeppelin in the other genres, or Black Sabbath." And here we are. —*Glenn Danzig*

06/86 Glenn Danzig
Photo: Suzanne Burns

JULY 1986: JESSE MARTINEZ

This photo was taken in Sacramento, at the first pro contest I ever entered. It was extremely hot, everybody was dying—I was really stoked right after my run, but then I hit a rock and crashed. So that was pretty fitting. I ended up getting 8th or 10th place, but this issue alone is one of the high points of my whole career. To this day I still show it to my family. I'm really stoked on it; always will be.

I'd have to say, these were the best times of my life. I couldn't have been any happier riding for Powell, flying everywhere—it was pretty much a skater's dream. The first time I ever saw this issue was an accident. We were on a Bones Brigade tour, and I was with Steve Caballero in New York City in a giant bookstore. Cab goes, "Hey, turn around." So I did, and there's 10 of 'em in a row on the rack! "Oh my God, that's me!" I bought two. When I actually opened it I was quite surprised to see how many pictures and ads I had. It was like, "Jesus Christ. What did I do for them? I know I rode their Thunders, but…"

If you look under my bed—and I'm not lying—I have two boxes of original *Thrashers* from the first few years. I still rummage through those boxes now and then and think about those days and the Venice issue *Thrasher* did for us, with all the neighborhood crew like Stranger and Block. Several guys in Venice still have that copy. *Thrasher* was a big part of Dogtown and Venice. We may have been Dogtown here, but *Thrasher* exposed us to the world.

Someone asked me a while back, "Who do you want to thank?" I thanked a bunch of people—but I also thanked *Thrasher* magazine, because I don't forget. —*Jesse Martinez*

07/86 Jesse Martinez
Photo: Steve Keenan

Jesse Martinez frozen in full kick-out over a Sacto street contest. Classic, no-copy cover.

08/86 Mike Vallely
Inset: James Hetfield, Metallica
Photos: MoFo

Where skaters gather. Throughout the recent Pro/Am at VA Beach, skaters from all points East mixed it up in the parking lot of Trashmore ramp, the only place they can legally skate. Here Mike Vallely hand walks a sadplant in front of an equally able crew.

09/86 Mark Gonzales
Photo: MoFo

Just when you've seen everything, Mark Gonzales comes up with another bizarre, new, twisted maneuver.

10-11/86 Tony Hawk
Photo: MoFo

In addition to spinning McTwists and 720s, flipping varials, air-walkin' six feet over and flappin' inverts, Tony Hawk knows his basic chops. Grinding at the Pink Motel during another PP shoot.

JULY 1986 $1.50

THRASHER

AUGUST 1986 $1.75

THRASHER

METALLICA

SEPTEMBER 1986 Can. $3.00 $1.75

THRASHER

ST. LOUIS
OUT OF CONTROL

SKATE ROCK

MARK GONZALES
'NOTHING WRONG WITH THIS' INTERVIEW

OCEANSIDE STYLING
STREET AND FREE MIX IT UP ON THE BEACH

OCTOBER / NOVEMBER 1986 Can. $3.00 U.S. $1.75

THRASHER

VACANCY

TRIX YOU
CAN'T DO

VENICE
SUMMER

STREET MEAT

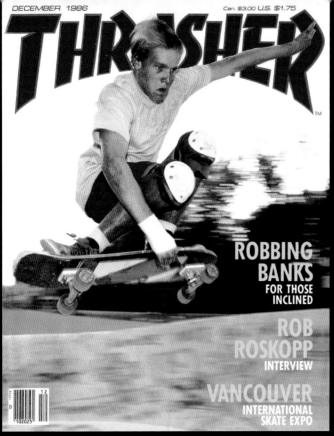

DECEMBER 1986
Can. $3.00 U.S. $1.75

THRASHER

ROBBING BANKS
FOR THOSE INCLINED

ROB ROSKOPP
INTERVIEW

VANCOUVER
INTERNATIONAL SKATE EXPO

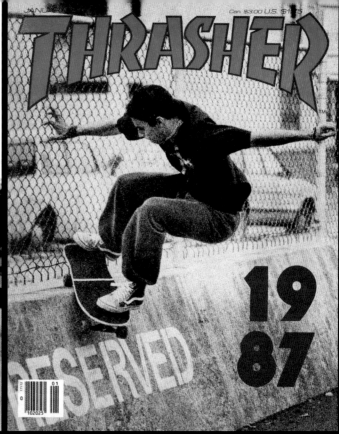

Can. $3.00 U.S. $1.75

THRASHER

19
87

RESERVED

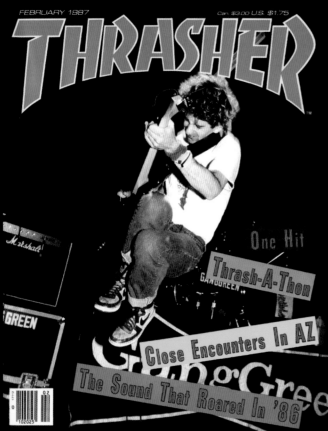

FEBRUARY 1987
Can. $3.00 U.S. $1.75

THRASHER

One Hit

Thrash-A-Thon

Close Encounters In AZ

The Sound That Roared In '86

12/86 Chris Miller
Photo: MoFo

Amid tight security and a hectic schedule of events at the World Championships in Vancouver, Canada, most skaters found time to skate and have fun. Chris Miller drives a frontside air out of the snake-run at Vancouver Skatepark.

01/87 Jim Thiebaud
Photo: MoFo

Locked and loaded, Jim Thiebaud dominates a rather abrupt transition during an SF street session.

02/87 Chris Doherty
Photo: MoFo

Chris Doherty, power guitarist for Gang Green, gets a rock air at the On Broadway in SF.

03/87 Jeff Phillips
Photo: MoFo

Upset victor at the NSA finals in Anaheim, Jeff Phillips gets a lofty indoor ollie flight. He whooped Hawk while high on acid.

MARCH 1987

Can. $3.00 U.S. $1.75

THRASHER

™

1986 PRO-AM CLIMAX
ADOLESCENTS
TWO CITIES
720—THE GAME

04/87 Brian Brannon
Photo: Bryce Kanights

In the vast wasteland between the Sierra Madre range and the Rocky Mountains lies the smooth desert belly of mother nature. Even here, suburban sprawl grows unchecked across the fragile environment, fueled by water projects that spare nothing in their path. Like parasites on a fresh kill, a sturdy breed of skaters venture into these badlands to feed on the carcasses of man's excess. One structure, described as the "Stonehenge" of skateable architecture, was built as a backdrop for a car commercial shoot. Desert skater Brian Brannon clings like a lizard on a hot rock below the unattainable edge of the man-made monolith.

05/87 Mike Muir
Photo: MoFo

Mike Muir, lead singer of Suicidal Tendencies, lets us have it in an interview.

06/87 Steve Alba
Photo: Steve Keenan

Summer or bust. Steve Alba grabs a shirtless carve on the 6th Street Wave in Upland.

07/87 Mark Rogowski
Photo: MoFo

Mark Rogowski, WFO slashback at the X-acto pool.

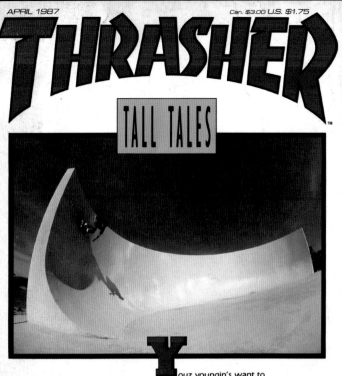

APRIL 1987

Can. $3.00 U.S. $1.75

THRASHER

TALL TALES

Youz youngin's want to hear tell of some vertical ventures from truly glorious days gone by? Well then, gather 'round and, hey, stop pickin' your nose.

"This tale goes way back, back when skate rock was a wheel and a street plant was something the coppers would send you to the big house for.

Continued on page 55

04
0 17111
102025 0

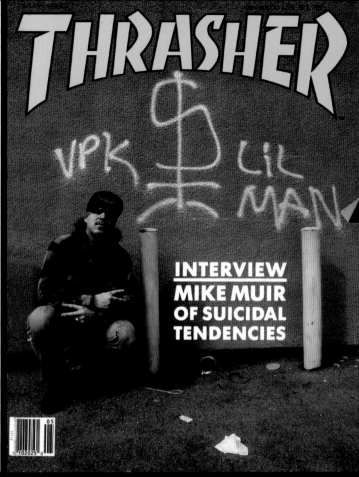

THRASHER

VPK $ LiL MAN

INTERVIEW
MIKE MUIR
OF SUICIDAL
TENDENCIES

05
102025 0

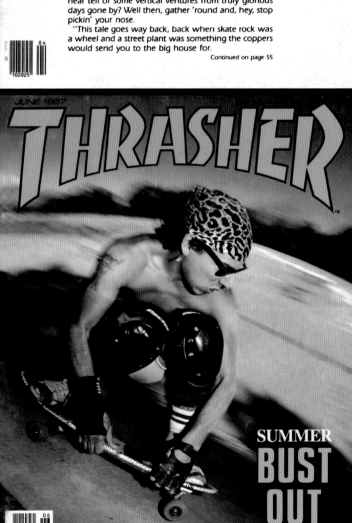

JUNE 1987

THRASHER

SUMMER
BUST
OUT
ISSUE

06
0 102025 0

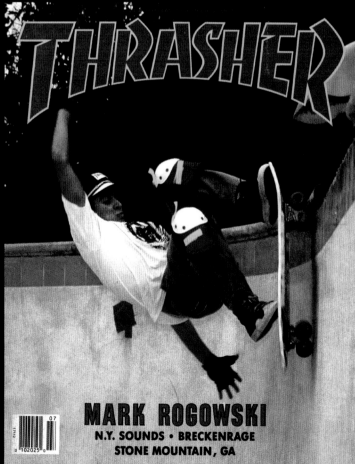

THRASHER

MARK ROGOWSKI
N.Y. SOUNDS • BRECKENRAGE
STONE MOUNTAIN, GA

07
0 102025 0

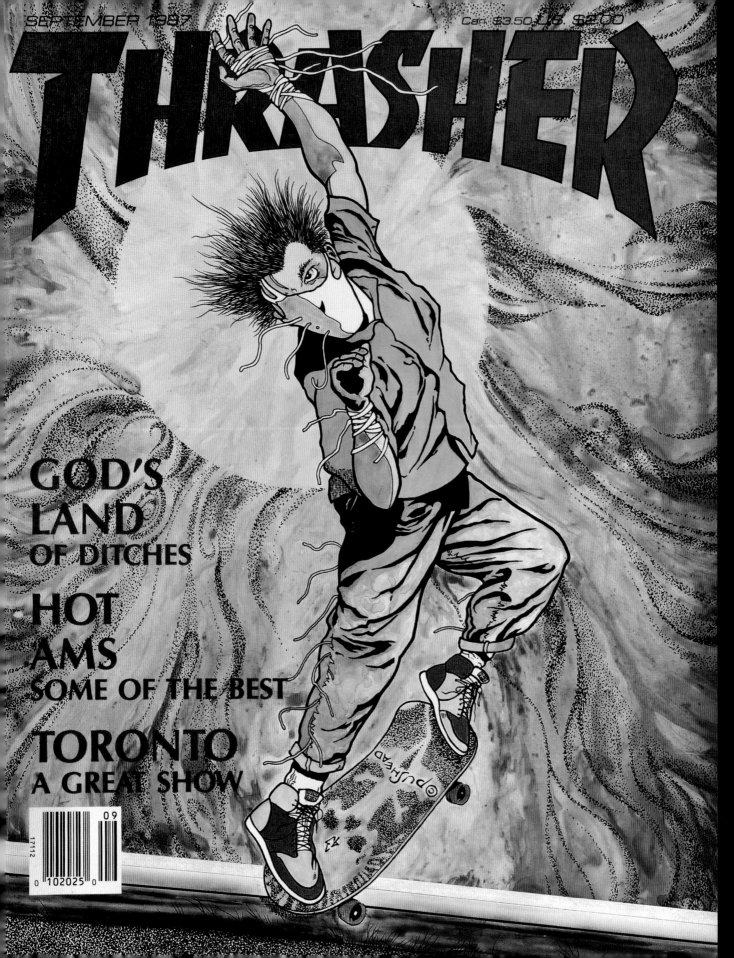

11/87 Steve Caballero
Photo: MoFo

Steve Caballero front boards a street
bench slide on the French Riviera, Nice.

12/87 Eddie Reategui
Photo: Steve Keenan

Compression release.
Eddie Reategui caught jammin'
at the Slamma in Savannah.

01/88 Eric Dressen
Photo: Chuck Katz

Eric Dressen teeters a tail tap on the
coping edge of a pool in Beverly Hills, CA.

02/88 Skater: Tony Vitello
Model: Katrina "Honey"
Baumgartner
Photo: CR Stecyk III

Evil shows itself in many forms. And,
yes, once again my brothers, skating is
back on the seller's block to the highest
bidder. Take heed, bretheren, we're in
big trouble now. They know we're here.

NOVEMBER 1987 Can $3.50 U.S. $2.00

THRASHER

POOL JONES

SUPER RAMP
The Rise and The Fall

MISSION: EUROPA Part II

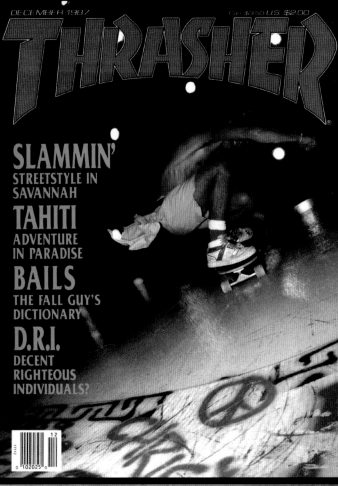

DECEMBER 1987 Can $3.50 U.S. $2.00

THRASHER

SLAMMIN'
STREETSTYLE IN SAVANNAH

TAHITI
ADVENTURE IN PARADISE

BAILS
THE FALL GUY'S DICTIONARY

D.R.I.
DECENT RIGHTEOUS INDIVIDUALS?

SISTERS ARE REVOLTING • ROLLING OVER 30 • HELL TOUR TWO

THRASHER

JANUARY 1988
U.S. $2.00
Can. $3.50

THE OLDEST TRICKS
ARE NOT WHAT YOU THINK

CONTESTS:
TAKE IT OR LEAVE IT

DEE DEE RAMONE MOUTHS OFF

EAST COAST AMS

PHOTOGRAFFITI

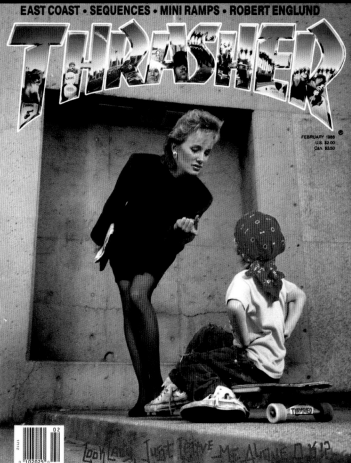

EAST COAST • SEQUENCES • MINI RAMPS • ROBERT ENGLUND

THRASHER

FEBRUARY 1988
U.S. $2.00
Can. $3.50

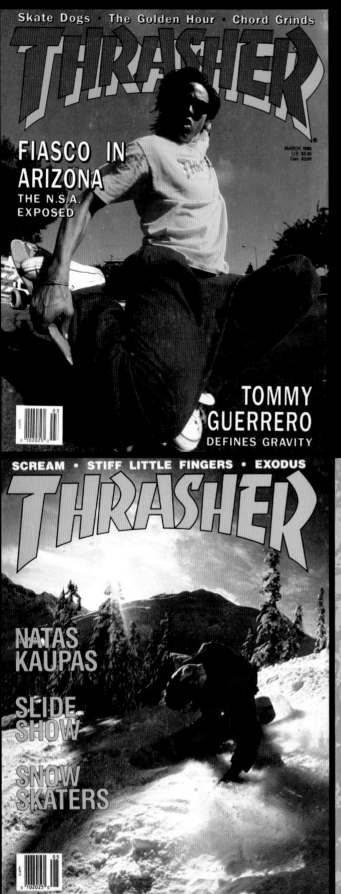

MAY 1988: ROB ROSKOPP

Thrashin'? In the snow? Those dudes must have thought they had it made. —*Jake Phelps*

03/88 Scott Oster
Photo: Chuck Katz

Scott Oster, squatting a very difficult G-turn with style.

04/88 Steve Alba
Photo: Steve Keenan

Ten years after winning at Spring Valley, Steve Alba is still powering. Frontside tap-in, Dolphin Pool.

05/88 Rob Roskopp
Photo: Bryce Kanights

Mid-day sun over picturesque Mt. Baker and Rob Roskopp in snowboard paradise.

06/88 Christian Hosoi
Photo: Michael Blanchard

Christian Hosoi, cool, calm, and collecting another first place win at the mini-ramp challenge in Vancouver, BC.

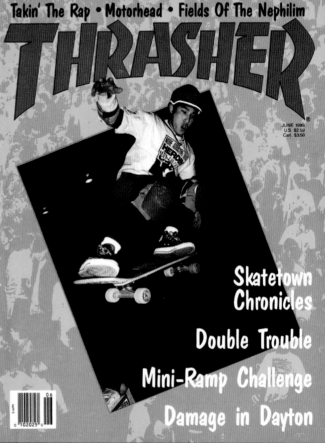

THRASHER

APRIL 1988
U.S. $2.95
CAN $3.50

GO FIND YOUR OWN SPOT
Stop Whining Start Looking

COJONES
Do You Have What It Takes?

WORLD'S GREATEST SKATER
Interviewed

OCTOBER 1988: DAVE HACKETT

When focus and aggression collide, it's a beautiful thing. I remember seeing this cover of *Thrasher* and getting the most aggro feeling. It seemed as though Dave Hackett was putting it all on the line. I tried to emulate the feeling I got from this photo countless times, by pushing as fast as I could and doing frontside slappies—later realizing that skating in a backyard pool and snapping frontside grinds like that is super gnar! Regardless of the terrain, put it all on the line… Or coping, I should say. Seek and destroy! —*John Cardiel*

07/88 John Dettman,
Danny Sargent & Luke Ogden
Photo: Bryce Kanights

Legalize it. Skateboarding and the American way are juxtaposed in this month's legal issue. John Dettman, Danny Sargent, and Luke Ogden do a hair pin.

08/88 "Make Your
Obsession Palatable"
Artwork: Robert Williams

Detail, from Robert Williams' piece entitled, "Make your obsession palatable, you might have to eat it."

09/88 Sam Esmoer
Photo: MoFo

Longtime wildcat Sam Esmoer holds a floater over the Moon Bowl in Phoenix, AZ.

10/88 David Hackett
Photo: Chuck Katz

Lock and load: David Hackett gets fully wound-up, yet stays loose as a goose, on a frontside pool grind.

THRASHER

JULY 1988
U.S. $2.50
$3.50

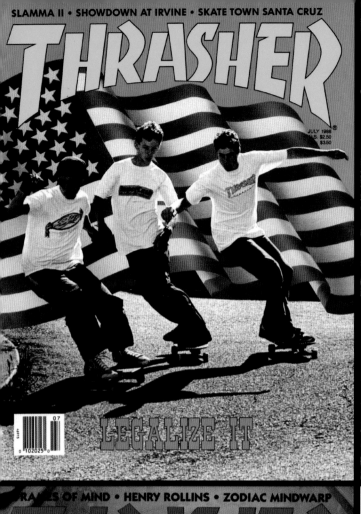

LEGALIZE IT

07
0 102025

THRASHER

AUGUST 1988
U.S. $2.50
Can. $3.50

INTERVIEW
ERIC DRESSEN

EXTRAORDINARY
ROBERT WILLIAMS

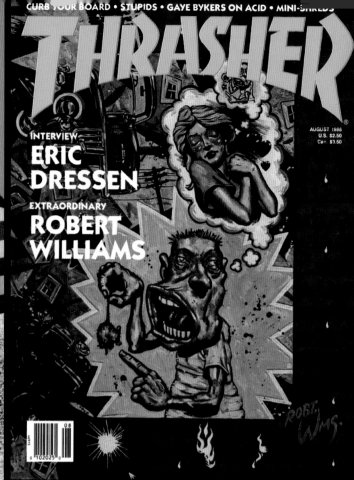

ROBT. WMS.

08
0 102025

THRASHER

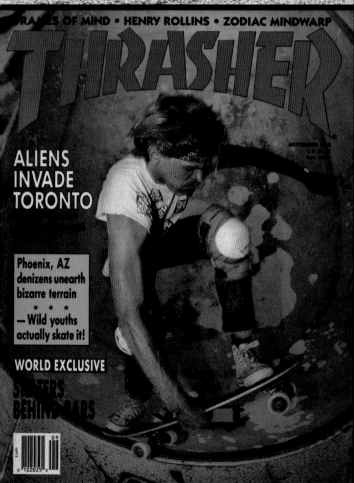

ALIENS INVADE TORONTO

Phoenix, AZ denizens unearth bizarre terrain
★ ★ ★
— Wild youths actually skate it!

WORLD EXCLUSIVE

SKATERS BEHIND BARS

09
0 102025

THRASHER

TERRAIN FOR THE INSANE

OCTOBER 1988
US. $2.50
CAN. $3.50

RIGGED, RIPPED AND DAMAGED

¿QUE PASA IN ALBUQUERQUE?

KODAK KR 64 5032

BATTERED MAN RETURNS

10
0 102025

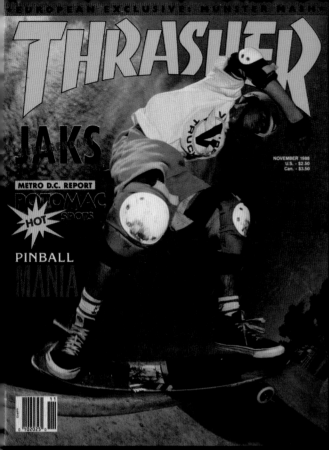

THRASHER

JAKS

METRO D.C. REPORT

POTOMAC HOT SPORTS

PINBALL MANIA

NOVEMBER 1988
U.S. - $2.50
Can. - $3.50

11/88 Hugh "Bod" Boyle
Photo: Bryce Kanights

Hugh Boyle, nosepick D at YMCA Skate Camp in Santa Clara, CA. The girls just call him "Bod."

12/88 Lance Mountain
Photo: Luke Ogden

Lance Mountain, Smith vert over the mini-monolith ramp at the Sacramento Raceway.

WINTER 1988 Tony Alva
Photo: Kevin Thatcher

Tony Alva speed running a canyon bowl wall deep in Beverly Hills. The "electric," elusive T.A. makes his long-overdue appearance on a *Thrasher* cover.

01/89 Jay Adams
Photo: Luke Hudson

With punishing elegance, the elusive and intrusive master of the abusive, Jay Adams, harsh grinds the Egg Bowl above his cryptic scratching: "Salba, we were here, you weren't. Soy Zipperhead Jay Boy Venice Surf & Skate Ratz."

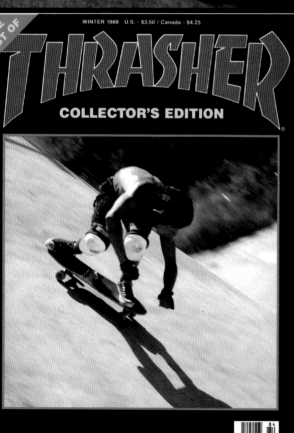

THE BEST OF

THRASHER

COLLECTOR'S EDITION

WINTER 1988 U.S. - $3.50 / Canada - $4.25

GUARANTEED TO BLOW YOUR MIND

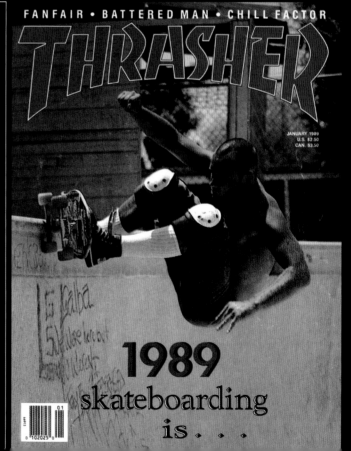

THRASHER

JANUARY 1989
U.S. $2.50
CAN. $3.50

1989
skateboarding
is . . .

THRASHER

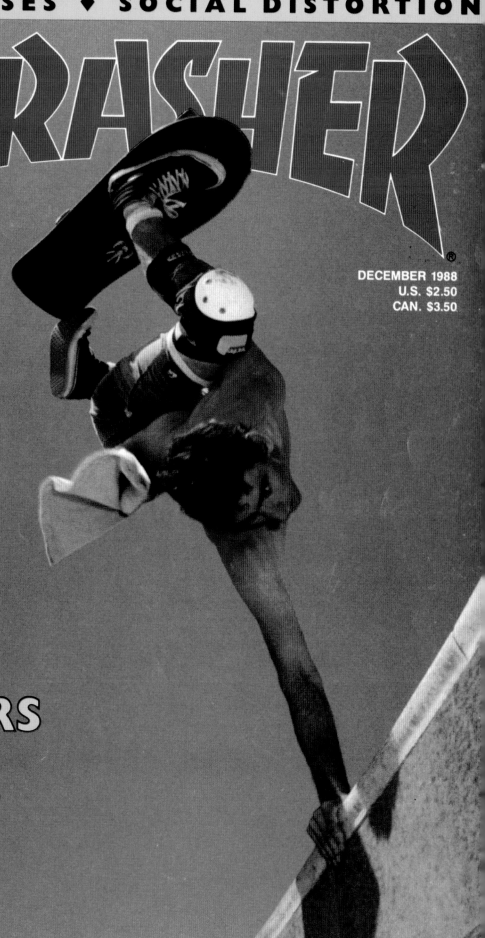

DECEMBER 1988
U.S. $2.50
CAN. $3.50

BIG
NAMES
ON LITTLE
RAMPS

TRUE CONFESSIONS

I Ollied The
Berlin Wall

BOISE
MEMOIRS

LUNCHMEAT
EAT

02/89 Vladimir Morozov
Photo: Torin Boyd

19-year-old Vladimir Morozov tic-tacs through Lenin Plaza while the man looks the other way.

03/89 Robby Olhisher
Photo: Scott Starr

Robby Olhisher, clinging like a fly to the edge of the massive Tea Gardens bowl.

04/89 Brian Brannon
Photo: Kevin Thatcher

Brian Brannon on edge under a blazing Arizona sunset at Thrasherland.

05/89 Chris Miller
Photo: MoFo

Chris Miller facing up to real life, hard skating.

THRASHER

FEBRUARY 1989
U.S. $2.50
CAN. $3.50

SKATERS
of the world
UNITE

02
0 102025 0

THRASHER

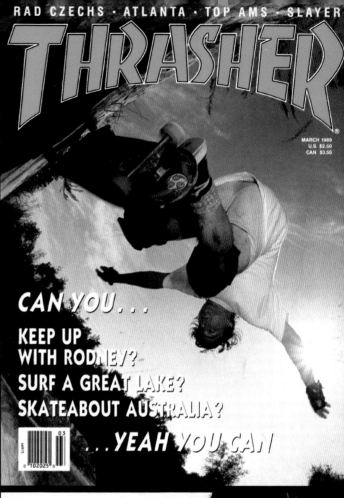

MARCH 1989
U.S. $2.50
CAN. $3.50

CAN YOU...

KEEP UP
WITH RODNEY?
SURF A GREAT LAKE?
SKATEABOUT AUSTRALIA?

...YEAH YOU CAN

03
0 102025 0

THRASHER

APRIL 1989
U.S. $2.50
CAN. $3.50

04
0 102025 0
lust for life

THRASHER

MAY 1989·U.S $2.50·CAN $3.50

SEVEN SEQUEN
ST...
B...
ITALIAN STY
SKATER AN
THE GHOST
LIVING COLO
CHRIS MILLER
NSA FINALS
KILLER POOL
THE MINI-EST R
SKATERS VERSU
THE PEDESTRIAN
TWOFOURSEVEN
POOLS-A-PLEN
STAR TREK

05

THRASHER

History of the Skateboard

ISSUE 100

interviews:
**PETERS
HOSOI
CABALLERO
HAWK**

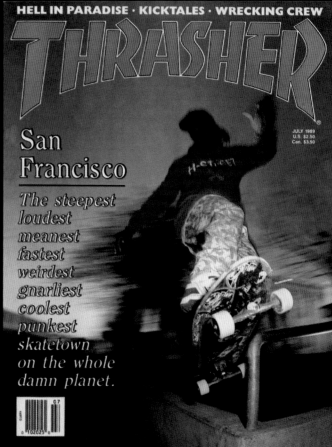

THRASHER

San Francisco

*The steepest
loudest
meanest
fastest
weirdest
gnarliest
coolest
punkest
skatetown
on the whole
damn planet.*

06/89 John Hutson
Photo: Reg Casselli
John Hutson at speed.

07/89 Ron Allen
Photo: Bryce Kanights
Ron Allen, dusky frontside boardslide
at Oakland Tech.

08/89 Carabeth Burnside
Photo: Dan Cavalheiro
Flashy, fast, and furious frontside air by
Carabeth Burnside at the Vans ramp.

THRASHER

AUGUST 1989
U.S. $2.50
CAN. $3.50

RAMP
PARKS

ONE HUNDRED
POOLS

09/89 Danny Sargent
Photo: Kevin Thatcher

Danny Sargent pulls off an ollie-to-pick
on the edge in Pacific Heights, SF.

10/89 Jeremy Henderson
Photo: Bill Thomas

Pushing his own limits in
pursuit of pavement domination,
Jeremy Henderson hits the wall at
the Brooklyn Bridge banks.

11/89 Scott Oster
Photo: Geoff Van Dusen

Scott Oster applies a stylish stroke
to the asphalt canvas.

12/89 Jeff Kendall
Photo: Matz Oscarsson

Jeff Kendall smokes a hot Smith grind
on his way to 3rd at the Titus Cup.

THRASHER

SEPTEMBER 1989
U.S. $2.50
Can. $3.50

BRAIN
BOMB
EXPLOSIVE PHOTOS

GLOBAL
INVASION
GET OUTTA TOWN

AERIAL
SEARCH
POOLS EXPLAINED

THRASHER
N.Y.C.

WEEKEND WARRIORS

MORE PAGES · MORE TRASH

OCTOBER 1989
U.S. $2.50
CAN. $3.50

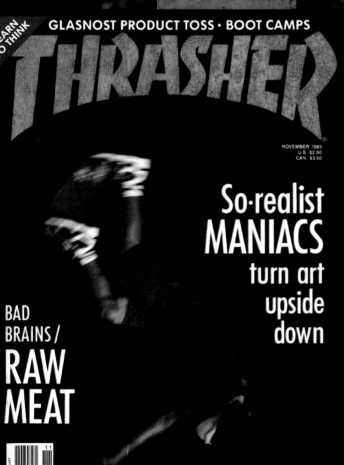

LEARN TO THINK

THRASHER

NOVEMBER 1989
U.S. $2.50
CAN. $3.50

So·realist
MANIACS
turn art
upside
down

BAD
BRAINS /
RAW
MEAT

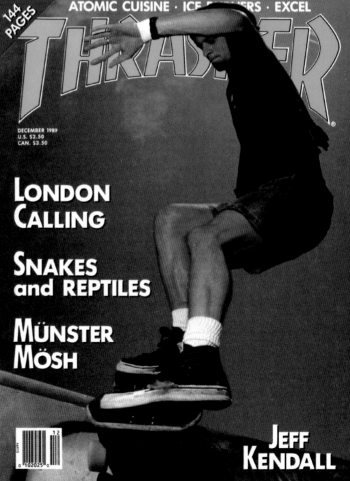

144 PAGES

THRASHER

DECEMBER 1989
U.S. $2.50
CAN. $3.50

LONDON
CALLING

SNAKES
and REPTILES

MÜNSTER
MÖSH

JEFF
KENDALL

FEBRUARY 1990: GEORGE NAGAI

This was the very first shot I ever had in a magazine, so to get the cover was really cool. I was at a contest in Phoenix, AZ when my old team manager for Powell, Todd Hastings, handed it to me— I thought it was one of those fake magazine covers where they super-impose your face on the front, like at amusement parks! It's an ollie grab on flat. Hard to believe what you could get away with in those days. —*George Nagai*

01/90 Steve Caballero
Photo: MoFo

After years of hosting at his own ramp, Steve Cab now enjoys the fruits of others' labors. Boned indy-to-fakie at Christian Hosoi's ramp.

02/90 George Nagai
Photo: Scott Starr
Inset: Mike Ranquet
Photo: Sonny Miller

The roadsign commands, and George Nagai avoids its predictable route.

Inset: Mike Ranquet rocks out.

03/90 Marc Hollander
Photo: Scott Starr

Marc Hollander carves aplenty at the Tilt Pool.

04/90 Karma Tsocheff
Photo: Geoff Van Dusen

Strobed-out multiple movements by Karma Tsocheff, one of the many unsung ripper upstarts you only hear about.

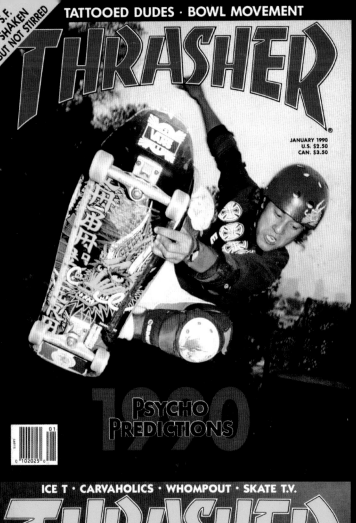

S.F.
SHAKEN
BUT NOT STIRRED

THRASHER

JANUARY 1990
U.S. $2.50
CAN. $3.50

PSYCHO PREDICTIONS

1990

01
0 102025 0

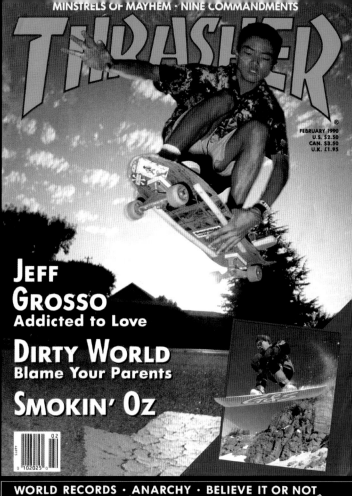

THRASHER

FEBRUARY 1990
U.S. $2.50
CAN. $3.50
U.K. £1.95

JEFF GROSSO
Addicted to Love

DIRTY WORLD
Blame Your Parents

SMOKIN' OZ

02
0 102025 0

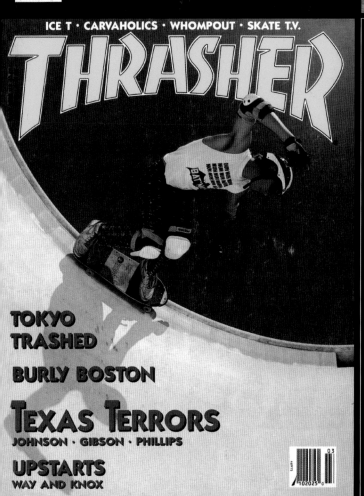

THRASHER

TOKYO TRASHED

BURLY BOSTON

TEXAS TERRORS
JOHNSON · GIBSON · PHILLIPS

UPSTARTS
WAY AND KNOX

03
102025 0

THRASHER

APRIL 1990 U.S. $2.50 CAN. $3.50 U.K. £1.95

04
0 102025 0

MAY 1990: FRANKIE HILL

This spot's at Cleveland Middle School in downtown Santa Barbara, CA. Jim Fitzpatrick used to work at Powell back then, and I rode for Powell—now he's the principal of that school. Ironic. I'd already boardslid it before we shot the cover. I tried it a bunch of times. It was so hard. Then Smolik boardslid it in Shorty's *Fulfill the Dream* video, making it look like nothing!

I was completely blown away when I got the mag. I thought it was a miracle; it was a day I'll never forget. —*Frankie Hill*

05/90 Frankie Hill
Photo: MoFo

Hell-bent to obliterate any surface, fast furious Frankie Hill beats another banister into submission.

06/90 Butch Sterbins
Photo: MoFo

Butch Sterbins, freight train rock 'n' roll slide at the Del Mar Fairgrounds parking lot streetstyle.

07/90 Tim Galvin
Photo: Kevin Thatcher

Mystery skater in mysterious terrain, Tim Galvin. Pipa Grande.

08/90 Bob Pereyra
Photo: Chuck Katz

Jonesing for some serious speed, Bob Pereyra unleashes his land luge.

THRASHER

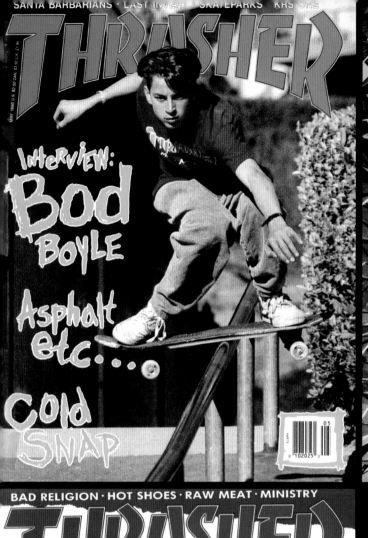

INTERVIEW:

Bod
Boyle

Asphalt etc....

Cold
Snap

MAY 1990

BONUS GAME INSIDE

THRASHER

PRO FILES
Close-Ups on 1990's Best

DEL MAR DELUGE
Let the Season Begin

THRASHER

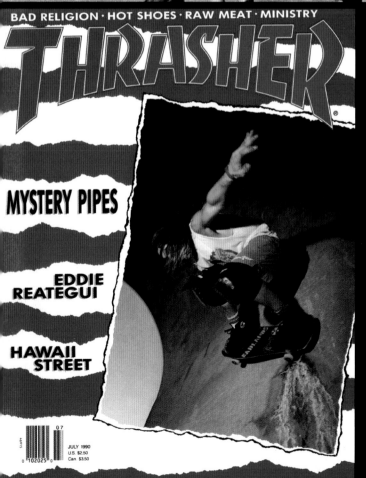

MYSTERY PIPES

EDDIE REATEGUI

HAWAII STREET

THRASHER

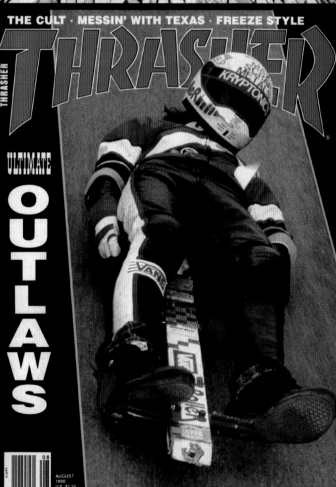

ULTIMATE
OUTLAWS

VANDALS · CREATURES · RAW MEAT

THRASHER

MIKE **YOUSSEFPOUR**

WADE **SPEYER**

AGGRESSION LESSON

MEXICAN HELL RIDE

POLYNESIAN POOL HEROES

09 SEPT
1990
U.S.
$2.50
Can.
$3.50

46915

0 102025 0

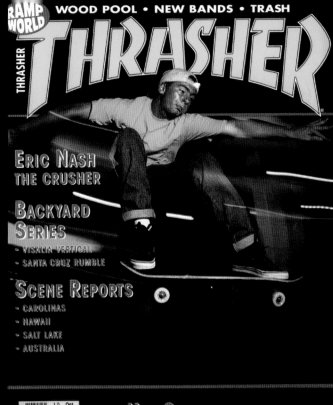

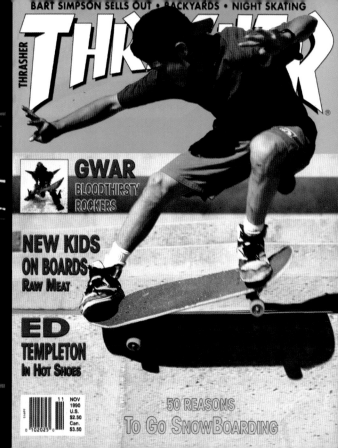

THRASHER

THRASHER

EUROPE

STREET CROSSOVER MINIS

VERT

12 DEC
1990
U.S.
$2.50
Can.
$3.50

0 102025 0

51 6951

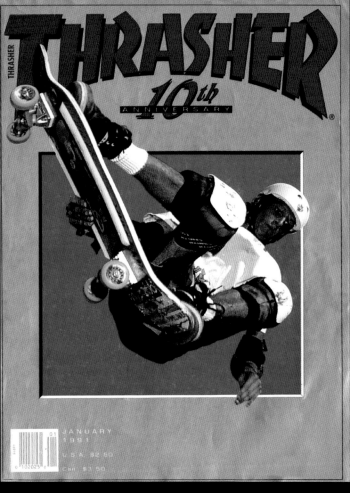

THRASHER

10th ANNIVERSARY

JANUARY
1991
U.S.A. $2.50
Can. $3.50

JANUARY 1991: TONY HAWK

Ed Riggins, our publisher, will tell you that this Tony Hawk 10th anniversary cover was the biggest seller of all time. Melon to fakie on his own backyard facility, Airwalks, rails, ponytail… Oh, the '90s! Tony Hawk is bad-ass. —*Jake Phelps*

12/90 Omar Hassan
Photo: Scott Starr

Cool as a cucumber, Omar Hassan vaults over the many transitional planes of the Blockhead facility.

01/91 Tony Hawk
Photo: Scott Starr

Tony Hawk, his model, his ramp, his yard, his house, his world. Bring on another ten years!

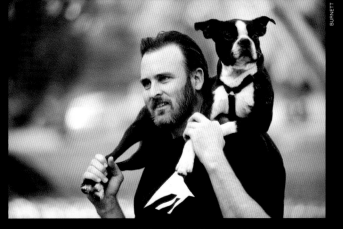

FEBRUARY 1991: ED TEMPLETON

The only time I ever met Scott Starr, the photographer who shot this photo, was on this day. He had long hair. He approached me and said, "I shoot for *Thrasher*" —and to tell you the truth, it kind of creeped me out. He wanted me to go to the beach so he could get a sunset shot, and you know that's usually a bad sign. You're obviously amped to get the front of *Thrasher* either way, and I was nose bumping back

"I NEVER KNEW WHAT THE 'NC-15 NO CRYBABIES' WAS"

then, but I'm sure I could have done something gnarlier had I known I was shooting for a cover. I don't think he really knew it was going to be a cover, either.

Look how gigantic the shoes were. They almost look like air casts! If you look closely, you can see that I drew a bunch of little pictures on them, too. I think those shoes fall under the "wacky" category at this point. I never knew what the "NC-15 No Crybabies" was. That kind of freaked me out. And "Win a Pinball Machine?" Weird times.
—*Ed Templeton*

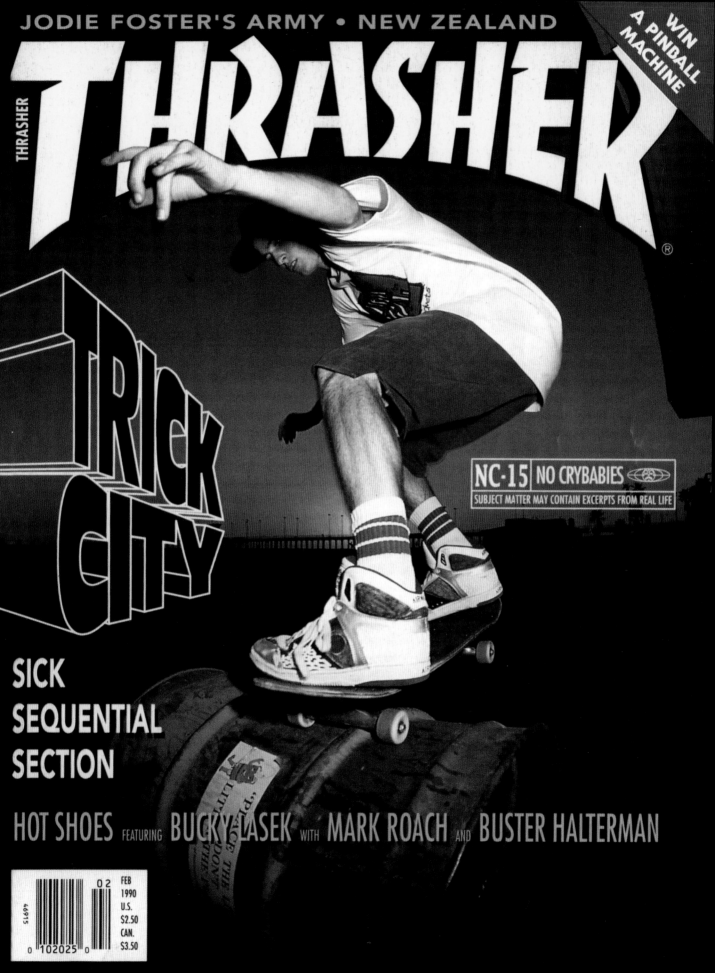

JODIE FOSTER'S ARMY • NEW ZEALAND

WIN A PINBALL MACHINE

THRASHER

THRASHER

TRICK CITY

NC-15 NO CRYBABIES
SUBJECT MATTER MAY CONTAIN EXCERPTS FROM REAL LIFE

SICK
SEQUENTIAL
SECTION

HOT SHOES FEATURING BUCKY LASEK WITH MARK ROACH AND BUSTER HALTERMAN

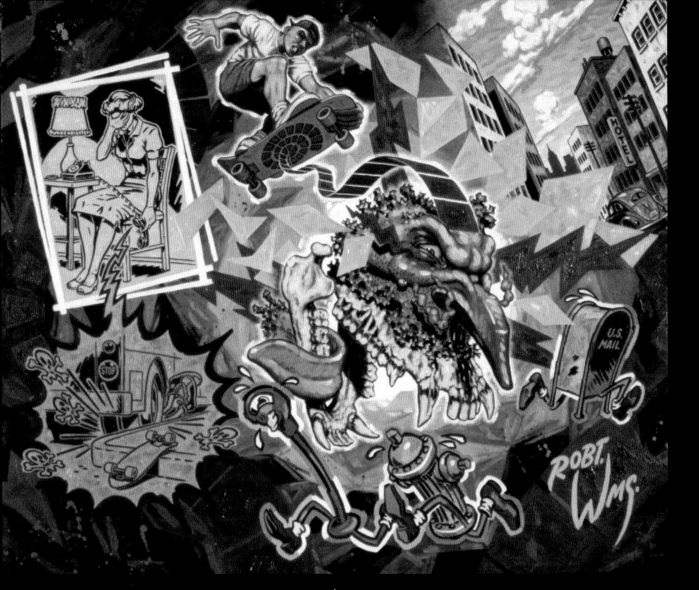

03/91 "The Face That Moves Fire Hydrants"
Artwork: Robert Williams

Scholastic Designation: The brazen style of a gnarly curb surfer who displays garish emblems on the bottom of his board fares much better in the death slalom of everyday traffic than the timid panty-waist with a plain board who looks both ways and then skates under a bus. *Remedial Title:* Woe unto those who ride a scab-raft with a band-aid sail on a pus-filled sea.

04/91 Todd Shinto
Photo: Geoff Van Dusen
Board: Bray Aerospace
and Ancell Technologies

Todd "Thrash Gordon" Shinto points his perpetual motion sky stick toward the city.

05/91 Pep Williams
Photo: Block

Pep slides a bleacher in Venice, California.

06/91 Jonah Guzzi
Photo: MoFo

Special delivery, Jonah Guzzi pops a dapper one-footed ollie sidekick.

Inset detail of "The Wave" by Pushead.

APRIL 1991: FUTURE SKATEBOARDS SLED
April Fools used to be our "Funnn" issue; hence the spaceboard. Studio shots are cool, but we geeked it on this one. Stick to wheels.

JUNE 1991: JONAH GUZZI
MoFo needs a cover, gets the receptionist to kick a one-footer. It was a short employment. —*Jake Phelps*

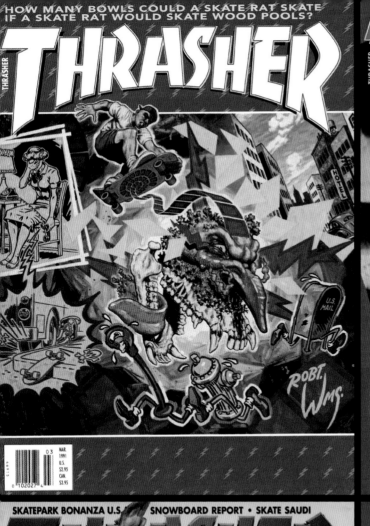

THRASHER

ROBT. Wms.

MAR. 1991 U.S. $2.95 CAN. $3.95

THRASHER

SCOOP:
FUTURE SKATEBOARDS

APRIL 1991 U.S. $2.95 CAN. $3.95

THRASHER

street
TUFF
BASTARDS

ZOUNDS!

BLITZPEER
HOUSE OF WHEELS

BIG DRILL CAR

HOT SHOES

ALAN PETERSEN

FRANKIE HILL

ERIC SANDERSON

GEORGE WATANABE

MAY 1991 • U.S. $2.95 • CAN. $3.95

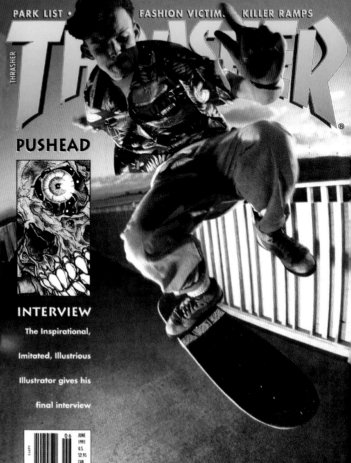

THRASHER

PUSHEAD

INTERVIEW

The Inspirational,

Imitated, Illustrious

Illustrator gives his

final interview

JUNE 1991 U.S. $2.95 CAN. $3.95

07/91 Steve Caballero
Photo: MoFo

Steve Caballero frontside rock 'n' roll slides with gusto and confidence at the NSA/Vision shindig.

08/91 Eddie Reategui
Photo: Scott Needham

Wet and dry: Eddie Reategui takes on the drought with aerial defiance at an undisclosed pipe location.

Sequence: Christian Fletcher
Sequence Photos: Swegles

Illustrating the influence of skateboarding on surfing, Christian Fletcher imitates a flying fish with a high oceanic ollie.

09/91 Brandon Chapman
Photo: Scott Starr

Brandon Chapman floats to disaster over a wooden wave in suburban paradise.

10/91 Ray Barbee
Photo: Sleeper

Ray Barbee levitates above his board on this frontside ollie kickflip, demonstrating Zen and the art of deck maintenance.

THRASHER

PHOTO
SPECIAL

HOT SHOES

JOSH SWINDELL J.J. ROGERS

07 JULY
1991
U.S.
$2.95
CAN.
$3.95

THRASHER

Skate

Surf

Special

08 AUG.
1991
U.S.
$2.95
CAN.
$3.95

FREE RAMP PLANS OFFER

THRASHER

MODERN MOTION

BACKSIDE DISASTER to School Issue

SKATEBOARDS:
HOW THEY ARE MADE

09 SEP
1991
U.S.
$2.95
CAN.
$3.95

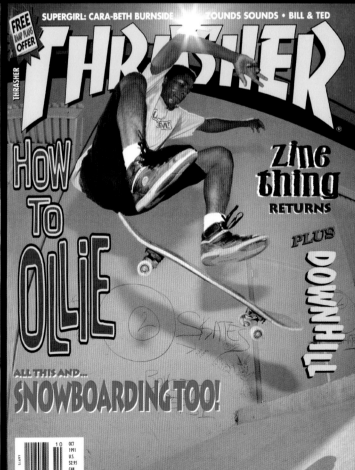

FREE RAMP PLANS OFFER

THRASHER

HOW TO OLLIE

zine thing RETURNS

PLUS

DOWNHILL

ALL THIS AND...
SNOWBOARDING TOO!

10 OCT
1991
U.S.
$2.95
CAN.
$3.95

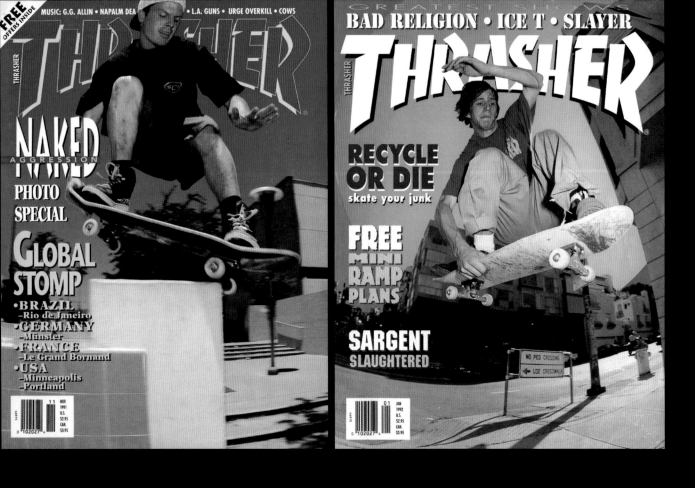

FREE OFFERS INSIDE

MUSIC: G.G. ALLIN • NAPALM DEA • L.A. GUNS • URGE OVERKILL • COWS

THRASHER

THRASHER

NAKED
AGGRESSION

PHOTO
SPECIAL

GLOBAL
STOMP

- **BRAZIL**
 –Rio de Janeiro
- **GERMANY**
 –Münster
- **FRANCE**
 –Le Grand Bornand
- **USA**
 –Minneapolis
 –Portland

11 NOV 1991 U.S. $2.95 CAN. $3.95

0 102027 4

GREATEST SHOWS

BAD RELIGION • ICE T • SLAYER

THRASHER

THRASHER

RECYCLE
OR DIE
skate your junk

FREE
MINI
RAMP
PLANS

SARGENT
SLAUGHTERED

NO PED CROSSING
← USE CROSSWALK

01 JAN 1992 U.S. $2.95 CAN. $3.95

0 102027 4

PUBLIC ENEMY • FUGAZI • TOYS PULLOUT

THRASHER

THRASHER

SF

OMAR HASSAN VS DANNY WAY

SHOWDOWN

12 DEC.
1991
U.S.
$2.95
CAN.
$3.95

0 102027 4

46915

MEAT PUPPETS • NITZER EBB

THRASHER

BACK ON THE STREETS

- HOUSTON
- HISTORY
- NOSE-REVOLUTION
- LONG BEACH

SKATER OF THE YEAR

MODERN COMIX

IN THE SNOW

FEB 1992 U.S. $3.25 CAN. $4.25

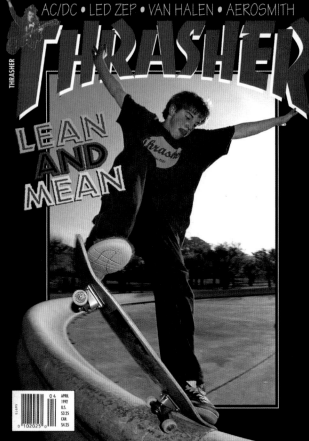

AC/DC • LED ZEP • VAN HALEN • AEROSMITH

THRASHER

LEAN AND MEAN

APRIL 1992 U.S. $3.25 CAN. $4.25

02/92 Eric Britton
Photo: Block

Venice local Eric Britton takes the
sensible way down a flight of stairs.

04/92 Ronnie Bertino
Photo: Lance Dawes

An empty fountain in Golden Gate
Park provides plenty of room for a
Ron Bertino noseblunt transfer.

03/92 Chet Thomas
Photo: Xeno

Chet Thomas utilizes extreme
compression for maximum height.

NIRVANA • DAMNED • CRAMPS • SLAYER

THRASHER

THRASHER

®

?

"duh"

03 MARCH 1992 U.S. $3.25 CAN. $4.25

0 102025 0

4695

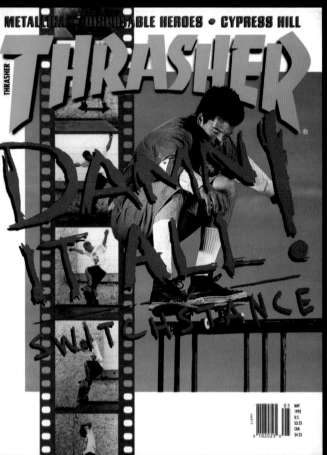

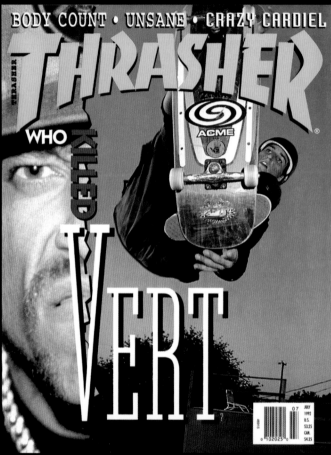

JUNE 1992: PAT DUFFY

I loved going to these rails at San Francisco State University in
the early '90s, because they were made of the best metal to grind.
We would trek in from Marin just to skate here. It totally caught me
by surprise when I saw that *Thrasher*. I had no idea they were going
to use the photo for a cover. I was still in high school, so I was
pretty psyched—180 nosegrind on the four-stair, with giant,
size-40 rolled-up jeans. —*Pat Duffy*

05/92 Tom Knox
Photo: Sleeper
Sequence: Kevin Thatcher

What seemed impossible has become
routine. Tom Knox vaults a bike rack
while John Montessi bluntslides.

07/92 Ice-T and Remy Stratton
Photo: Chris Ortiz
Photo of Ice-T: Jon Wiederhorn

Original gangster Ice-T has his eye
on you while Remy Stratton releases
a monster tailgrab to fakie free-fall at
another extinct vert ramp.

06/92 Pat Duffy
Photo: Bryce Kanights

Marin stairway killer Pat Duffy
goes right for the throat with a
vicious 180 nosegrind down a steel
frame at SF State.

seattle-ites poli-sci rap

L7 · RAW FUSION · SOUNDGARDEN · CONSOLIDATED · BEASTIE BOYS

ya da...

Femme (phunky, phunk)

THRASHER

THRASHER

SUMMER stench
School SUCKS SUCKS
DISINFORMATION! SUCKS!

Gnarlmasters:
SALMAN AGAH

Stylee Brah!

DEL THA
Funkee Homosapien

mr C is lame!!

SKYPER

I LOVE MATH

GRRRRRRRRRRIN

I DON'T

LUNGERS

Pat's where it's At

NEAL
HENDRIX

why do you
think
they call
it dope!?

R.I.P!

KA-
CHING!

FOR A GOOD GRIND
CALL MARSHA 358-69

RENT-A
COPS
ARE
cool!

Gnarly

30mm
Beauties!

AKIE

Luncheoom

JUNE
1992
U.S.
$3.25
CAN.
$4.25

08/92 Sean Sheffey
Photo: Chris Ortiz

On a Sunday in Golden Gate Park,
Sean Sheffey stalls before sticking
a heelflip backside shove-it.

09/92 Jovontae Turner
Photo: Bryce Kanights

Jovontae Turner heelflips 180 backside
at the world-famous EMB.

10/92 Daniel Powell, Esq.
Photo: Chris Ortiz

Daniel Powell, Esq. hangs for a frozen
moment before skidding through a
noseblunt slide.

11/92 Alphonso Rawls
Photo: Chris Ortiz

Every urban environment has numerous
forms for skaters to amuse themselves
on. Alphonso Rawls lays back in one
called Sad Diego.

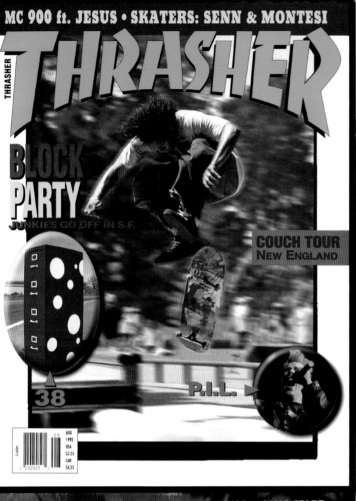

MC 900 ft. JESUS • SKATERS: SENN & MONTESI

THRASHER

THRASHER

BLOCK PARTY
JUNKIES GO OFF IN S.F.

COUCH TOUR
New England

38

P.I.L.

AUG 1992 USA $3.25 CAN $4.25

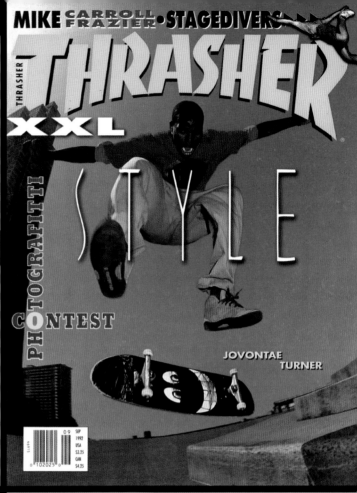

MIKE CARROLL FRAZIER • STAGEDIVERS

THRASHER
THRASHER
XXL

PHOTOGRAFITTI

STYLE

CONTEST

JOVONTAE TURNER

SEP 1992 USA $3.25 CAN $4.25

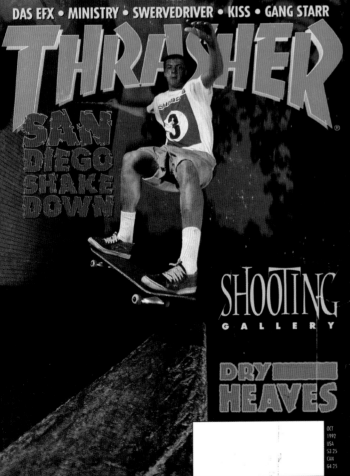

DAS EFX • MINISTRY • SWERVEDRIVER • KISS • GANG STARR

THRASHER

SAN DIEGO SHAKE DOWN

SHOOTING GALLERY

DRY HEAVES

OCT 1992 USA $3.25 CAN $4.25

SPECIAL family values ISSUE!

THRASHER

CHICAGO
down town

ROBBED
boyce & dyrdek

COLD
world

MUSIC
• therapy?
• wool
• thud

bush/clinton
MASTER DEBATE

NOV 1992 USA $3.25 CAN $4.25

MARCH 1993: RICK IBASETA

My life in 1993 was all skateboarding. I'd just turned 21 and I was riding for Underwood Element, skating with Cardiel, Jefferson Pang—we actually got the covers one after the other. Julien got a cover, too. Three Underworld dudes on the front of *Thrasher* almost right in a row. And my friends Gonz and Henry Sanchez got covers right after that!

The spot in this photo is on Market Street in San Francisco. A car had run into the bar and lowered it. I was there with our photographer Bryce Kanights—it was a backside ollie out of the street to 50-50, coming out frontside into the little walkway. The thing I noticed was that *Thrasher* Photoshopped the light post. They also altered the color of my shirt—I was wearing a blue shirt against a blue background, so they turned my shirt gold. It was a shirt Gonz had made for me.

These days, skating is a little heavier. It's harder to ollie, but it's cool. I'm a family guy now. I work downtown nine-to-five, I have a little girl, a dog, a wife… I have a much better time skating now, leaving everything behind and being in my own world, but skating back then—we were being creative, coming up with new stuff—there's no comparison. —*Rick Ibaseta*

12/92 Mike Carroll
Photo: Bryce Kanights
Alone and free, Mike Carroll throws a crossed-up nosegrind at Hubba Hideout.

01/93 Tim Brauch
Photo: Bryce Kanights
Tim Brauch crumbles a high and mighty nosegrind in San Jose.

02/93 Jeff Pang
Photo: Chris Ortiz
The Brooklyn Bridge banks, a timeless East Coast spot, gets caressed by favored son Jeff Pang.
Inset: Coco Santiago, heelflip.

03/93 Rick Ibaseta
Photo: Bryce Kanights
After a car smashed through the crosswalk, Rick Ibaseta took advantage of the debris.

THRASHER

THRASHER

50 UNKNOWNS

+

AGAH
SENN
SANTOS
RICK'S
DUFFY

=

100% EVIL

DEC 1992 USA $3.25 CAN $4.25

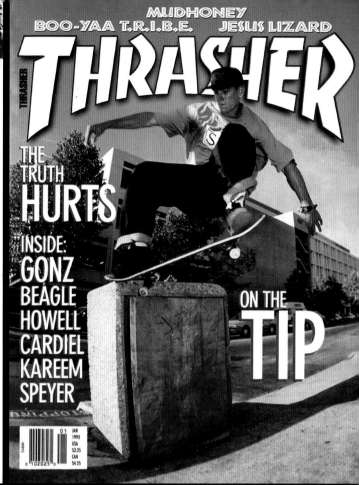

THRASHER

THRASHER

THE TRUTH HURTS

INSIDE:
GONZ
BEAGLE
HOWELL
CARDIEL
KAREEM
SPEYER

ON THE TIP

01 JAN 1993 USA $3.25 CAN $4.25

0 102025

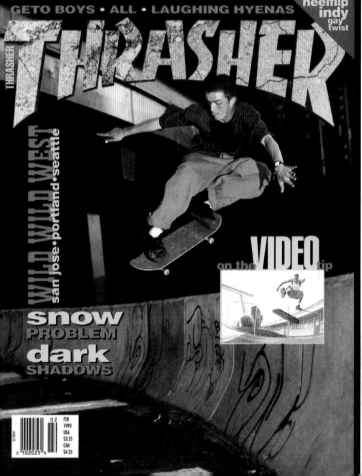

danny way
heelflip
indy
gay twist

THRASHER

THRASHER

WILD WILD WEST
san jose ● portland ● seattle

VIDEO
on the tip

snow PROBLEM
dark SHADOWS

02 FEB 1993 USA $3.25 CAN $4.25

0 102025

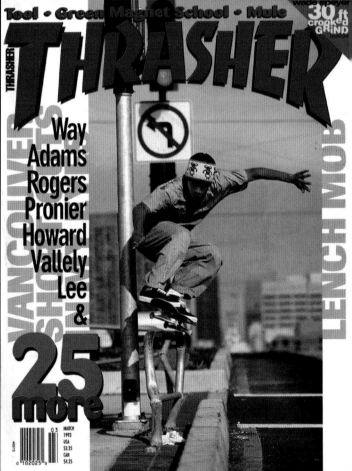

wade speyer
30 ft crooked GRIND

THRASHER

THRASHER

VANCOUVER SHOCKERS

Way
Adams
Rogers
Pronier
Howard
Vallely
Lee
&

25 more

LENCH MOB

03 MARCH 1993 USA $3.25 CAN $4.25

0 102025

THRASHER

THRASHER

JOHN CARDIEL
skater of the year

04 APRIL
1993
USA
$3.25
CAN
$4.25

4615 1695

0 102025 0

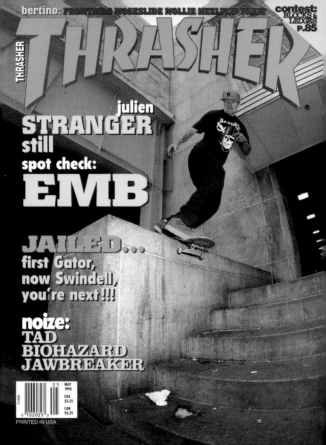

THRASHER

THRASHER

julien
STRANGER
still

spot check:
EMB

JAILED...
first Gator,
now Swindell,
you're next!!!

noize:
TAD
BIOHAZARD
JAWBREAKER

05 MAY
1993
USA
$3.25
CAN
$4.25

0 102025

PRINTED IN USA

APRIL 1993: JOHN CARDIEL

Cardiel was our NorCal bro, and hot shit when he got SOTY
in 1992; he was as raw as it got, and he'd try to make anything.
When we thought up the hoop of fire, we actually had a staff artist—
Kevin Ancell—to help build it, and a place at the old Hunter's Point
Naval Shipyard where no one would mess with us.

Some fools thought it was fake, but if you know John, you know
he'd never fake anything. It turned out to be one hell of a cover
featuring one hell of a dude. Another rule we learned: Don't fuck
with the logo! Flames? Skulls? Stars? Stripes? Stick with the Banco
typeface and we're good. —*Jake Phelps*

04/93 John Cardiel
Photo: Bryce Kanights

Shot into the spotlight from the depths
of hell, there is no one hotter than 1992
skater of the year, John Cardiel.

05/93 Julien Stranger
Photo: Bryce Kanights

Cops? Yep. Julien Stranger? Yep.
Backside lipslide? Yep. Steps?
Count 'em bitch!

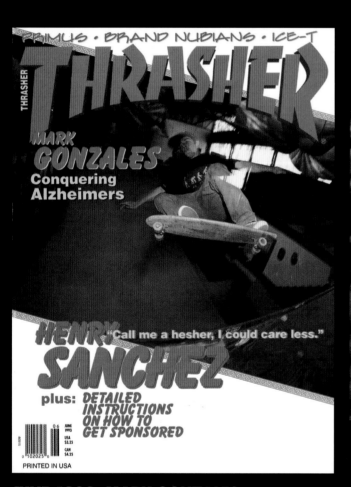

JUNE 1993: MARK GONZALES

This photo of Gonz on the Widowmaker in Oakland, CA is intense for so many reasons. He came to skate that day without a board, so he'd been riding my Henry Sanchez deck for most of the session. Near the end of the ride he grabbed this 1965 clay wheeler with no kicktail off the wall—remember, clay wheels are very slippery. He ran up the opposite side of the ramp, all the way to the coping, jumped on, rode back down… Frontside ollie out, last photo on the roll. Instant classic. —*Jake Phelps*

06/93 Mark Gonzales
Photo: Bryce Kanights

Mark Gonzales proves that, even 30 years ago,
he still would have been amazing on a skateboard.
Zero griptape and clay wheels two feet out over
the Widowmaker in West Oakland.

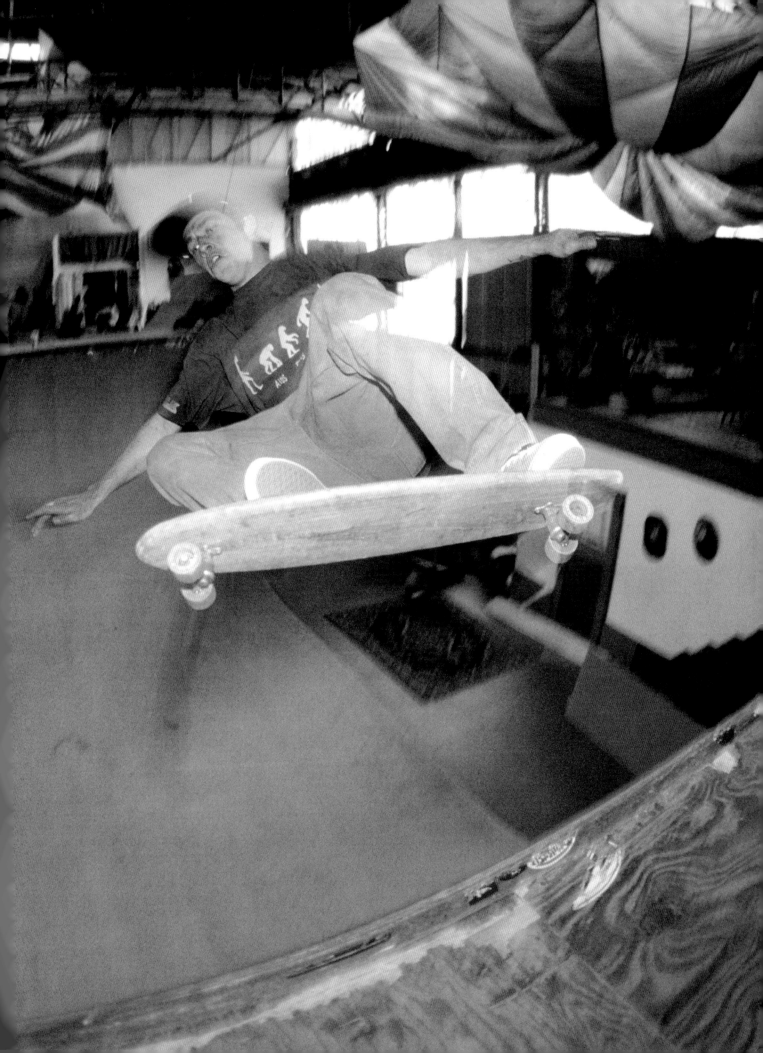

08/93 Joe Sierro
Photo: Sean Dolinsky

Jason Adams
Photo: Bryce Kanights

Justin Ortiz
Photo: Chris Ortiz

A triad of images unfurls in celebration
of 150 consecutive issues of hard rollin'.

07/93 Henry Sanchez
Photo: Bryce Kanights

Henry Sanchez, a moment before
sticking a heelflip frontside noseslide
in San Mateo, CA.

09/93 Karma Tsocheff
Photo: Sean Dolinsky

Karma Tsocheff makes pinpoint
contact with a 180 nosegrind to forward
on a metal and cement banister.

10/93
Logo: Jimbo

Skate fast past the graveyard
or the Burlyman will get ya.

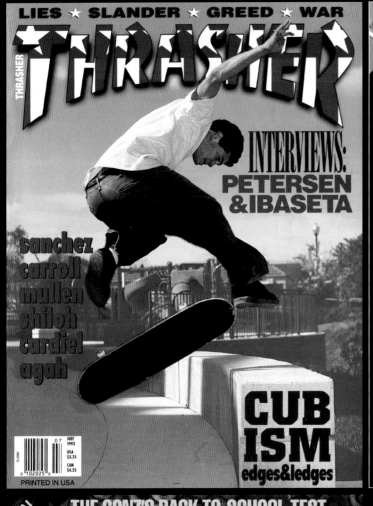

LIES ★ SLANDER ★ GREED ★ WAR

THRASHER

INTERVIEWS:
PETERSEN
&IBASETA

sanchez
carroll
mullen
shiloh
cardiel
agah

CUB
ISM
edges&ledges

07 JULY 1993
USA $3.25
CAN $4.25

PRINTED IN USA

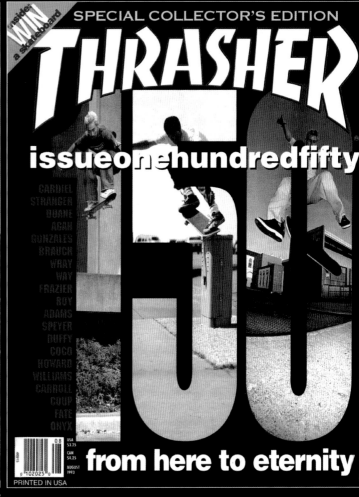

SPECIAL COLLECTOR'S EDITION

THRASHER

issueonehundredfifty

150

CARDIEL
STRANGER
DUANE
AGAH
GONZALES
BRAUCH
WRAY
WAY
FRAZIER
RUY
ADAMS
SPEYER
DUFFY
COCO
HOWARD
WILLIAMS
CARROLL
COUP
FATE
ONYX

from here to eternity

08 USA $3.25
CAN $4.25
AUGUST 1993

PRINTED IN USA

WIN

THE GONZ'S BACK-TO-SCHOOL TEST

THRASHER

NSA DEPRESSION
SESSION

SORRY
BUT YOU'VE GOT
DETENTION

dAMnation

FREE
SKATE SPOTS

SNOW DICE

BAD
RELIGION

GG
ALLIN

MAD
FLAVA

GURU's
JAZZ-
MATAZZ

BOTTOM
12

09 USA $3.25
CAN $4.25
SEPTEMBER 1993

PRINTED IN USA

SPECIAL RAZORBLADES IN CANDYBARS ISSUE!

THRASHER

SKATEBOARDING
1943—1993

10 USA $3.25
CAN $4.25
OCTOBER 1993

PRINTED IN USA

THRASHER

"IT DOESN'T **PAY** TO **BE** DOWN"
rick howard

AM•SLAM FINALS

NOVEMBER 1993
USA $3.25
CAN $4.25

PRINTED IN USA

11/93 Rick Howard
Photo: Bryce Kanights

Native Canadian and smooth dresser Rick Howard switches up on a 360 kickflip above a steep embankment.

12/93 Eric Koston
Photo: Jody Morris

Eric Koston, as in Boston, above a 180 kickflip at the San Diego Greyhound yard.

01/94 Carl Shipman
Photo: Bryce Kanights
Inset Photo: Lisa Johnson

Carl Shipman, front blunt Hubba Hideout.

02/94 Salman Agah
Photo: Mark Madeo

A look into the mind of Salman Agah, *Thrasher's* Skater of the Year.

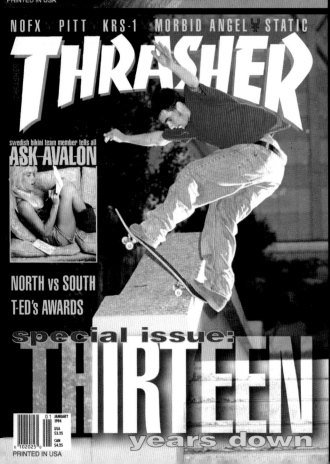

NOFX PITT KRS-1 MORBID ANGEL STATIC

THRASHER

swedish bikini team member tells all
ASK AVALON

NORTH vs SOUTH
T-ED's AWARDS

special issue:
THIRTEEN
years down

JANUARY 1994
USA $3.25
CAN $4.25

PRINTED IN USA

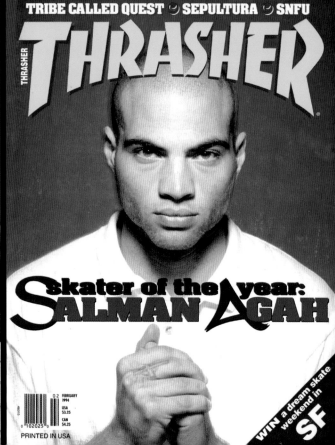

TRIBE CALLED QUEST ♡ SEPULTURA ♡ SNFU

THRASHER

Skater of the year:
SALMAN AGAH

FEBRUARY 1994
USA $3.25
CAN $4.25

PRINTED IN USA

WIN a dream skate weekend in SF

New Kingdom • Above The Law • Season To Risk

THRASHER

THRASHER

matt beach beats the best

BACK to the CITY

HELL FIRE

in SPAIN, ENGLAND, BELGIUM, GERMANY and FRANCE

FROST BITES

SLOPE versus STREET

HAPPY LAND

KILLER KEGGER

1 2 DECEMBER 1993

USA $3.25

CAN $4.25

46915

0 102025 0

PRINTED IN USA

MAY 1994: MARK GONZALES

"Do I look like a street skater?" Gonz, just back from New York, drew me this doodle—the original had no color, and it actually said "Toyota" on the shirt. It was Mark's social commentary on the state of skateboarding at that time: The look was hot, skating was not. Last-minute classic. —*Jake Phelps*

03/94 Jason Adams
Photo: Lance Dalgart

At the legendary Uvis spillway, Jason Adams gets back to his roots by way of a kickflip fakie 15 feet up.

Inset: Remy Stratton
Photo: Bryce Kanights

Remy Stratton, egg like fuck, Norwalk, California.

04/94 Jamie Reyes
Photo: Scott Starr

Jamie Reyes shows the boys what's up with a 360 kickflip at Aala Park in Hawaii.

05/94 "Hey Do I Look…"
Artwork: Mark Gonzales

Some hate it and some love it, but all over the world, people are trying to cop the skater "look." No matter how much money they spend, they'll never get it if they have to buy it.

06/94 Mike Frazier
Photo: Bryce Kanights

The line between the streets and the coping is ever-evaporating, and Mike Frazier is right in the thick of it with a kickflip mute at Andy's ramp in Oakland, California.

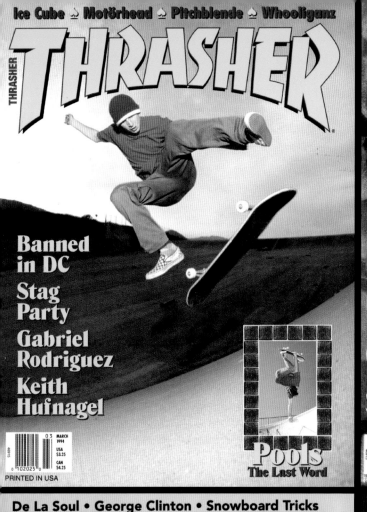

Ice Cube ♣ Motörhead ♣ Pitchblende ♣ Whooliganz

THRASHER

THRASHER

Banned in DC

Stag Party

Gabriel Rodriguez

Keith Hufnagel

Pools
The Last Word

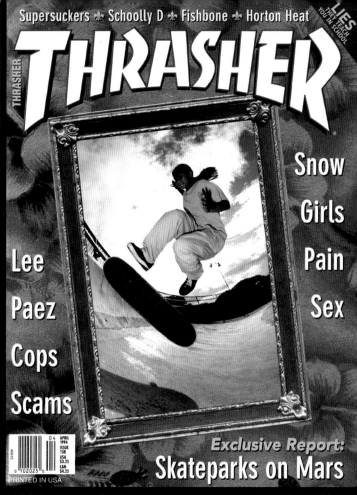

Supersuckers ⚜ Schoolly D ⚜ Fishbone ⚜ Horton Heat

LIES THEY TEACH YOU IN SCHOOL

THRASHER

THRASHER

Lee

Paez

Cops

Scams

Snow

Girls

Pain

Sex

Exclusive Report:
Skateparks on Mars

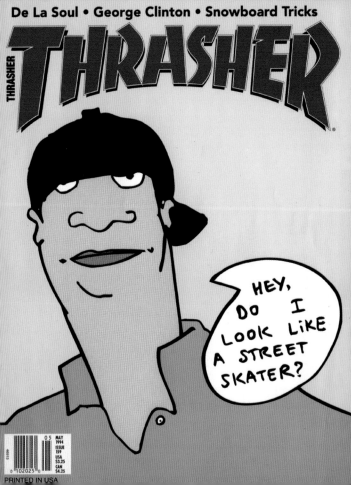

De La Soul • George Clinton • Snowboard Tricks

THRASHER

THRASHER

> HEY, DO I LOOK LIKE A STREET SKATER?

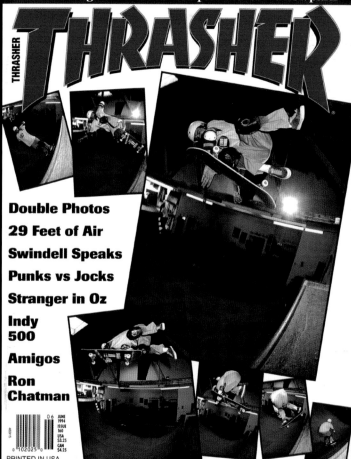

Helmet ∞ Fugees ∞ Casual ∞ Supernatural ∞ Snowpark

THRASHER

THRASHER

Double Photos

29 Feet of Air

Swindell Speaks

Punks vs Jocks

Stranger in Oz

Indy 500

Amigos

Ron Chatman

THRASHER

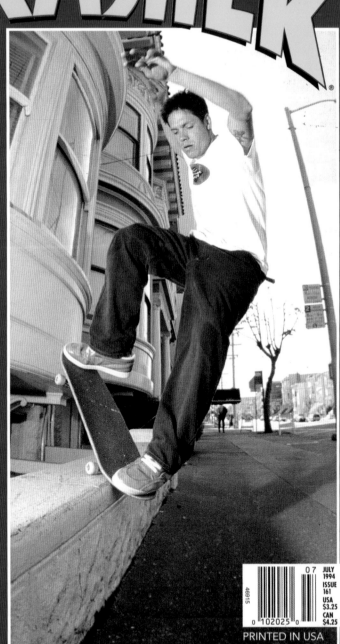

Unleashed in the East
PA–NY–DC–CT

Blacked-Out in Brazil
Cardiel–Stranger

Omar
Pool & Street

PC Death
Video Game Lowdown

07 JULY 1994 ISSUE 161 USA $3.25 CAN $4.25

46915

0 102025 0

PRINTED IN USA

07/94 Jaya Bonderov
Photo: Noah Martineau

Jaya Bonderov has come a long way from
Photograffiti (January 1988, page 74)
to the cover of this month's mag, but in
skateboarding—as in life—the cream will
always rise to the top. Nosegrind stylee in
Baghdad by the Bay.

08/94 Matt Pailes
Photo: Erik Butler

Far above the city, Matt Pailes arcs a
wild ride into the urban void.

THRASHER

PAVED
NEW
WORLD

0 8 AUGUST
1994
ISSUE
162
USA
$3.25
CAN
$4.25

46915

0 102025

PRINTED IN USA

SEPTEMBER 1994: ANDY ROY

This is in South Lake Tahoe, at a casino, in 1994. We were
Hell Riding, dude. Terrorizing and skating. That's all there was to
do. When we skated, we got busy. We didn't give a fuck what was in
front of us. If there were any parties afterwards, we'd go ruin them,

"TERRORIZING AND SKATING"

too—and the next day? Give us something else to skate. Start running
people over skating. There just ain't nothing better than skating and

THRASHER

War with Satan

Barbee & Mandoli on Christianity

BANNED

09

SEPT
1994

ISSUE
163

USA
$3.25

CAN
$4.25

0 102025 0

46915

PRINTED IN USA

10/94 Clockwise from left:
Bob Burnquist
Photo: Left 1

At 17 years old, Bob Burnquist is limber
enough to bone seven-foot frontside airs.

Lint
Photo: Jesse Fischer

True punk will never die. Just ask Lint
and the guys in Rancid.

Dave Duren
Photo: Bryce Kanights

In the black of night, Dave Duren fakie
ollie nosegrinds at Brown Marble.

11/94 Alan Petersen
Photo: Bryce Kanights

The man in black, Alan Petersen, sets
sail at the foot of Santa Monica Pier.

12/94 Wade Speyer
Photo: Bryce Kanights

Burn baby burn. Wade Speyer catches
fire in Marseilles, France.

01/95 Mike Conway
Photo: Noah Martineau

Unknown and uncaring, Mike Conway
steams a chrome banister.

MC SOLAAR ◆ RANCID ◆ MACHINE HEAD ◆ ARTIFACTS ◆ MERMEN

THRASHER

ENGLISH
The Fine Art of Finesse

10 OCT 1994 ISSUE 164 USA $3.25 CAN $4.25 PRINTED IN USA

G LOVE ◆ KILLDOZER ◆ MOTOCASTER ◆ BRAND NUBIAN

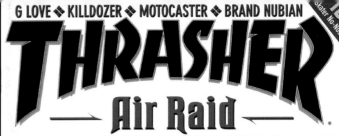

THRASHER
Air Raid

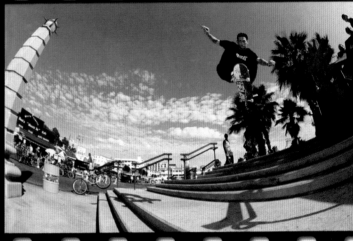

Road Kill: Pennsylvania & Colorado

1 1 NOV 1994 ISSUE 165 USA $3.25 CAN $4.25 PRINTED IN USA

BOOTSY ◆ BOSSTONES ◆ SUICIDAL ◆ TAD ◆ GAS HUFFER

THRASHER

WADE BURNS EUROPE

1 2 DEC 1994 ISSUE 166 USA $3.25 CAN $4.25 PRINTED IN USA

Duane ◆ Jay ◆ Karma ◆ Paez ◆ Frazier ◆ Hendrix

THRASHER

Know the Past... Seize the Future

 0 1 JAN 1995 ISSUE 167 USA $3.25 CAN $4.25 PRINTED IN USA

FEBRUARY 1995: FRED GALL

I was staying at Keith Hufnagel's house in San Francisco at the time with Ben Liversedge and the Meatball, Chris Keefe. Peter Bici was there too. I'd been saying, "Man, I wanna go skate Hubba," but they were like, "Whatever. That place is played." I said, "I don't care! It's my dream!" I couldn't even 50-50 it at first 'cause that thing is, like,

"THERE WAS ACTUALLY A RUMOR THAT I WAS SMOKING CRACK"

chest-high. I could do the switch frontside 180 to regular 5-0 because that was my trick—I actually got that before the grind. Then I got the switch crook, which actually looked like a switch back nosegrind. The switch 5-0 came about after I was smoking weed off the one-hitter in the back. That spot's famous for smoking crack, so there was actually a rumor that I was smoking crack—but I didn't even know what crack was then. I was only 15 years old! I still owe Jake another switch 5-0 on a Hubba—I owe myself. And I will do it. —*Fred Gall*

02/95 Fred Gall
Photo: Gabe Morford

Hubba Hideout has been ground and slid to death,
but not switch frontside like Fred Gall.

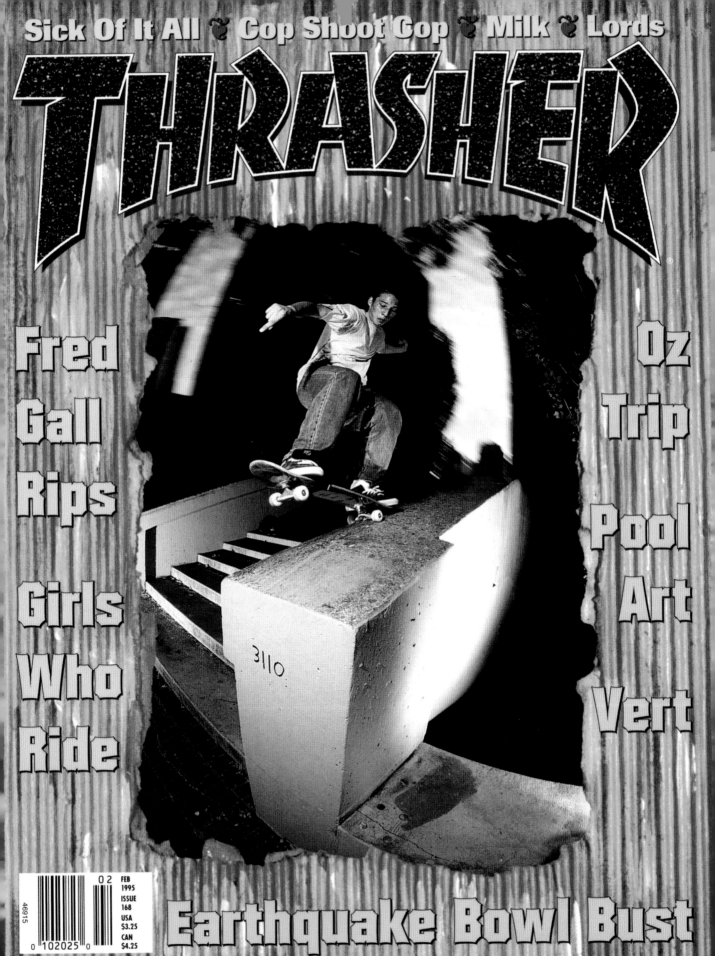

Sick Of It All ❧ Cop Shoot Cop ❧ Milk ❧ Lords

THRASHER

Fred
Gall
Rips

Girls
Who
Ride

Oz
Trip

Pool
Art
Vert

3110

02 FEB 1995 ISSUE 168 USA $3.25 CAN $4.25

Earthquake Bowl Bust

China White · Pete Rock & CL Smooth · More Girls

THRASHER

SKATER OF
THE YEAR
Mike
Carroll

BEYOND
LEVITATION
Donger

PRINTED IN USA

SLAYER * KURT COBAIN-FROM THE GRAVE * HURRICANE

THRASHER

PRINTED IN USA

03/95 Mike Carroll
Photo: Bryce Kanights

In the shadow of the Bay Bridge, Mike
Carroll clears a void and skids a long
frontside tailslide.

04/95 "Happy"
Artwork: Sean McKnight, age 7

The face of the next generation.

05/95 Max Schaaf
Photo: Dom Callan

Max Schaaf hovers above the Hunter's
Point area by way of half Cab LAME

BIG CHIEF * JACKYL * FARSIDE * ROLLING 85 MPH

THRASHER

TOM
BOYLE

DOWN
SOUTH

SLUGGO

TEXAS

05 MAY
1995
ISSUE
171
USA
$3.25
CAN
$4.25

46915

0 102025 0

PRINTED IN USA

SICK SWITCH VERT

THRASHER

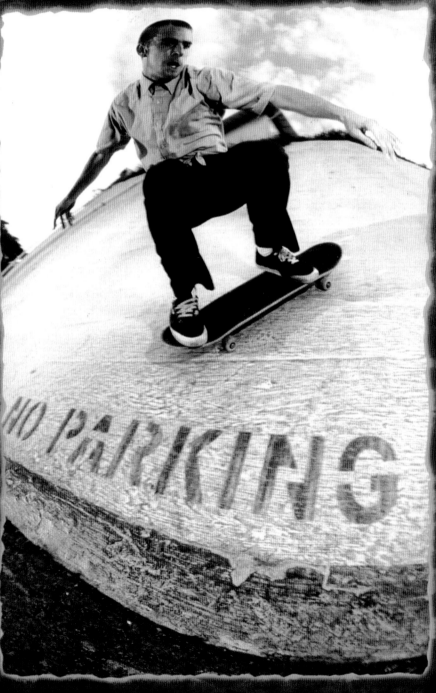

Ethan
Fowler

Gonz

Tony
Hawk

Slices
of Life

Fear

Paez
Family

JUNE
1995
ISSUE
172
USA
$3.25
CAN
$4.25

06

0 102025

46915

Christian Fletcher Hates Surfers

PRINTED IN USA

THRASHER

Cult of
the Longboard

JULY
1995
ISSUE
173
USA
$3.25
CAN
$4.25

46915

PRINTED IN USA

THRASHER

10FT

MEET THE
BOMB SQUAD

AUGUST
1995
ISSUE
174
USA
$3.25
CAN
$4.25

46915

PRINTED IN USA

JUNE 1995: ETHAN FOWLER

This is a switch wallride. I go backwards sometimes. It was
somewhere silly, just a steep wall/bank. I don't know why we shot
it—maybe a switch wallride was cool back then—but the fact that it
became a cover was shocking. It was just one of those mysteries, like,
"Oh shit. Look at me on the front." —*Ethan Fowler*

JULY 1995: CR STECYK III

As a photographer, I've recorded thousands of assorted images
over the course of my practice. Many of these moments are now
lost to my memory, but I worked on five *Thrasher* covers and can
recall specific details regarding all of them. This is a testimony to
the situational power intrinsic to appearing on the cover: The image
becomes enshrined in people's minds, including your own.

Strangest of all, experientially, was this self-portrait of me riding
at Topanga Summit. There was no premeditation involved with this
one as it was a quick snap of an everyday view. They selected it
for the cover of the July 1995 issue, and through that experience
I became a cover man myself. A fifteenth of a second and 35 years
of riding was all it took. —*CR Stecyk III*

06/95 Ethan Fowler
Photo: Gabe Morford

Up against the wall with a new twist,
Ethan Fowler, switch.

07/95 CR Stecyk III
Photo: CR Stecyk III

Some things never die, they just go
underground for a while until some
trendy person deems them cool.
Case in point: Longboards.

08/95 Phil Shao
Photo: Bryce Kanights

Sometime after six o'clock at night,
when the security guards had all
gone home, Phil Shao glided across
the death box in the very vertical
Blind School pool.

NOVEMBER 1995: QUIM CARDONA

This is in midtown New York City. There was a Real/Stereo tour going on: Matt Daher was there, Gabe Morford shot the photo, Huf was with us, and Matt Rodriguez as well. We were sessioning this pyramid made of bricks; the illest spot. The hip was made out of a smaller bank, and you landed in a bigger bank. There was no pushing room whatsoever. I had to run and jump on my board to even pop an ollie off the top of the thing. It was really hard to get the trick, but I finally made it. I took the magazine to math class my senior year of high school and my teacher was so psyched. She showed it to the whole class. This mag represents the determination and dedication I've put into my skating through the years, and it helps me push for the next decade. It was a big achievement. It brings back a nostalgic feeling, of being around people like Huf, Morford, and all the guys whose skating and shredding pushed me harder. That was beyond a ground-breaking time in skate history. Most skaters today don't know where it started or where it came from. Salute to the realness since day one! —*Quim Cardona*

10/95 Chad Muska
Photo: Lance Dalgart

Now it's your turn, Mister Crash and Burn. Chad Muska takes a 5-0 down a very old handrail in New York City during a lengthy tour across these United States.

09/95 Moses Itkonen
Photo: Scott Serfas

The grass grows greener in the Great White North. Moses Itkonen clears a patch with a switch tailslide.

11/95 Quim Cardona
Photo: Gabe Morford

Quim Cardona goes seriously frontside over a brick hip in New York City.

12/95 Mike Bouchard
Photo: Kelly Ryan

Mike Bouchard nosegrinds the City of Brotherly Love.

THRASHER

SWAMP TROGS FROM OUTER SPACE
SEQUENCES UP THE YIN-YANG

SEPT 1995 ISSUE 175 USA $3.25 CAN $4.25

PRINTED IN USA

THRASHER

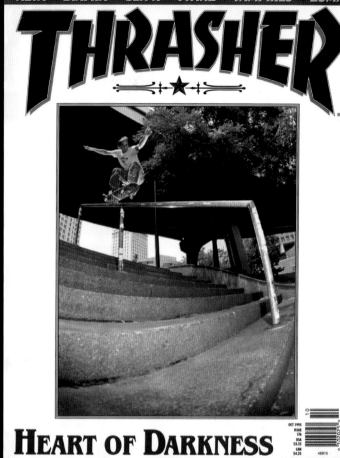

HEART OF DARKNESS

OCT 1995 ISSUE 176 USA $3.25 CAN $4.35

Third-Class Mail Enclosed

PRINTED IN USA

THRASHER

NEW YORK CITY
VIRGINIA BEACH
EUROPE

NOV 1995 ISSUE 177 $3.25 CAN $4.25

PRINTED IN USA

THRASHER

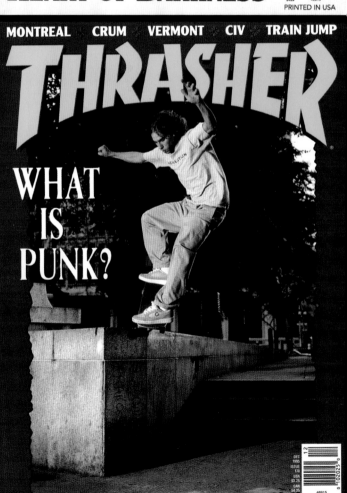

WHAT
IS
PUNK?

DEC 1995 ISSUE 178 USA $3.25 CAN $4.35

Celebrating Fifteen Years of Skateboarding

THRASHER

FIFTEENTH XV ANNIVERSARY

JAN
1996
ISSUE
179
USA
$3.25
CAN
$4.25

46915

PRINTED IN USA

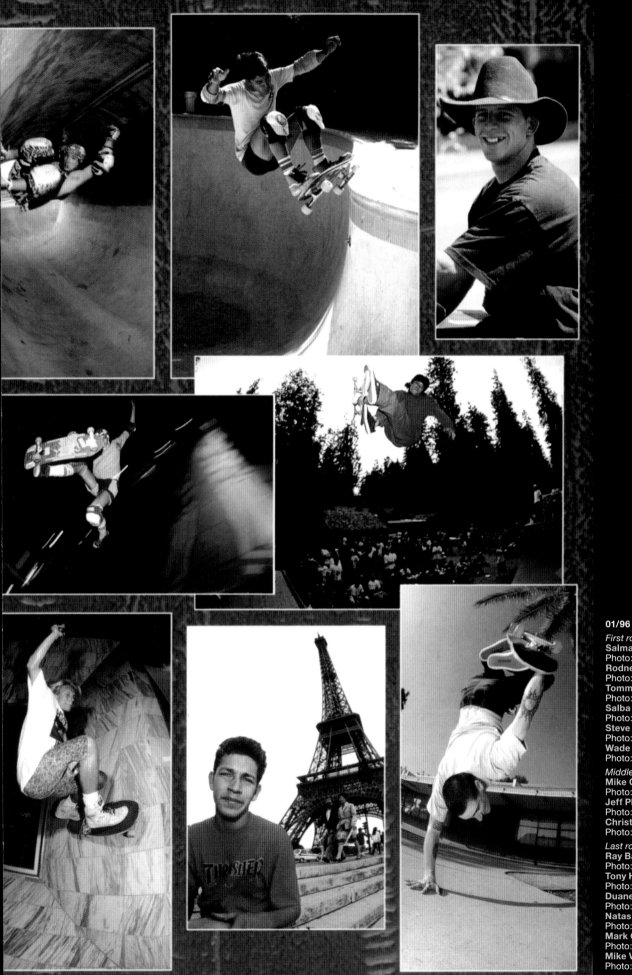

01/96

First row:
Salman Agah
Photo: Lance Dalgart
Rodney Mullen
Photo: Bryce Kanights
Tommy Guerrero
Photo: Bryce Kanights
Salba
Photo: Bryce Kanights
Steve Caballero
Photo: Kevin Thatcher
Wade Speyer
Photo: Bryce Kanights

Middle row:
Mike Carroll
Photo: Bryce Kanights
Jeff Phillips
Photo: MoFo
Christian Hosoi
Photo: Dave Duncan

Last row:
Ray Barbee
Photo: Luke Ogden
Tony Hawk
Photo: Lance Dalgart
Duane Peters
Photo: Lance Dalgart
Natas Kaupas
Photo: Luke Ogden
Mark Gonzales
Photo: MoFo
Mike Vallely
Photo: Jim Knight

FEBRUARY 1996: JUSTIN STRUBING

Look at that young, tender face and Mon-Chi-Chi hair. It was quite an honor to get a *Thrasher* cover, and I'm hoping to get another one someday. This was just before I moved up to San Francisco in the mid-'90s, in the Adrenalin days. I drove up from Santa Cruz to SF and met up with Jaya Bonderov and Luke Ogden, and we ended up at this pretty steep hill with a really nice ledge in Cole Valley, on Clayton Street. I'd been doing salad grinds on ramps and had just started messing with them on street. I hadn't really seen anyone doing them on street yet, so I started trying them on this ledge. The guy who

"WE GOT TWO SHOTS BEFORE GETTING KICKED OUT"

lived there was getting really bent, but we got two shots before getting kicked out. The ledge got skate-stopped right after that so I don't think anyone else really got to skate it. Every time I pass by it I point it out. We skated a bunch of spots that day and also shot another thing that ended up as an Adrenalin ad. I'd just set up a board but didn't put any stickers on it, so I was kinda bummed about that. Look at those Airwalk shoes, back when they were still a real company. This was the best time for skateboarding in San Francisco. All the spots were still there. Good times in 1995 for sure. —*Justin Strubing*

02/96 Justin Strubing
Photo: Luke Ogden

Justin Strubing salad grinds a painted ledge.

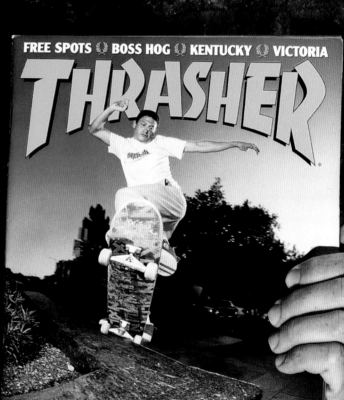

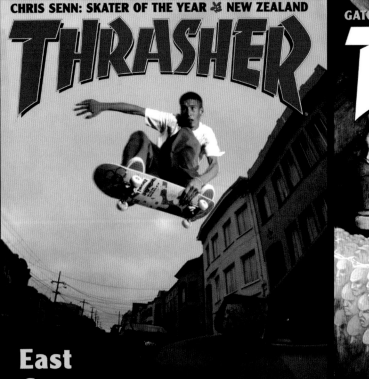

CHRIS SENN: SKATER OF THE YEAR ❧ NEW ZEALAND

THRASHER

East Coast Meltdown

GATOR TALKS • MOST HATED SKATERS • DEAD LAST

THRASHER

Bride of Grindenstein

PRINTED IN USA

PRINTED IN USA

MARCH 1996: RON WHALEY

Chris Senn was Skater of the Year and he didn't get the front.
It's one of our big issues. We gooned it. He's the only SOTY to never
have had a cover. Instead, Chris' mag featured Ron Whaley off a
jump ramp over Satva Leung's car.

APRIL 1996: BRIDE OF GRINDENSTEIN

Drawings of skulls can be rad, but when you start putting in 50-50s?
Sometimes, when someone works hard on something and they say
"Presto," you just gotta go with it. —*Jake Phelps*

03/96 Ron Whaley
Photo: Bryce Kanights

Flying over automobiles blocking
your driveway as demonstrated by
Ron Whaley is one of the many
advantages of jump ramps.

04/96 Bride of Grindenstein
Artwork: Mark DeSalvo

A hundred faces scream in pain under
the weight of a lengthy 50-50 by the
Bride of Grindenstein.

05/96 Coco Santiago
Photo: Bryce Kanights

Less than a quarter mile from
Anton LaVey's house, Coco Santiago
thrusts frontside in an underground
pipe 80 feet below San Francisco.

THRASHER

POOLS • PIPES •
PARKS • PORTLAND
• POSERS • PIGS •
and even POETRY

05

MAY
1996
ISSUE
184
USA
$3.25
CAN
$4.25

0 102025

46915

PRINTED IN USA

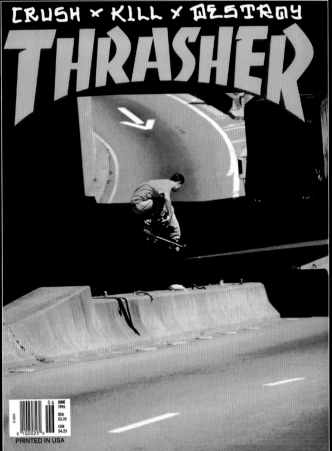

CRUSH × KILL × DESTROY
THRASHER

06 JUNE 1996 USA $3.25 CAN $4.25
PRINTED IN USA

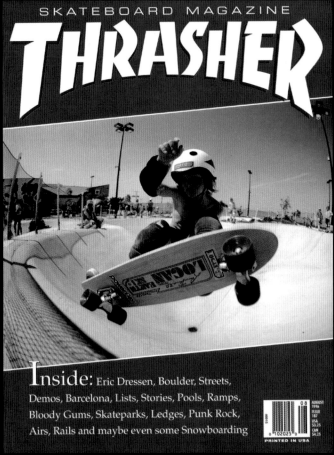

SKATEBOARD MAGAZINE
THRASHER

Inside: Eric Dressen, Boulder, Streets, Demos, Barcelona, Lists, Stories, Pools, Ramps, Bloody Gums, Skateparks, Ledges, Punk Rock, Airs, Rails and maybe even some Snowboarding

08 AUGUST 1996 ISSUE 187 USA $3.25 CAN $4.25
PRINTED IN USA

JUNE 1996: KARMA TSOCHEFF

Playing in traffic is what skateboarding in San Francisco is all about. Luckily, Karma snapped this ollie into Cesar Chavez Street when there were no cars in sight. The cover says it all: "Crush, Kill, Destroy." Karma has had plenty of rad photos, but this cover shot is the one that says "fuck it." Love you, Nosedog. HRC.

JULY 1996: PHIL SHAO

Fort Miley is one of the classic San Francisco spots. To ollie it is one thing; but to grind the top bar over the hip? *That's* a cover. What's funny is that there were, like, 20 people there, but not one other person made it into the shot. Spooky… RIP, Phil. —*Jake Phelps*

06/96 Karma Tsocheff
Photo: Bryce Kanights

Karma Tsocheff finds a new line in an unlikely place, launching into the Army St. 101 on-ramp in SF.

08/96 Eric Dressen
Photo: Bruce Hazelton

A very young Eric Dressen thrusts frontside in your face a-la Bob Jarvis at Skatopia in the summer of 1977. Think about it.

07/96 Phil Shao
Photo: Luke Ogden

When they put the railing up at Fort Miley, it was to save lives. Little did they know a terminator named Phil Shao would frontside grind it.

THRASHER

07

JULY
1996

ISSUE
185

USA
$3.25

CAN
$4.25

PRINTED IN USA

46915

0 102025 0

SEPTEMBER 1996: JONATHAN BOHANNON

Fausto asked me one day, "Who represents skateboarding?" My friend J-Bo was sitting right next to me, so I pointed and said, "Him." Fausto's friend, this artist named Gomez Bueno, was in town. He painted the portrait of Jonathan, brought it in, and said, "Here is cover!" A green black dude? Lost in translation. —*Jake Phelps*

DECEMBER 1996: SEAN SHEFFEY

We shot this in a Southern California schoolyard in Richard Mulder's neighborhood, while we were filming for Girl skateboards' *Mouse* video. We were skating every day, getting photos and filming. This trick actually took me a few tries; it wasn't that easy. It should have been! I saw a sequence in a mag recently and Leo Romero was grinding the whole thing from the flat. Amazing! I'm really proud of him, to see how far you can take skating with a lot of work. —*Sean Sheffey*

10/96 Mark Hubbard
Photo: Luke Ogden
The killer capsule in Alcobendas, Spain has its channel jumped by Mark Hubbard.

09/96 Jonathan Bohannon
Artwork: Gomez Bueno

11/96 Mike York
Photo: Luke Ogden
Who would have ever thought funny guy Mike York would be on the cover of the mag he heckles the most? In the Presidio, Mike frontside bluntslides to fakie over an old rail.

12/96 Sean Sheffey
Photo: Luke Ogden
Big Sean Sheffey rocks the house with a tall 50-50, LA style.

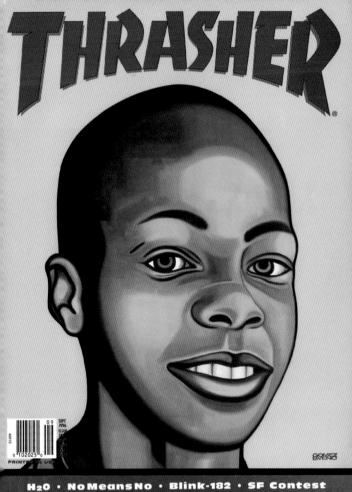

THRASHER

09 SEPT 1996 ISSUE USA $3.95 CAN $4.25
PRINTED IN USA
0 102025

THRASHER

10 OCT 1996 ISSUE 189 USA $3.95 CAN $4.75
PRINTED IN USA
0 102025

THRASHER

11 NOV 1996 ISSUE 190 USA $3.95 CAN $4.25
PRINTED IN USA
0 102025

THRASHER

Attack of the CONCRETE VAMPIRES

12 DEC 1996 ISSUE 191 USA $3.50 CAN $4.50
PRINTED IN USA
0 102026

SPECIAL COLLECTOR'S EDITION
SKATER OF THE YEAR ISSUE

THRASHER

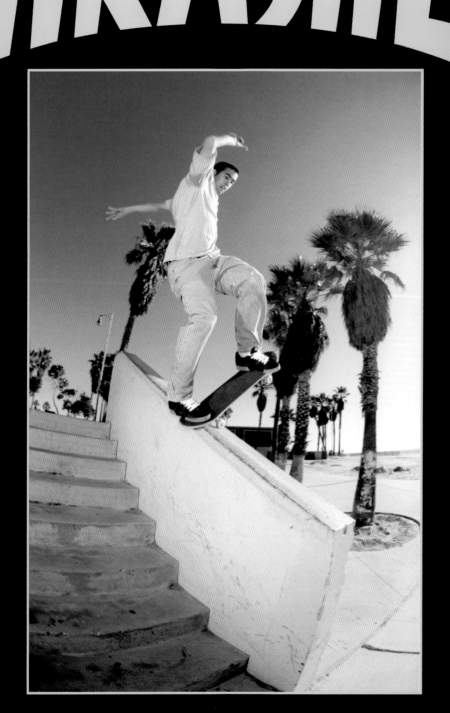

ERIC KOSTON

MARCH 1997

$3.50 US $4.50 CAN

ISSUE 194

PRINTED IN USA

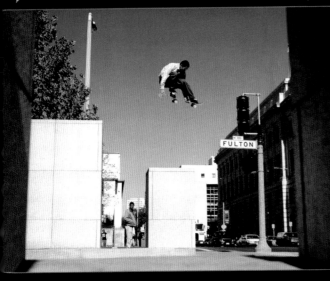

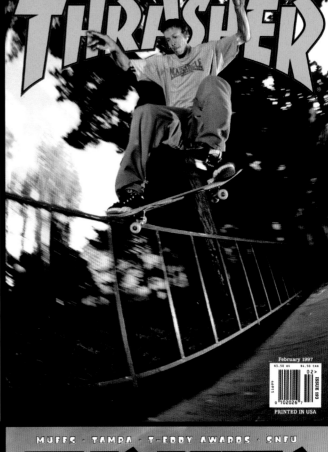

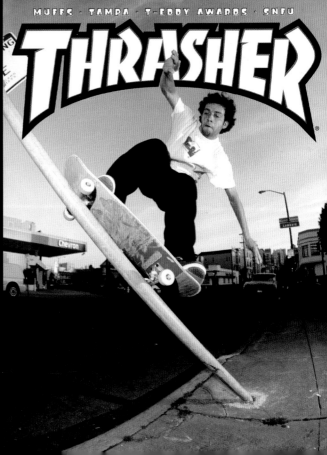

SKATEBOARD MAGAZINE

THRASHER

510 Texas Death Match **Gonz** Five Year Plan **Zipp** Peter Line **Buddies** Pier 7...

JAN 1997 ISSUE 192 USA $3.50 CAN $4.80 PRINTED IN USA

STREET ★ NEW YORK ★ POOLS ★ TIJUANA ★ BRAZIL

THRASHER

February 1997
$3.50 US $4.50 CAN
ISSUE 193
PRINTED IN USA

MUFFS · TAMPA · T-EDDY AWARDS · SNFU

THRASHER

MARCH 1997: ERIC KOSTON

A reluctant SOTY at best, Koston avoided his interview and waited until the last minute to get his cover. Photographer Luke Ogden flew down in the morning, they drove around for a few hours, and then ended up at this notorious spot in Venice, CA. Three tries later it was done and they were cruising back to LAX, and by the time midnight hit the photo was on its way to the printing plant. Last minute or what? —*Michael Burnett*

01/97 Danny Gonzalez
Photo: Gabe Morford
He came out to California to throw down, and he sure as hell did. Danny Gonzalez clears the air behind the new library in SF.

02/97 Scott Johnston
Photo: Luke Ogden
Mister Scott Johnston is never afraid to get down and dirty on the rail grind tip.

03/97 Eric Koston
Photo: Luke Ogden
It took awhile, but we got the shot. Eric Koston frontside noseblunt slides in Venice. Elvis Presley's birthday, Jan 8th, 1997, at 2:43pm. Thanks, Eric.

04/97 Mark Gonzales
Photo: Gabe Morford
Someone ran into a sign, then Mark Gonzales ground up it and came down backwards.

JUNE 1997: CHICO BRENES

Cool red. Killer dude. But what is it? Where's the reference?
What the fuck is going on here? —*Jake Phelps*

05/97 Quim Cardona
Photo: Gabe Morford

Quim Cardona, late night LA.

06/97 Chico Brenes
Photo: Luke Ogden

Over the gap and onto the tail,
Chico Brenes skids it backside.

07/97 Wade Speyer
Photo: Luke Ogden

Vert or street? Hip-hop or metal?
Hard workin' Wade Speyer proves his
metal above the vert of the legendary
Blind School pool in Berkeley.

08/97 Bobby Puleo
Photo: Luke Ogden

Bobby Puleo may be little, but he
ain't afraid of the dark. Midnight
nosegrind on Fulton Street in front
of your favorite church.

COLORADO • ZEKE • DJ MUGGS • AUSTRALIA

THRASHER

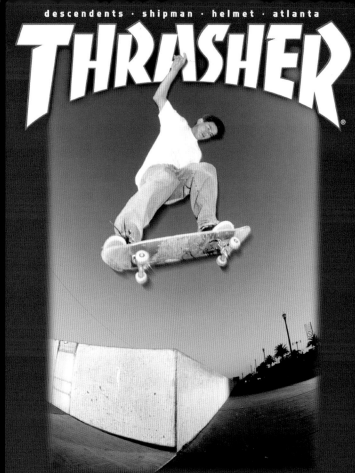

descendents • shipman • helmet • atlanta

THRASHER

CAMP LO • PORTLAND • KELCH • INDONESIA • BAD BLOOD • MECCA • MCKENNEY

THRASHER

JULY 1997 ISSUE 198
$3.50 US $4.50 CAN
07>
0 102026
PRINTED IN USA

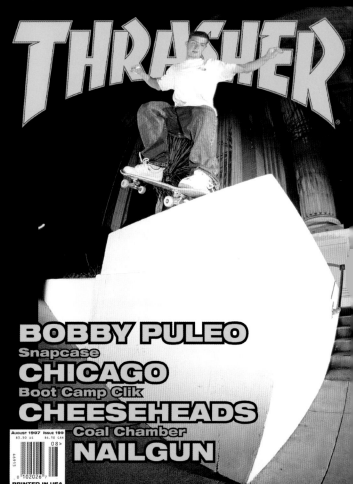

THRASHER

BOBBY PULEO
Snapcase
CHICAGO
Boot Camp Clik
CHEESEHEADS
Coal Chamber
NAILGUN

AUGUST 1997 ISSUE 199
$3.50 US $4.50 CAN
08>
0 102026
PRINTED IN USA

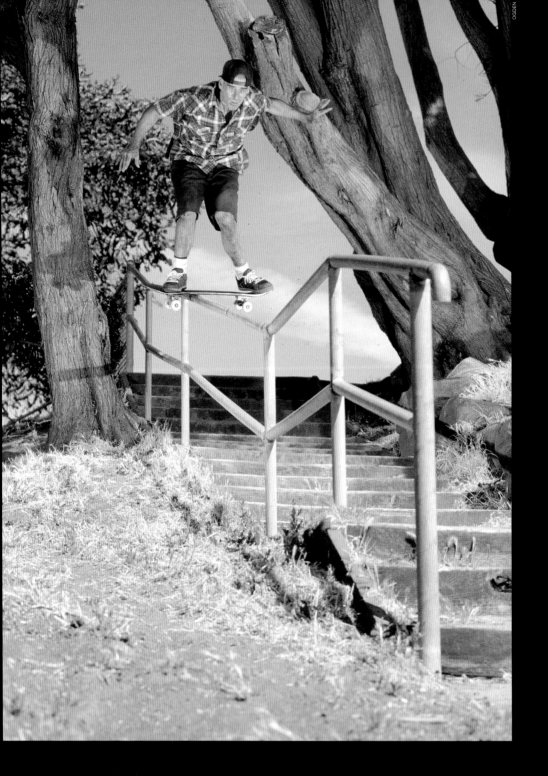

JOHN CARDIEL

Seventy-two tries on a very gnarly rail add up to one of the most wicked slams of all time. Johnzo hit his head so hard that his eyes were bleeding. This photo that Luke Ogden took of him on the ground was "a little too gnarly for the newsstand." Maybe so, but you gotta pay if you want to play. The rail is still there. If you want blood, you got it. —*Jake Phelps*

BATTERED, BRUISED, BLOODIED

THRASHER

AUGUST 1997 ISSUE 199
$3.50 US $4.50 CAN
08>
46915
0 102026 7
PRINTED IN USA

...AND BACK FOR MORE!

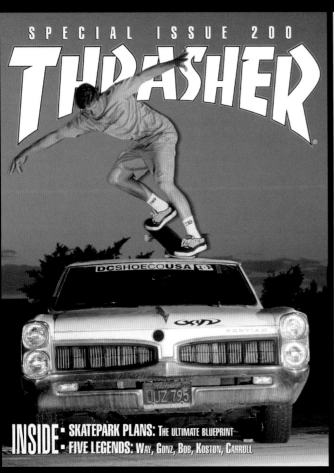

SPECIAL ISSUE 200

THRASHER

DCSHOECOUSA

PONTIAC

UUZ 795

INSIDE: SKATEPARK PLANS: THE ULTIMATE BLUEPRINT
FIVE LEGENDS: WAY, GONZ, BOB, KOSTON, CARROLL

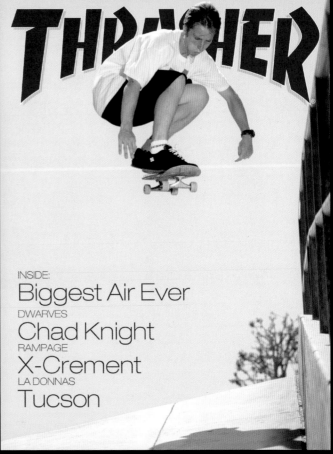

THRASHER

INSIDE:
Biggest Air Ever
DWARVES
Chad Knight
RAMPAGE
X-Crement
LA DONNAS
Tucson

NOVEMBER 1997: JEREMY WRAY

When you see a cover where the skater might die doing the trick,
you buy that mag. Rumor has it that the photographer, Dan Sturt,
slept in the bushes overnight to get this. "Make it or die," that's what
this baby said. Sturt the commando and J-Wray, no fear of death.
Tower-to-tower? Come on, dude… —*Jake Phelps*

11/97 Jeremy Wray
Photo: Daniel Harold Sturt

Commando Dan Sturt snapped only
three shots of Jeremy Wray bridging this
16-foot-gap in a desolate oil field before
being chased into a drain pipe and hiding
all night. All for the cause...

09/97 Danny Way
Photo: Luke Ogden

Danny Way had to be one. Number 200
with a backside noseblunt slide.

10/97 Keith Hufnagel
Photo: Gabe Morford

The calves of Keith Hufnagel allow him
to ollie as high as your chest. The hill is
steep and the drift is fat.

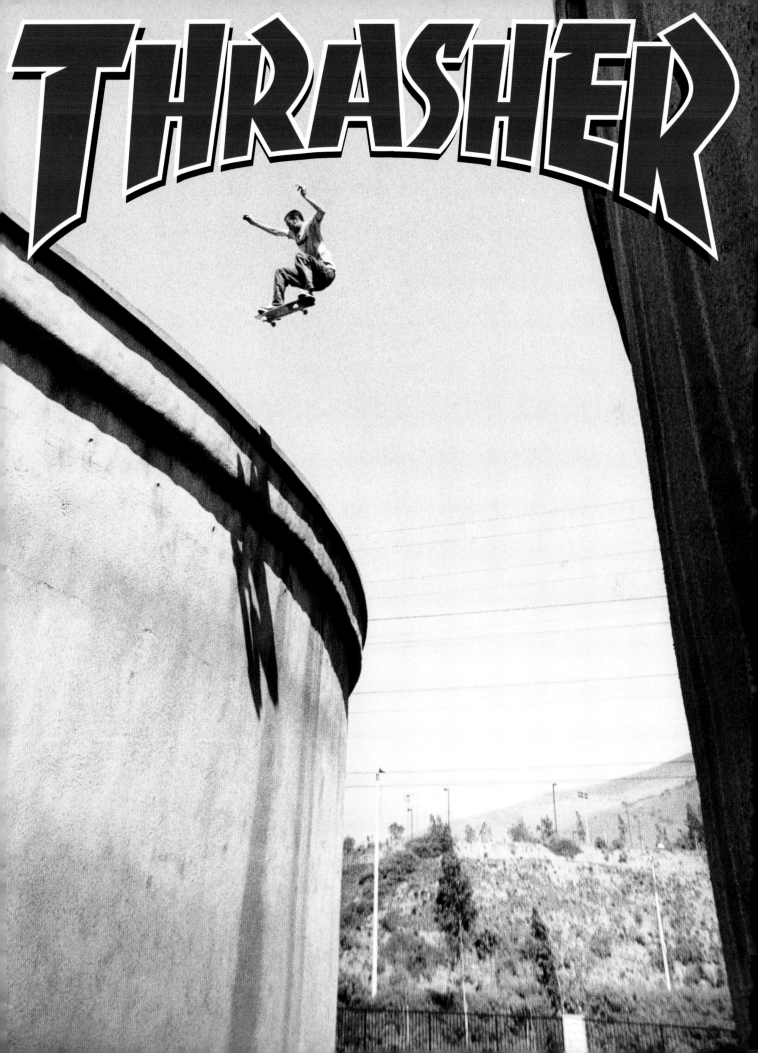

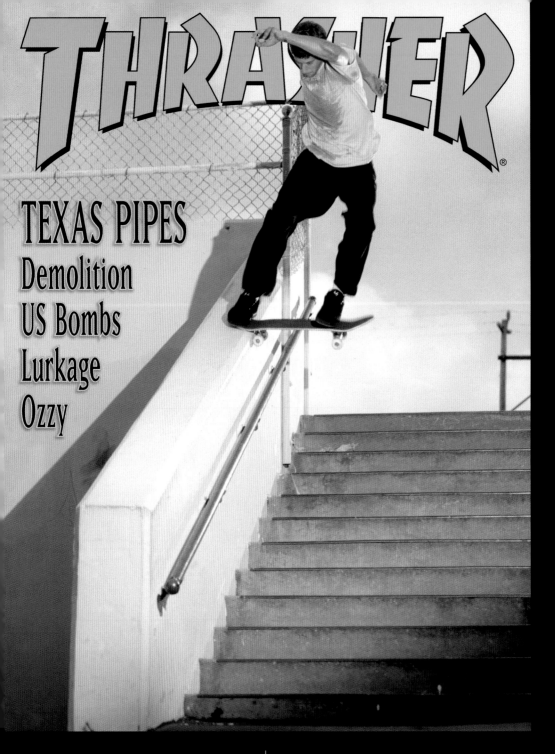

THRASHER

TEXAS PIPES
Demolition
US Bombs
Lurkage
Ozzy

12/97 Brian Anderson
Photo: Gabe Morford

"What ya gotta do is, well, just ollie out behind the fence and stick the shit."
Brian Anderson busts a healthy tailslide in the heart of Noe Valley.

01/98 "El Diablo Esta Perdido"
Artwork: Pushead

Seventeen years down, Pushead is back from the crypt with El Diablo Esta Perdido

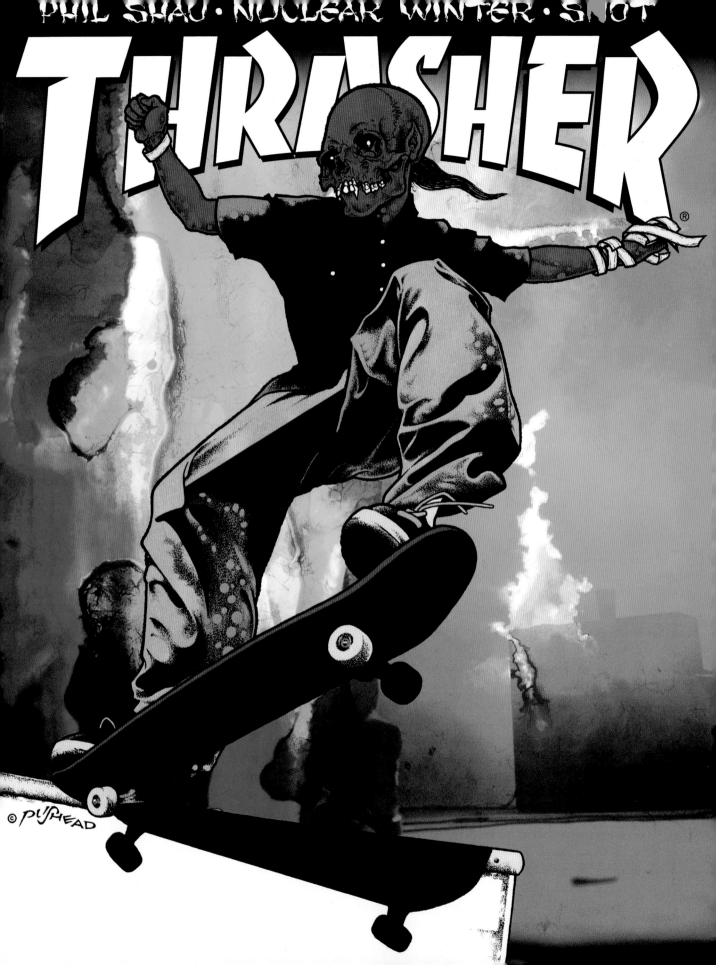

PHIL SHAO • NUCLEAR WINTER • SNOT

MARCH 1998: PETER HEWITT

Mic-E Reyes and I went to Quito, Ecuador in '96 on a recon mission. The next November, we went back down there with a full clip of gnar: Paez, Agah, Carroll, Cardiel, Peter Hewitt, and a grip of others. As you can see, the wall at Park de Carolina is kinda kinked. Right before he did this frontal, Peter had asked me, "Miller flip?"

"Do you want to die?" I replied. Frontside invert—upstream and into the pipe—meant a South American cover. Sketchy place. Total gnar-zone. —*Jake Phelps*

02/98 Pat Duffy
Photo: Luke Ogden

Pat Duffy sits on a fat kickflip in smoggy Los Angeles.

03/98 Peter Hewitt
Photo: Luke Ogden

Thirteen feet of concrete death wave couldn't stop Peter Hewitt from his frontside handplant fate.

04/98 Bob Burnquist
Photo: Luke Ogden

Me pediram para esccrever sobre esta foto. O que vou dizer? Eu já fui lá e acertei o ollie, agora tenho que elaborar um auto elogio? Não. O que eu tenho a dizer é que São Francisco é o bicho! Bob Burnquist (Made in Brazil).

05/98 Willy Santos
Photo: Michael Burnett

Willy Santos makes a feeble attempt to grind this rail in Los Angeles, CA. Frontside. Mike Burnett's first cover.

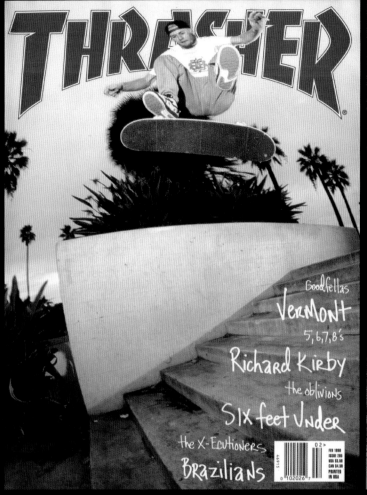

THRASHER

Goodfellas
Vermont
5,6,7,8's
Richard Kirby
the oblivions
Six feet Under
the X-Ecutioners
Brazilians

FEB 1998
ISSUE 205
USA $3.50
CAN $4.50
PRINTED
IN USA

02>
0 102026 7

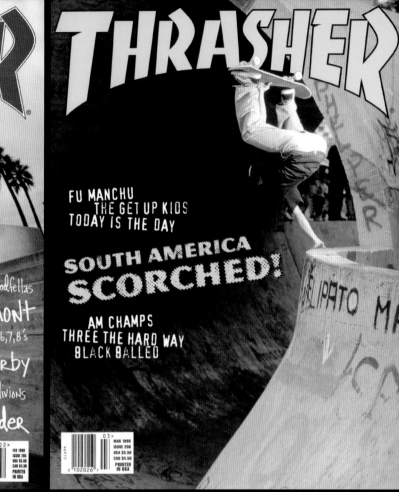

THRASHER

FU MANCHU
THE GET UP KIDS
TODAY IS THE DAY

SOUTH AMERICA
SCORCHED!

AM CHAMPS
THREE THE HARD WAY
BLACK BALLED

MAR 1998
ISSUE 206
USA $3.50
CAN $4.50
PRINTED
IN USA

03>
0 102026 7

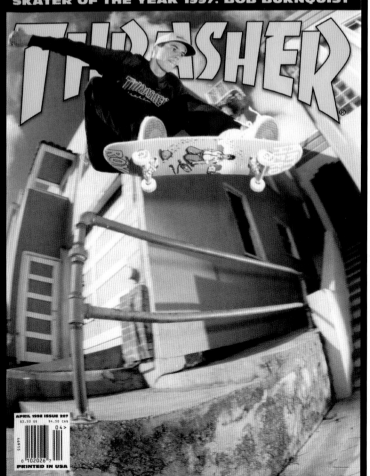

SKATER OF THE YEAR 1997: BOB BURNQUIST

THRASHER

APRIL 1998 ISSUE 207
$3.50 US $4.50 CAN

04>
0 102026 7
PRINTED IN USA

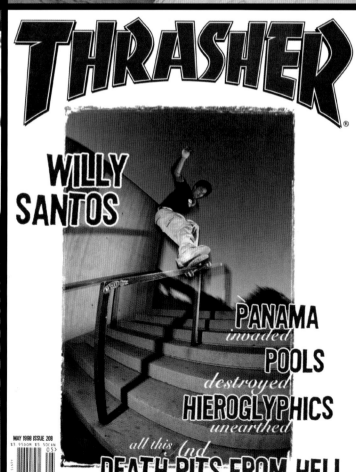

THRASHER

WILLY
SANTOS

PANAMA
invaded
POOLS
destroyed
HIEROGLYPHICS
unearthed
all this And
DEATH PITS FROM HELL

MAY 1998 ISSUE 208
$3.95DOM $5 SOCAN

05>
0 102025 7
PRINTED IN USA

ZASLAVSKY

JUNE 1998: MIKE CARROLL

This was in 1998, and it was in the Chocolate video, thank you very much. The spot is right across the street from a Wendy's. I was still living in San Francisco, on Fell Street at Baker, right across from the DMV in this white little bubbly almost modern-looking building. At the time I couldn't really do front crooks that good, but for some reason, on that day, it was working. I went there to try another trick that I was too pussy to do: A front blunt. This was the same day that I skated the SF Library and did a frontside flip over the big gap.

"IT WAS A TRICK THAT I'D ALWAYS WANTED TO DO BUT COULDN'T"

The shoes are DC Rick Howards. I'm wearing some harsh Fourstar cargos, and that's an FTC sweatshirt. Nick Tershay gave me the haircut. I was still riding Indy's back then—Oh wait. Those are Ventures. Purple and blue. I forgot that Ventures were anodized. Anodized are the shit. They look like pipes. I wanted to go back for the front blunt, but it was too scary—like ollieing-into-a-back-tail-to-manual scariness. I wasn't necessarily surprised when it came out, but I was stoked. I did like the photo, so I was psyched on it; usually I'm insecure or embarrassed about photos that come out. I appreciated it and it felt good, because it was a trick that I'd always wanted to do but couldn't.

I've had four *Thrasher* covers: There's this one, then my SOTY cover, the Japan air from Beauty and the Beast, and my first cover, which was a crooked grind down Hubba. I was wearing a Think shirt but I rode for Plan B. —*Mike Carroll*

06/98 Mike Carroll
Photo: Gabe Morford
Mike Carroll gets up, over, and locked into a frontside crooked grind on his favorite ledge.

SEPTEMBER 1998: MARC JOHNSON

Marc Johnson's a trippy dude, and he has the best feet in the biz. This switch front heel sold a lot of Emericas. Parking lot to parking lot, the body language and the feet proved he was no fluke. Tech burl is all his. —*Jake Phelps*

07/98 Ethan Fowler
Photo: Gabe Morford
Ethan Fowler 360 flips over a garbage can nipple protruding from one of the many mammary swells at Petaluma skatepark.

08/98 Bam Margera
Photo: Luke Ogden
Bam Margera grinds the three-quarter-pipe pocket at FDR skatepark, 16 feet above the asphalt floor.

09/98 Marc Johnson
Photo: Gabe Morford
Marc Johnson flings a switch frontside heelflip from parking lot to parking lot in San Jose, CA.

10/98 Wade Speyer
and Daewon Song
Photo: Luke Ogden
Whatever style of skateboarding you choose, either Wade Speyer or Daewon Song has already done it.

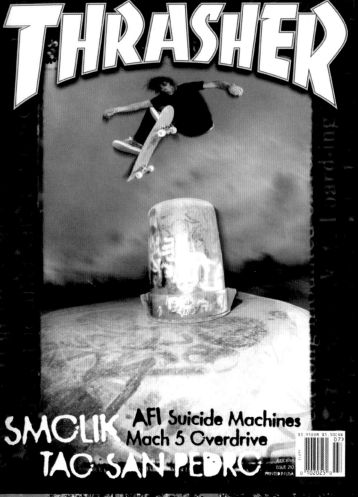

THRASHER

SMOLIK
TAC SAN PEDRO

AFI Suicide Machines
Mach 5 Overdrive

JULY 1998
ISSUE 210
PRINTED IN USA

$3.95 DOM $5.50 CAN

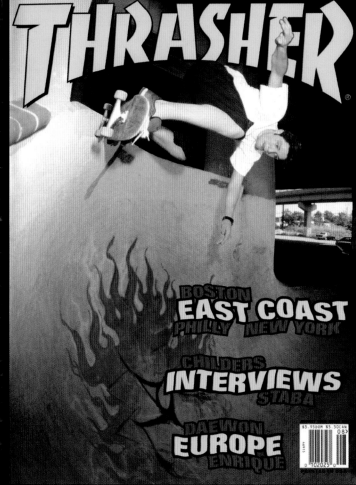

THRASHER

BOSTON
EAST COAST
PHILLY NEW YORK

CHILDERS
INTERVIEWS
STABA

DAEWON
EUROPE
ENRIQUE

$3.95 DOM $5.50 CAN

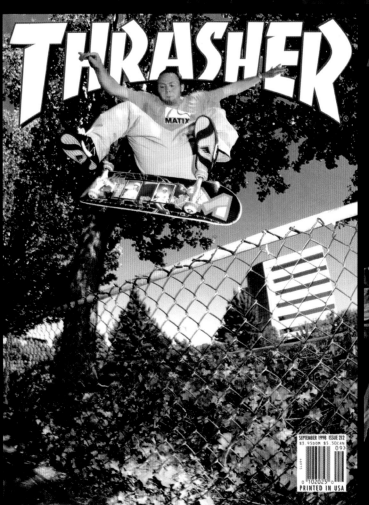

THRASHER

SEPTEMBER 1998 ISSUE 212
$3.95 DOM $5.50 CAN
PRINTED IN USA

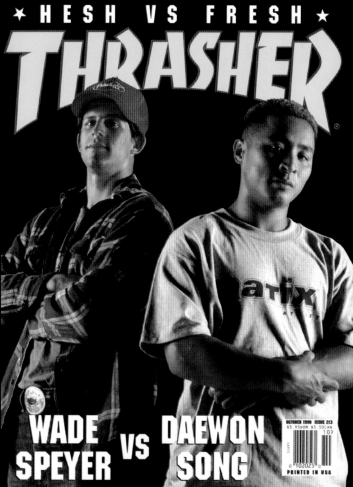

★ HESH VS FRESH ★

THRASHER

WADE
SPEYER VS DAEWON
SONG

OCTOBER 1998 ISSUE 213
$3.95 DOM $5.50 CAN
PRINTED IN USA

THRASHER

EXPLORE
AMERICA'S NORTHWEST AND CENTRAL PLAINS

CONQUER
FRESH CONCRETE
HANFORD
MODESTO
ARCATA

BEWARE
THE BUTCHER OF BUENOS AIRES

MORFORD

NOVEMBER 1998: JOHN CARDIEL

We were driving down the road in Utah on the Gnarcotica tour—
I'm pretty sure it was me and Mic-E Reyes up front—when we saw
this vert ramp right on the side of the freeway. I was tripping, telling
them to pull over, but Mic was like, "It's raining. We don't want to
go." I made 'em pull over anyway.

The ramp was crazy. Maybe it was built for BMX, because it had
a launch in it. All the Masonite was peeling up and everything was
soft because it was so wet, like a big ol' sponge. Riding it with our
regular boards wasn't even possible. Even if it'd been sunny out,

"I CAN'T BE CAUGHT SLIPPIN'"

it would've been hard to skate. The one side didn't even have
coping, it was all roll-in. Somebody was betting me to jump the
middle, so I grabbed Gabe's filmer board and rushed it. Rolling in
was the sketchiest part. Then we started stacking cans, and it turned
into a circus act, basically. When Gabe pulled out the camera I was
like, "I can't be caught slippin' right here," so I boned the fuck out
of it. No stink bug power grab fatty to flatty—that couldn't happen.
The photo Gabe took that ended up on the cover was the best shot,
but we still put one more can up after that. We stacked all of 'em, all
the cans we could find, but after clearing so many I'd start landing
out in the flat and then there was no style to it. Right after we hit the
road the sun came out.

I'm still rippin' today, bro. I take baths in Tiger Balm! —*John Cardiel*

11/98 John Cardiel
Photo: Gabe Morford

John Cardiel ropes in a wet and wild frontside poker
over some stacked water seal cans in Utah.

LOST COVERS

THRASHER

PHIL SHAO

1973 — 1998

NOVEMBER 1998: PHIL SHAO

Phil Shao loved AC/DC and the good times, and we all were shaken when he died at a hella young age. We wanted to dedicate something epic to him, and this "Back in Black" front showed that he came and went with a vengeance. But the boss said, "No dead guy covers," so we pulled it. Nearly 10 years later, Shane Cross became the first. RIP in peace, Brothers. My friends are gonna be there too. —*Jake Phelps*

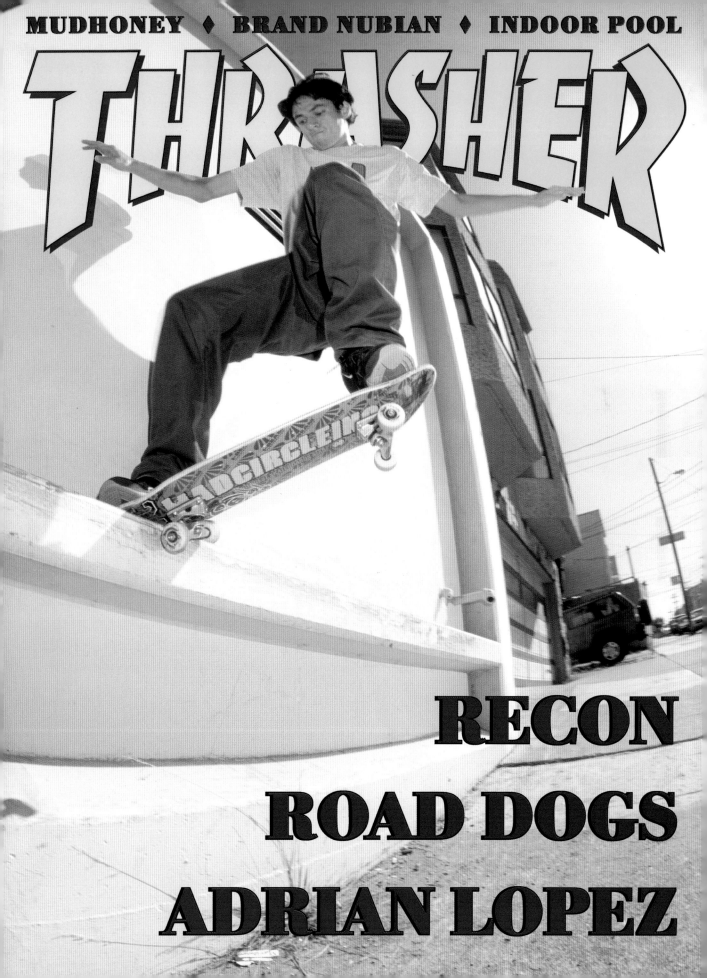

MUDHONEY ♦ BRAND NUBIAN ♦ INDOOR POOL

THRASHER

RECON

ROAD DOGS

ADRIAN LOPEZ

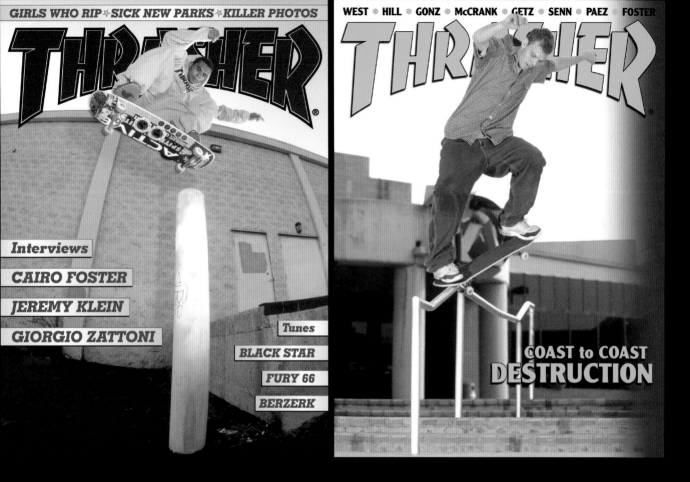

FEBRUARY 1999: GEOFF ROWLEY

Geoff Rowley is hands-down the gnarliest dude in 'boarding. Before
Dan Sturt shot this cover we'd had no images of the guy, but this photo
set in motion the onslaught to come. He even wore our gear, and
Thrasher started getting the best shit. Thanks, Geoff. —*Jake Phelps*

01/99 Richard Mulder
Photo: Michael Burnett
Double agent Richard Mulder
investigates the conspiracy theory
behind the alleged government
cover-up of his switch pole vault.

03/99 Rick Howard
Photo: Luke Ogden
Red Dragon Rick Howard rides
a crooked grind down the kink of
an LA handrail.

02/99 Geoff Rowley
Photo: Daniel Harold Sturt
British invader Geoff Rowley frontside
boardslides a steep-ass 16-stair handrail.

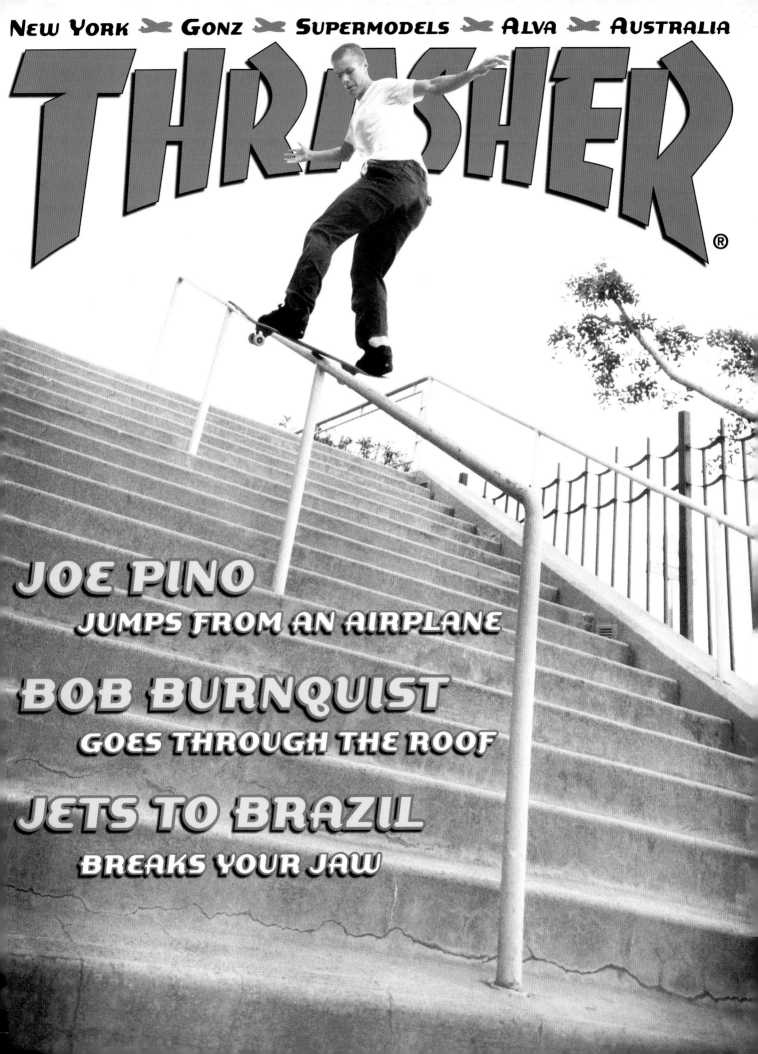

NEW YORK ✈ GONZ ✈ SUPERMODELS ✈ ALVA ✈ AUSTRALIA

THRASHER
®

JOE PINO
JUMPS FROM AN AIRPLANE

BOB BURNQUIST
GOES THROUGH THE ROOF

JETS TO BRAZIL
BREAKS YOUR JAW

APRIL 1999: ANDREW REYNOLDS

He pulled a *Weekend at Bernie's* at the SOTY party, but despite his debaucherous dabbling, Drew was just starting to come into his own as one of the best skaters of all time. Front blunt at the synagogue in Miami, FL was simple for him, but it made for a classic SOTY cover. —*Michael Burnett*

04/99 Andrew Reynolds
Photo: Lance Dawes

Your 1998 Skater of the Year, Andrew Reynolds, frontside bluntslides a thick rail in his home state of Florida.

05/99 Jerry Hsu
Photo: Gabe Morford

A newly-crowned titan of techgnar, Jerry Hsu slings a switch heelflip off a loading dock and over a handrail.

06/99 Jeff Lenoce
Photo: Josh Stewart

Up 'n' comer Jeff Lenoce 5-0s a Floridian hybrid ledge-rail.

07/99 Marcus McBride
Photo: Luke Ogden

Why is San Francisco the best place in the world to skateboard? Ask Marcus McBride about the eye-bleeding speed awaiting him after he lands this monster ollie. He'll tell you, "It's the hills." Come and get some.

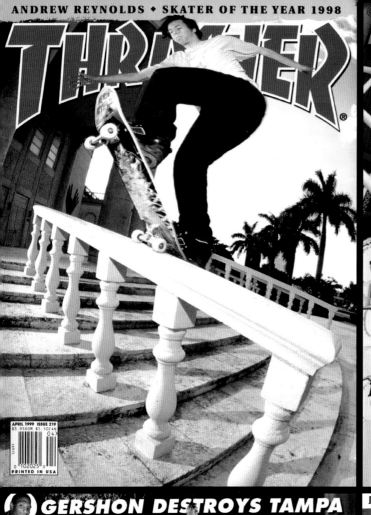

ANDREW REYNOLDS • SKATER OF THE YEAR 1998

THRASHER

APRIL 1999 ISSUE 219
$3.9500M $5.50CAN
04
PRINTED IN USA

© AGNOSTIC FRONT © RICKY OYOLA JAILED IN OZ ©

THRASHER

EMB
Rest In Peace

JAPAN
Hassle Free

AROUND THE WORLD
in 19 days

MAY 1999 ISSUE 220
$3.9500M $5.50CAN
05
PRINTED IN USA

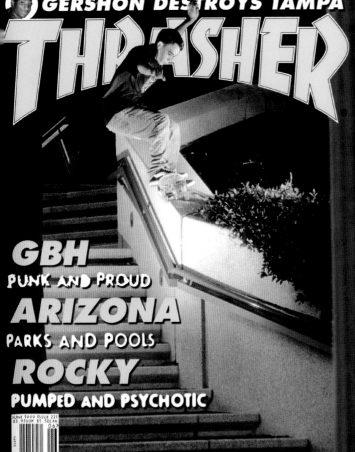

GERSHON DESTROYS TAMPA

THRASHER

GBH
PUNK AND PROUD

ARIZONA
PARKS AND POOLS

ROCKY
PUMPED AND PSYCHOTIC

JUNE 1999 ISSUE 221
$3.9500M $5.50CAN
06

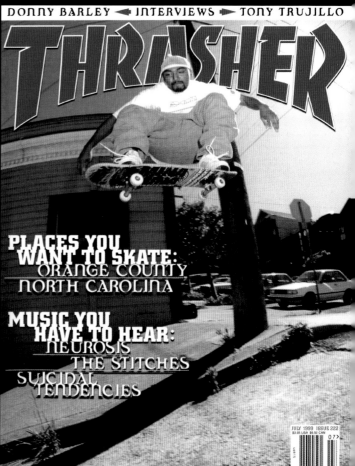

DONNY BARLEY ◄ INTERVIEWS ► TONY TRUJILLO

THRASHER

PLACES YOU WANT TO SKATE:
ORANGE COUNTY
NORTH CAROLINA

MUSIC YOU HAVE TO HEAR:
NEUROSIS
THE STITCHES
SUICIDAL TENDENCIES

JULY 1999 ISSUE 222
$3.95 USA $5.50 CAN
07
PRINTED IN USA

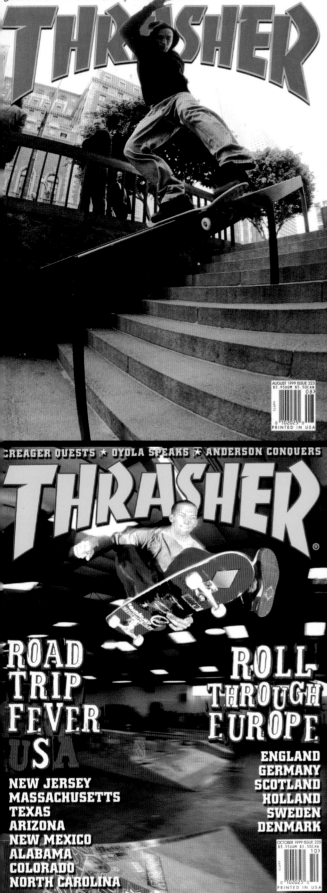

THRASHER

AUGUST 1999 ISSUE 223
$3.95 US $5.50 CAN
PRINTED IN USA

THRASHER

INTERVIEWS

Geoff **ROWLEY**

Brian **SUMNER**

Sick **NEW PARKS**

Total **ANNIHILATION**

SEPTEMBER 1999 ISSUE 224
$3.95 US $5.50 CAN
PRINTED IN USA

THRASHER®

ROAD TRIP FEVER USA

NEW JERSEY
MASSACHUSETTS
TEXAS
ARIZONA
NEW MEXICO
ALABAMA
COLORADO
NORTH CAROLINA

ROLL THROUGH EUROPE

ENGLAND
GERMANY
SCOTLAND
HOLLAND
SWEDEN
DENMARK

OCTOBER 1999 ISSUE 225
$3.95 US $5.50 CAN
PRINTED IN USA

NOVEMBER 1999: RICHARD PAEZ

The session was me, Nik Freitas, Dale Blackman, and the owner of the ramp, some miles outside of Visalia, CA. At the time I was riding for Consolidated, Volcom, Thunder, Spitfire wheels, and Puma shoes. Nik was living in Visalia and shooting for *Thrasher*. It was just a normal session, shooting the skating. We weren't trying to do anything special. A couple months later I was at Ermico, which is the foundry where they make the trucks and wheels, with Joey Tershay. Fausto Vitello was there, and he let me know: "So, you got the cover of the mag this month!" I thought he was confusing me with my brother, Jesse, who was more of the "pro" skater at the time. —*Richard Paez*

08/99 Jamie Thomas
Photo: Michael Burnett
While the world waits for buses and paychecks, big Jamie Thomas switch lipslides in LA. PTL.

09/99 Royce Nelson
Photo: Luke Ogden
A silhouetted Royce Nelson chucks one over the San Francisco skyline.

10/99 Kerry Getz
Photo: Michael Burnett
The king of the kickflip, Kerry Getz, snaps one into a lien air over the hip at the Radlands contest in Northampton, England.

11/99 Richard Paez
Photo: Nik Freitas
Richard Paez is the first of his family to grace the cover. Alley-oop nollie somewhere in the San Joaquin Valley.

THRASHER

YOUTH GONE MAD

DECEMBER 1999: RED

Red is a man of few words, but what he's built with his own hands says it all. The Lincoln City park was his baby on the Oregon Coast. He liked it so much that he moved there and built on more stuff after this shot was taken—the last project being a down-hill snake run of death. After it was finished he had a head-on collision, and had to be helicoptered to Portland due to massive trauma. The hospital hit him with a bill for $172,000 dollars. He almost died at his own park! Love the costume: C1RCA shirt, red camo cargos… Red really don't give a fuck. —*Jake Phelps*

01/00 Steve Caballero
Photo: Kevin Thatcher

Appearing on the cover for a record 10th time, and likely to be looked upon as the greatest skater of the last century, is Steve Caballero. This frontside corner air on a freestyle board with an out of character look-back is one for the ages.

12/99 Mark Scott
Photo: Luke Ogden

A man reborn. Mark Scott flies frontside on his latest concrete masterpiece: Lincoln City, OR. Step back.

02/00 Erik Ellington
Photo: Michael Burnett

Kicking ass and taking names—
The Mule, Erik Ellington, backside flips a lengthy loading dock.

03/00 Paul Machnau
Photo: Michael Burnett

Paul Machnau slices into a precarious frontside slider.

THRASHER

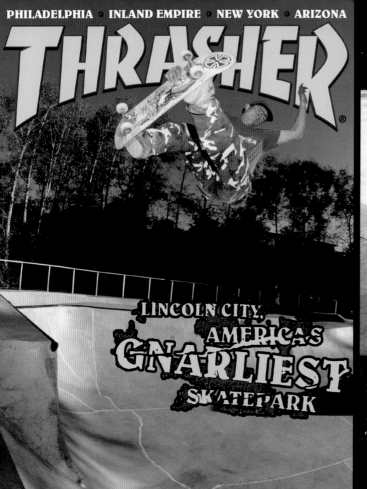

LINCOLN CITY,
AMERICA'S
GNARLIEST
SKATEPARK

THRASHER

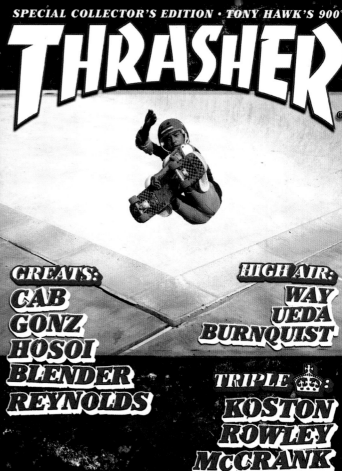

GREATS:
CAB
GONZ
HOSOI
BLENDER
REYNOLDS

HIGH AIR:
WAY
UEDA
BURNQUIST

TRIPLE:
KOSTON
ROWLEY
McCRANK

THRASHER

KILLER SPOTS

hella parks
burly rails
secret pools

THRASHER

iNSiDE: **MUMFORD**
URUGUAY
BRAZiL
CHiLE **CHALMERS**
ARGENTiNA

DiSOBEDiENCE

APRIL 2000: BRIAN ANDERSON

Heavily inspired by Master-P and the hip-hop crimes against Photoshop that were running hot that year, BA's cover found him kicking back in a Valhalla of stoke: A bedazzled throne atop a bed of Spitfires and Indys, his trusty dog at his side, Cristal chillin', smoking a blunt while SF burned in a drizzle of $100 bills. Yes, this was supposed to be ridiculous, but BA is a SOTY legend. —*Michael Burnett*

"BA'S COVER FOUND HIM KICKING BACK IN A VALHALLA OF STOKE"

This was my Skater of the Year cover, and I was really stoked on the way it came out. This champaign is Veuve Clicquot Ponsardin—it's very expensive. Jake bought it and then he drank it. Luke was reprimanded by the cops for taking these pictures of the car: "What are you doing? You can't take photos of a police car!" For having a non-skate cover, I think it's cool to have one that's at least funny, so people get a kick out of it. All my friends complimented me—Mike Carroll told me he thought it was one of the best covers ever. I'm stoked we did it. Everybody got a good laugh, and it looks just like one of those rap album covers. The execution was perfect. —*Brian Anderson*

04/00 Brian Anderson
Photo collage: Berry, Morford, and Ogden
Bling-bling, Master B is 'bout it, 'bout it.

THRASHER

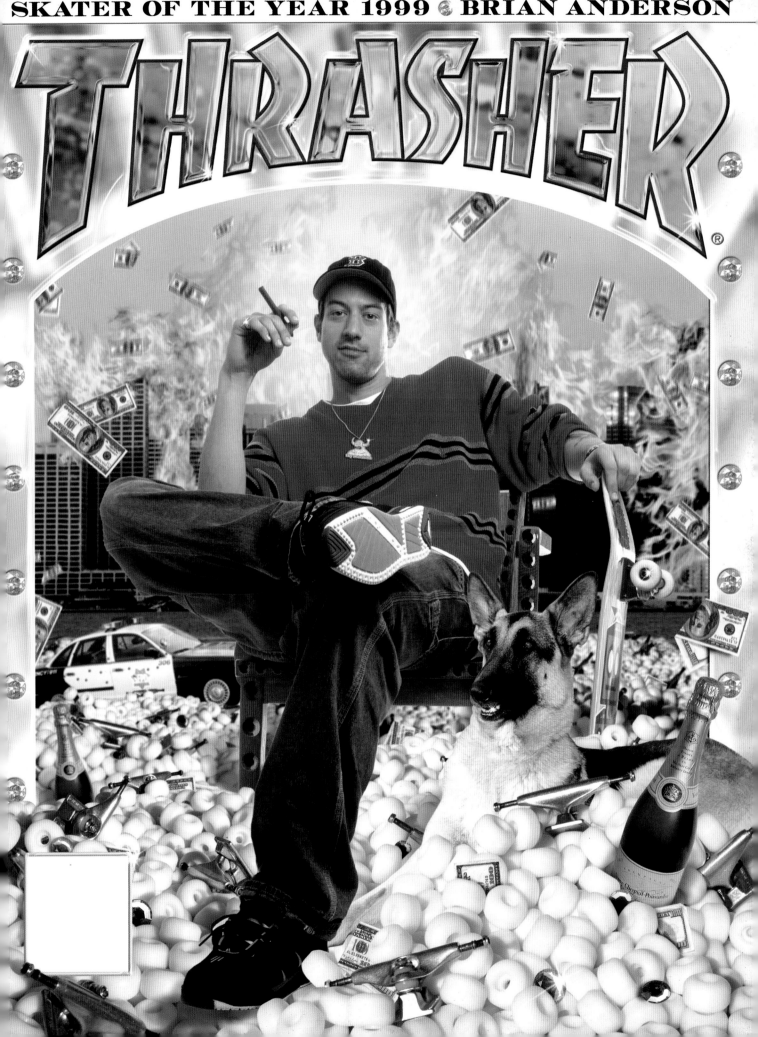

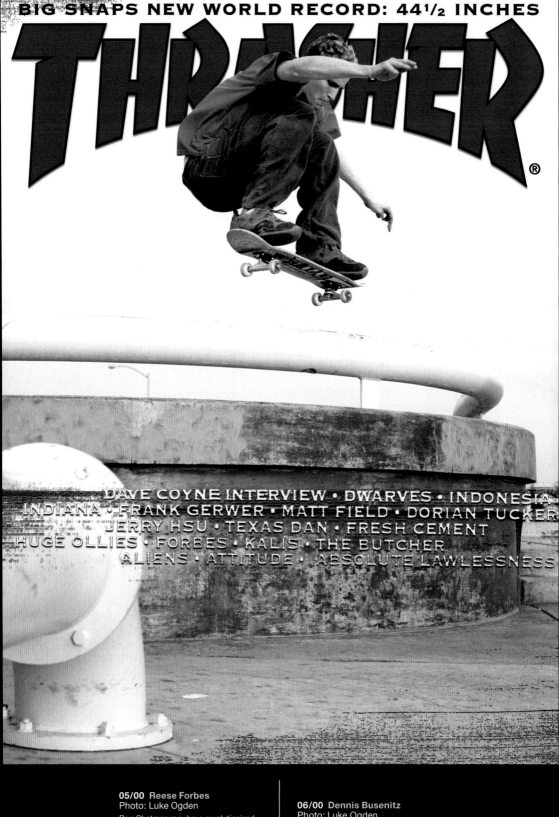

THRASHER ®

DAVE COYNE INTERVIEW • DWARVES • INDONESIA
INDIANA • FRANK GERWER • MATT FIELD • DORIAN TUCKER
JERRY HSU • TEXAS DAN • FRESH CEMENT
HUGE OLLIES • FORBES • KALIS • THE BUTCHER
ALIENS • ATTITUDE • ABSOLUTE LAWLESSNESS

05/00 Reese Forbes
Photo: Luke Ogden

Ron Chatman may have revolutionized
the fakie ollie in *Rubbish Heap*, but
Reese Forbes is raising the bar at the

06/00 Dennis Busenitz
Photo: Luke Ogden

Doubling the size of the main hip with
a mean shifty, Dennis Busenitz takes

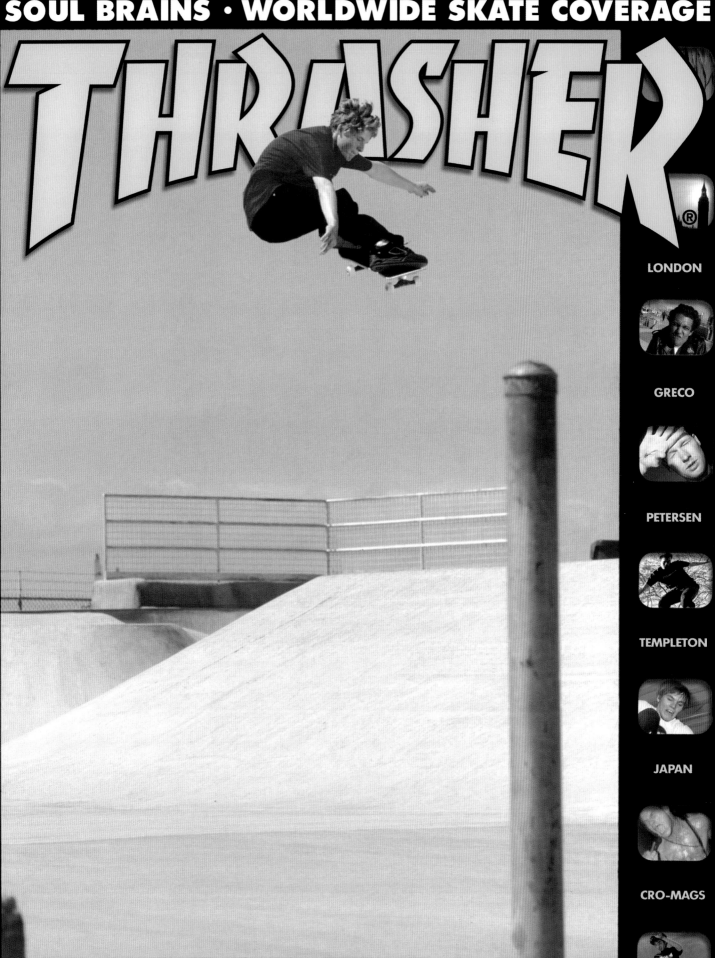

SOUL BRAINS · WORLDWIDE SKATE COVERAGE

THRASHER

LONDON

GRECO

PETERSEN

TEMPLETON

JAPAN

CRO-MAGS

THRASHER

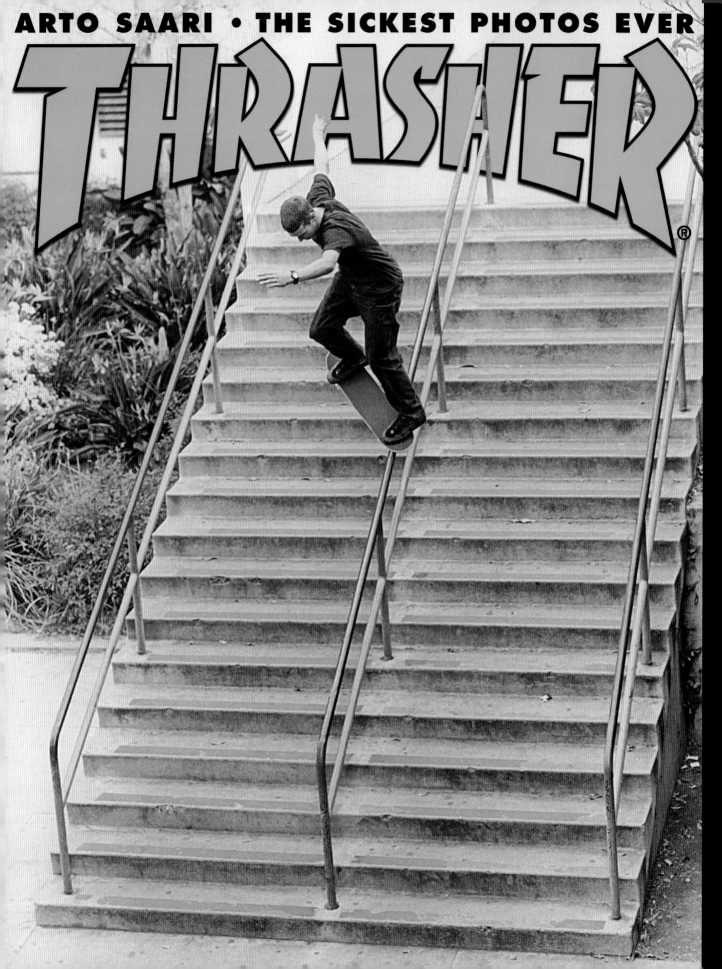

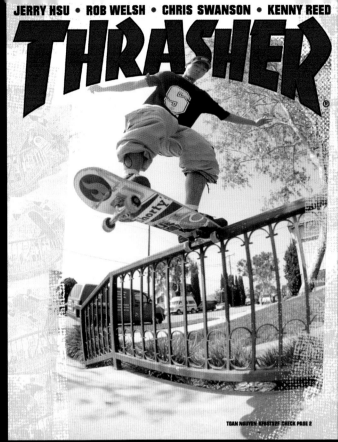

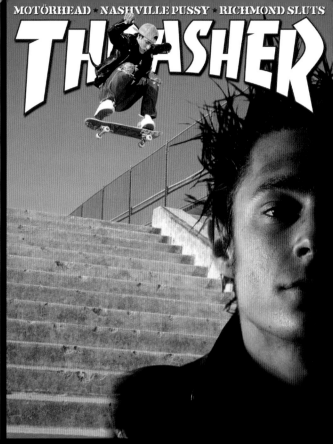

JULY 2000: ARTO SAARI

"Okay. I'm scared shitless. What the fuck am I going to do?" That's
what I was thinking to myself as I was getting ready to skate this rail.
Right then, Dan Sturt—the photographer—stops me and says, "Arto!
Arto! Come over here!"

 "No," I told him. "I'm about to skate this thing!" But he wouldn't let up.

 "Arto, no! Come stand next to Geoff first! Come up here!"

 So I walk up to where they're filming from, and I stand next to Geoff,
and Sturt takes a single picture. I'm all, "Is that it?"

 "Yeah," he says. "You never know when someone's going to die."
—*Arto Saari*

07/00 Arto Saari
Photo: Daniel Harold Sturt

Saari kids, if you thought Arto was
finished, this crooked grind is only
the beginning.

08/00 Toan Nguyen
Photo: Michael Burnett

Oh what?! He kickflipped into that?
Toan Nguyen fulfills the dream in the
sunny LBC. Kickflip backside tailslide
to fakie.

09/00 Jim Greco
Photo: Luke Ogden

Out of his mind and onto our cover,
Jim "Schnapps" Greco finally reels in
the switch frontside flip down the big
set at Lincoln—after about 151 tries.

I've had four *Thrasher* covers, and this front nose in Oakland was my second.

Luke Ogden was sitting right in the danger zone—I remember landing it and rolling straight towards him and then having to jump over him. He was pretty much in my way, but the photo came out rad. No one's ever seen the footage of this. Nowadays, if you don't

"NO ONE'S EVER SEEN THE FOOTAGE"

see the film footage of a trick, people think you didn't land it or that something was wrong with it. But honestly, I don't even remember if anyone filmed it.

It's cool thinking back about Luke and shooting photos with him. One time we got to a spot and I was having doubts about whether I could pull what I wanted to do, and he said, "There's no better time than the present." That always resonated with me. —*Cairo Foster*

10/00 Cairo Foster
Photo: Luke Ogden

Sometimes, in the darkest hour, the greatest things can transpire. Case in point: A fully-recovered Cairo Foster puts 100-percent into a tall frontside noseslide in Bump City.

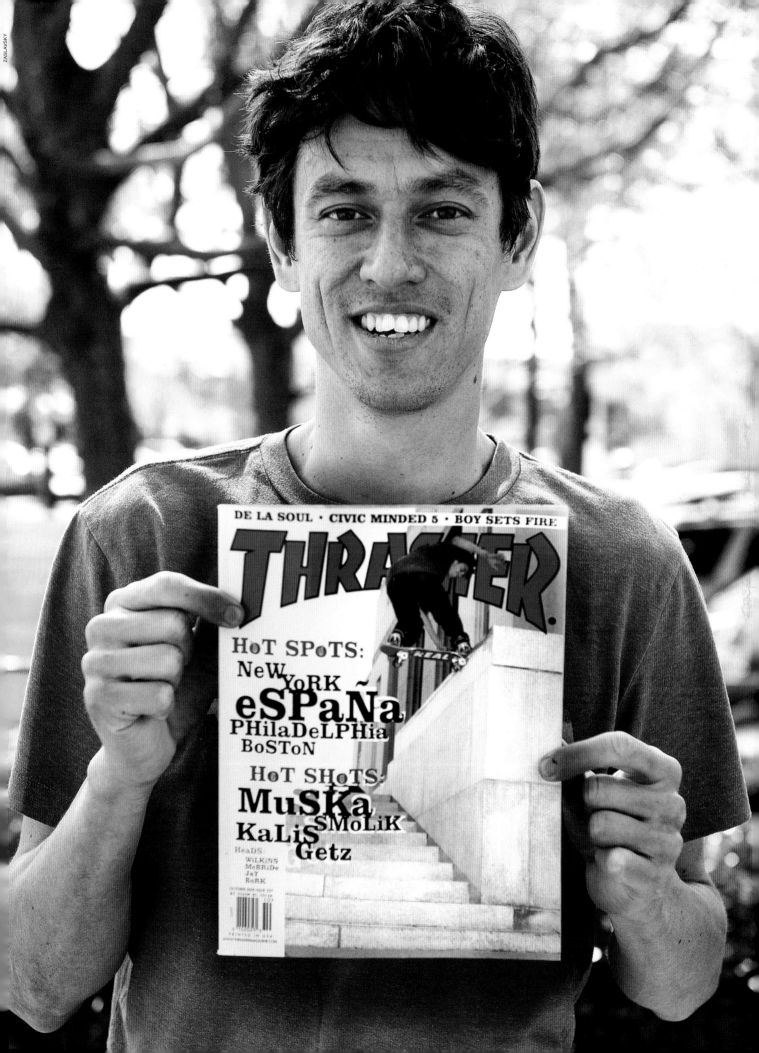

ZASLAVSKY

DE LA SOUL · CIVIC MINDED 5 · BOY SETS FIRE

THRASHER.

HoT SPoTS:
NeW YoRK
eSPaÑa
PHilaDeLPHia
BoSToN

HoT SHoTS:
MuSKa SMoLiK
KaLiS Getz

HeaDS:
WILKiNS
McBRiDe
JaY
BoRK

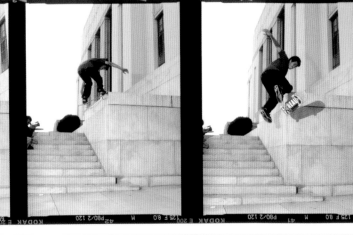

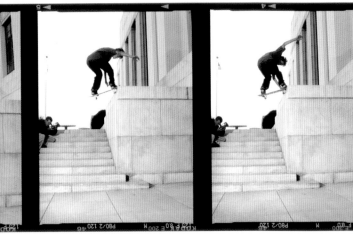

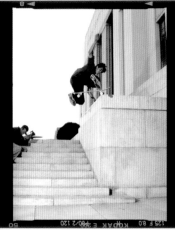

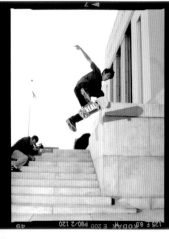

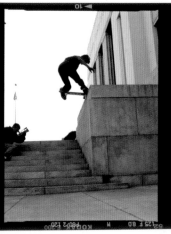

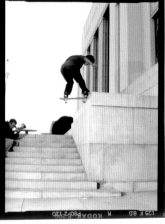

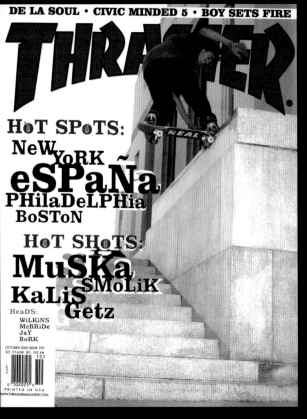

WHAT'S THE DIFFERENCE?

The cover photograph isn't a "one try, do-or-die" deal.
Being that it's usually the gnarliest thing in the mag that
month means that the skater may have tried the trick a
couple dozen times before rolling away—and that's just
the beginning of the process when it comes to selecting
the best frame to publish for eternity. A roll of film (or,
these days, a digital camera's memory card) may contain
30 images that, to the naked eye, are seemingly identical.
But put them under a magnifying loop and the details start
to emerge. Is one image sharper than the rest? Does one
frame show the skater more locked in to the trick than the
others? Which shot best shows the logos of the dude's
sponsors on his board, shoes, and shirt? It's a hard recipe
to mix, with different ingredients each issue and many
cooks in the kitchen. But the cream always rises to the top.

 Thrasher's editor, Jake Phelps, sums it up: "When I look
for a cover, I want something that's going to make me
remember that moment. I want it to instantly recall
"time," "photographer," and "skater." It should make me
want to go to the spot. I'm lookin' for an expression on the
skater's face that conveys just how dangerous what he's
doing is, that if he doesn't make it he's either gonna break
his arm or die."

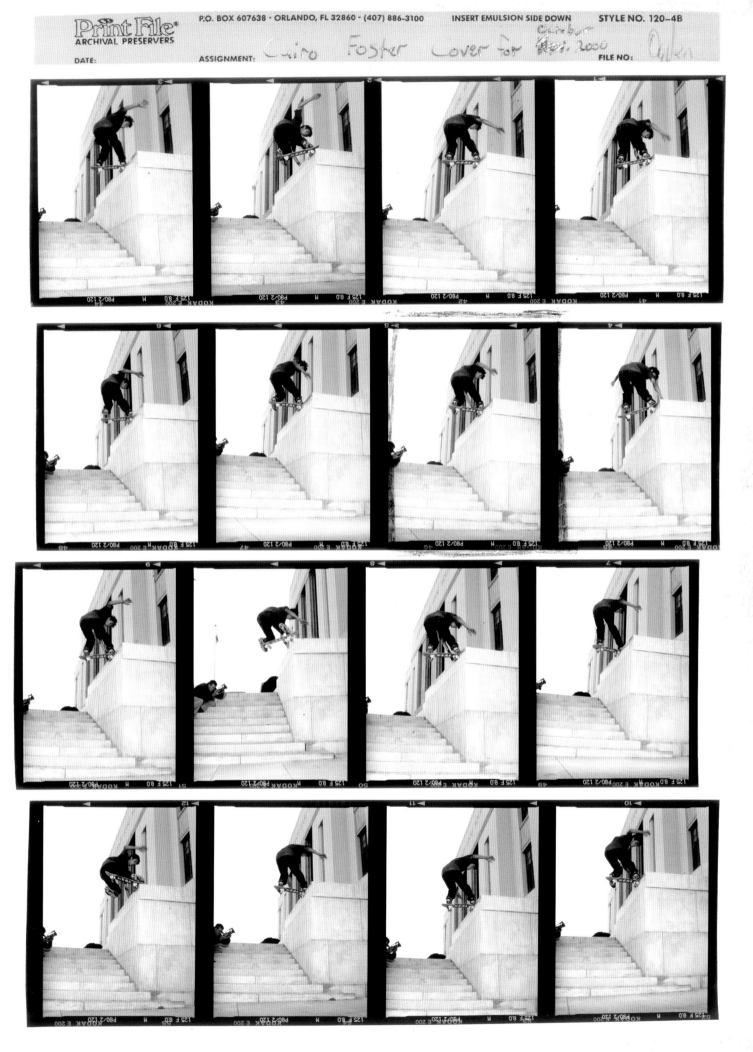

Print File®
ARCHIVAL PRESERVERS
P.O. BOX 607638 · ORLANDO, FL 32860 · (407) 886-3100 INSERT EMULSION SIDE DOWN STYLE NO. 120–4B
DATE: ASSIGNMENT: Chino Foster Cover for October 2000 FILE NO:

11/00 **Jason Dill**
Photo: Lance Dawes

Staying up late, wearing cool gear,
driving like crazy—Jason Dill gets
demented and bluntslides a rail in LA.

12/00 **Eric Koston**
Photo: Michael Burnett

Who else but Koston would back lip a
double-set handrail and not even film it?

01/01 **Oblivion**
Photo: Luke Ogden

Charging headlong into the next 20
years of skateboarding and not looking
back. *Thrasher* mag has been there
and done that.

02/01 **Steve Olson**
Photo: Michael Burnett

Super-hero Steve Olson hurls through a
gale-force switch crooks in downtown SD.

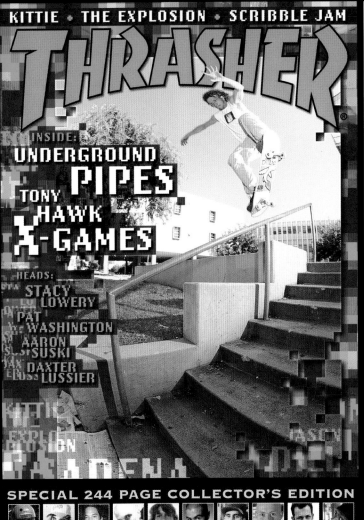

THRASHER

INSIDE:
UNDERGROUND PIPES
TONY HAWK
X-GAMES

HEADS:
STACY LOWERY
PAT WASHINGTON
AARON SUSUKI
DAXTER LUSSIER

THRASHER

Eric Koston, Who else?

JAPAN • TORONTO
Brandon Biebel • Chad Knight • Steve Bailey
FROGFACE

$3.99 US $4.99 CAN

PRINTED IN USA

0 71486 03029 4

12>

HAWK MUSKA HOSOI THOMAS SAARI KOSTON CARDIEL JOHNSON GONZALES WILLIAMS

THRASHER

1981
TWENTIETH X ANNIVERSARY
2001

PENNY
GRECO
DILL
ALVA
STEAMER
BARLEY
HOWARD
REYNOLDS
BURNQUIST
TEMPLETON

KALIS
GETZ
DUFFY
McKAY
SHEFFEY
DREHOBL
McCRANK
MARIANO
BUCCHIERI
ELLINGTON

TWENTY YEARS AND GRINDING

JANUARY 2001 ISSUE 240
$3.99US $4.99CAN
01>
0 1486 03029 4
PRINTED IN USA
www.thrashermagazine.com

THRASHER

TECH GNAR SUPERSTARS
LOUDER DOBSTAFF DAVIS

@ PAPPALARDO
@ OYOLA
@ GARCIA
@ LEBRON
@ HARRIS

JERON WILSON
INTERVIEW

COOKIN' IN COLORADO

FEBRUARY 2001 ISSUE 241
$3.99US $4.99CAN
02>
0 71486 03029 4
PRINTED IN USA
WWW.THRASHERMAGAZINE.COM

THRASHER

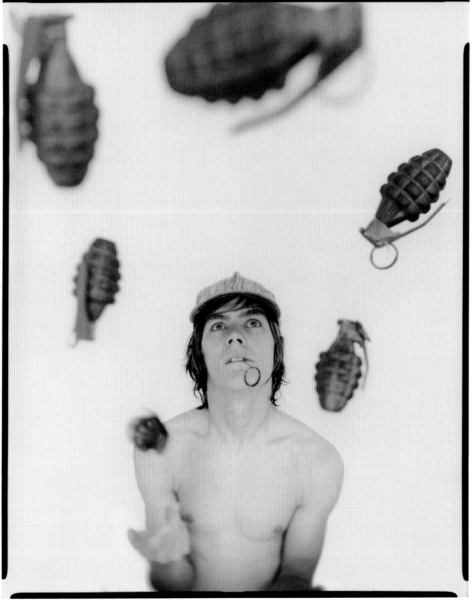

APRIL 2001 · ISSUE 243
$3.99US $4.99CAN

04>

0 71486 03029 4

PRINTED IN U.S.A.
WWW.THRASHERMAGAZINE.COM

THRASHER

BEATDOWN:
GRECO VS. ROWLEY

ANARCHY
DOWN UNDER

DREHOBL
ANDERSON
STABA and
UPSON

DESTROY
AUSTRALIA

MARCH 2001 · ISSUE 242
$3.99US $4.99CAN
PRINTED IN USA
WWW.THRASHERMAGAZINE.COM

THRASHER

AM
INVASION

ELIAS BINGHAM
BASTIEN SALABANZI
PATRICK MELCHER
JOEL MEINHOLZ
COLT CANNON
CHRIS COLE

MAY 2001 · ISSUE 244
$3.99US $4.99CAN

APRIL 2001: GEOFF ROWLEY

Rowley and Sturt combined forces to make a kill portrait, which perfectly represented Geoff's skating. Juggling six hand grenades? You try it! The pins are in, so nobody got dead. —*Jake Phelps*

04/01 Geoff Rowley
Photo: Daniel Harold Sturt

Pull the pin and wait for detonation. Geoff (SOTY) Rowley is ready to explode.

03/01 Dan Drehobl
Photo: Luke Ogden

When he's not sleepin' in a coffin, Dan (Corpsy) Drehobl can launch a frontside air on anything. This TFA assault happens to be in Kempsey, NSW.

05/01 Elias Bingham
Photo: Luke Ogden

Prop up a metal grate and, next thing you know, an old spot is new again. Elias Bingham, deep shifty at dusk.

THRASHER

TAMPA PRO
THE LOOP OF DEATH:
WHO MADE IT, WHO GOT SERVED

SNOOP DOGG
SKATES G-FOOTED

JERRY HSU
HAS A POSSE

HAWAII
KALE IS CRAZY

JUNE 2001 · ISSUE 245
$3.99US $4.99CAN

06>

0 71486 03029 4

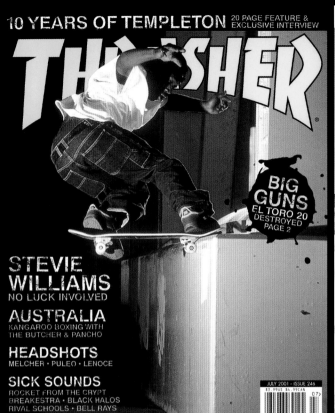

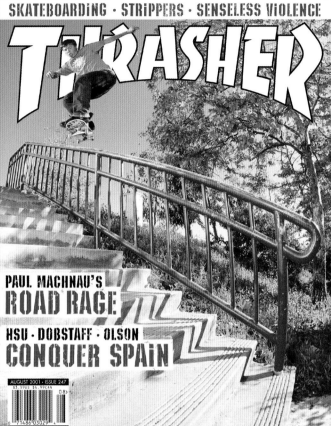

06/01 Alan Petersen
Photo: Luke Ogden

Ollies are his game, and Alan Petersen

07/01 Stevie Williams
Photo: Shelby Woods

The pop of Stevie Williams is best
described as "whatever." Check the

08/01 Wes Lott
Photo: Michael Burnett

Wes Lott may not have the name
recognition of an Eric Koston or a
Kenny Hughes, but just look at all those

BURNETT

SEPTEMBER 2001: GEOFF ROWLEY

This spot's in Lyon, France. We were on a trip to Barcelona and decided to switch it up and go to French Fred's hometown for a few days. Bastien didn't come with us because Fred wouldn't let him in the vehicle with any drugs, because we had to drive over the border.

It was a great trip. The spots were really good and I was feelin' it. I remember looking at the ledge and thinking, "Man, when the fuck am I going to come back to Lyon, France? That's never going to happen. I've got to do this now if I'm ever going to skate this thing." I clearly remember thinking that. I like spots that no one has ever

"I WAS BASICALLY OLLIEING INTO THIN AIR"

skated, and I don't think anyone had ever skated this spot like that before, so that was a bit of an incentive, too. I ate shit a couple of times. It was really, really grindy and really fast. I did a manual down it at first. You can't see it until after you ollie, so I was basically ollieing into thin air. The next one I landed Primo off the end, because it grinded so fast and I slipped off. I might have bailed one more after that, and then I made it. It's one of those spots where you either land it or you slam. You aren't landing it and doing some sort of powerslide and bringing it back again. You're up or you're down on that one. I had no idea it was going to be a cover, so I was excited when it came out. It's one of the best covers I've had so I was really pumped. —*Geoff Rowley*

09/01 Geoff Rowley
Photo: Michael Burnett

Blast five stairs, stick the backside 50-50
at Mach 5 and coast off the end, yeah right.
SOTY Geoff Rowley lives up to the hype.

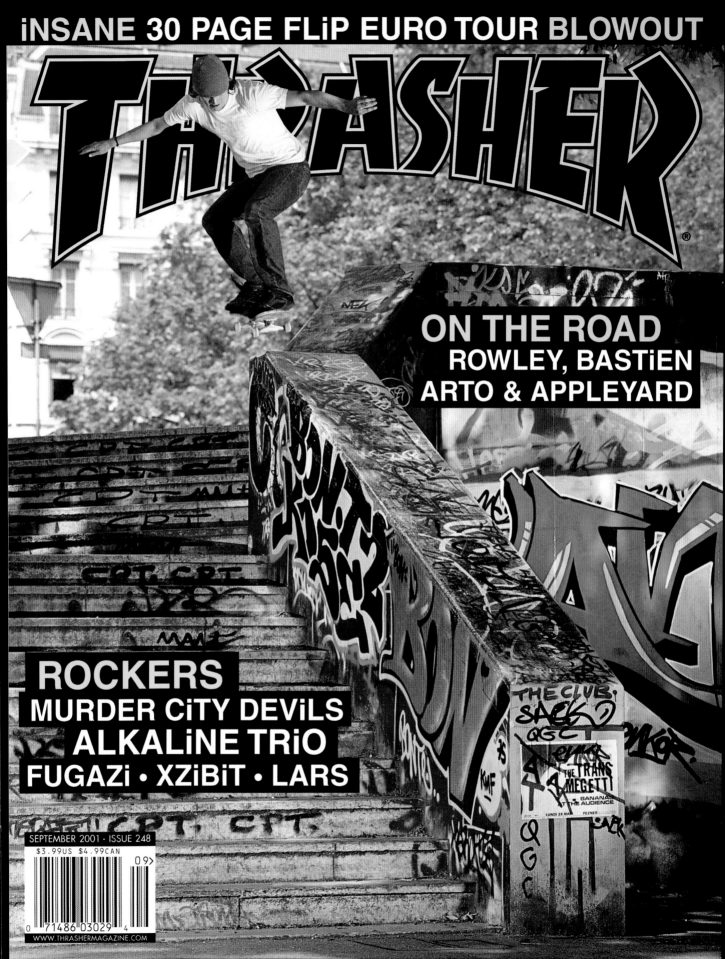

iNSANE **30 PAGE FLiP** EURO TOUR **BLOWOUT**

THRASHER

ON THE ROAD
ROWLEY, BASTiEN
ARTO & APPLEYARD

ROCKERS
MURDER CiTY DEViLS
ALKALiNE TRiO
FUGAZi • XZiBiT • LARS

SEPTEMBER 2001 · ISSUE 248
$3.99US $4.99CAN

0 71486 03029 4

09>

WWW.THRASHERMAGAZINE.COM

Getting the cover of *Thrasher* is the biggest surprise a skateboarder could ever get… But at the time, my hopes seemed really slim—to think Jake was going to put some hippie on the front! Still, checking out the mag since I was 12 had such a big influence on the way I dressed and wanted to feel on my board.

This cover was shot in Japan. I'd been there more than a dozen times between 2000 and 2005. We were treated like rock stars there and our team was like no other. All family and friends.

But on the evening when this photo was taken, we were all in need of a break from the two-hour pit stops where we'd try to order vegetarian food for 14 guys in a country where fish sauce is the staple ingredient. It was hard to deal with, and nerves were running thin on this particular night, so we split up the peaceful warriors. Some blazed back to the room, but a few of us went out to really hit Tokyo, where we found this super sick spot.

"IT WAS A FULL-MOON NIGHT"

It was an awesome, full-moon night in the middle of summer. We were there for hours—the security would only come out when Gabe Morford tried to take a photo or Dan Wolfe would turn his video camera lights on. We were all hungry to get something because we knew it was going to come out proper, but after a few foiled fake-outs on the guards, the whole crew packed it up and bowed out… But not before Gabe and his ninja eye were able to bang off some keepers: Nate Jones' back tail, this nosegrind, and another sick back tail in the front of the building with Hot Rod slashing the lip at mach-10.

The sick blue flat rail off of some long steps made for a good photo. Not too crazy, and the bright white Real board probably didn't hurt. Thanks *Thrasher*, and Fausto, for making this kid's childhood dreams come true—and for keeping my head on straight in my perspective of what skating's all about. Once in a while you may find your delight in the strangest of places. Be here now. —*Matt Field*

10/01 Matt Field
Photo: Gabe Morford
In a flash, Matt Field goes the distance
with a frontside nosegrind on that one Japanese rail.

SKATEBOARD MAGAZINE FROM HELL

THRASHER

ROAD DOGS
THOMAS
MUMFORD
ROWLEY

CHERRY PARK
LOWERY
MONTOYA

DEAD MAN SKATING
DREHOBL

ZOUNDS
WHITE STRIPES
UNWOUND ANTISEEN

OCTOBER 2001 · ISSUE 249

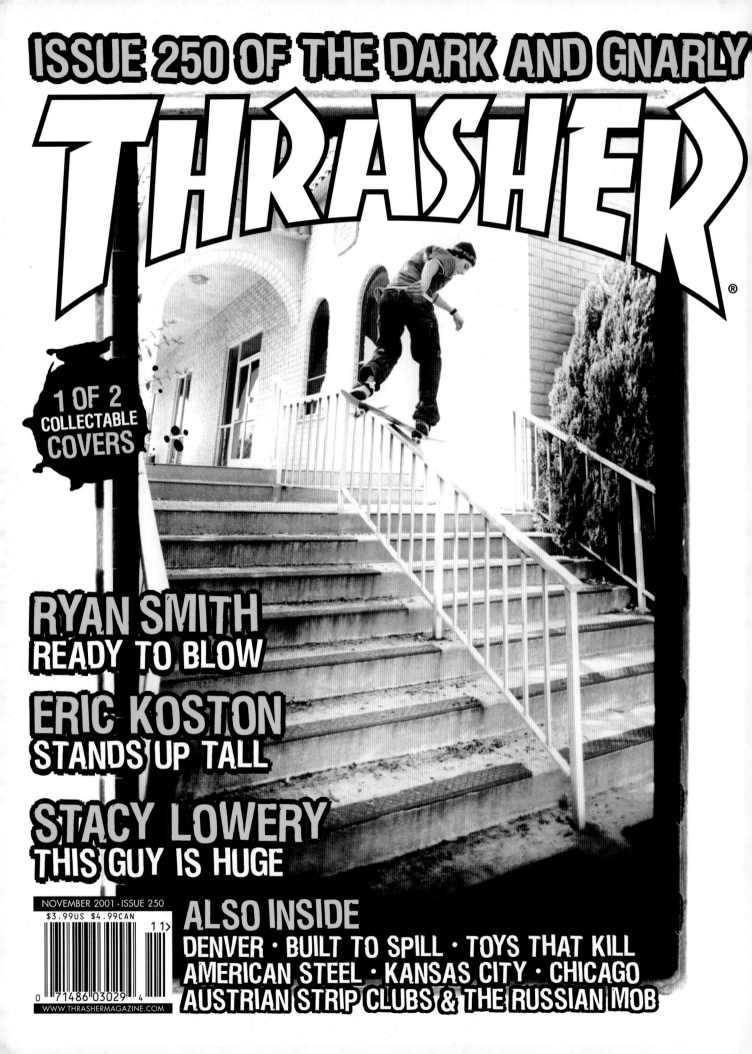

ISSUE 250 OF THE DARK AND GNARLY

THRASHER

1 OF 2
COLLECTABLE
COVERS

RYAN SMITH
READY TO BLOW

ERIC KOSTON
STANDS UP TALL

STACY LOWERY
THIS GUY IS HUGE

NOVEMBER 2001 · ISSUE 250
$3.99US $4.99CAN

ALSO INSIDE
DENVER · BUILT TO SPILL · TOYS THAT KILL
AMERICAN STEEL · KANSAS CITY · CHICAGO
AUSTRIAN STRIP CLUBS & THE RUSSIAN MOB

0 71486 03029 4

WWW.THRASHERMAGAZINE.COM

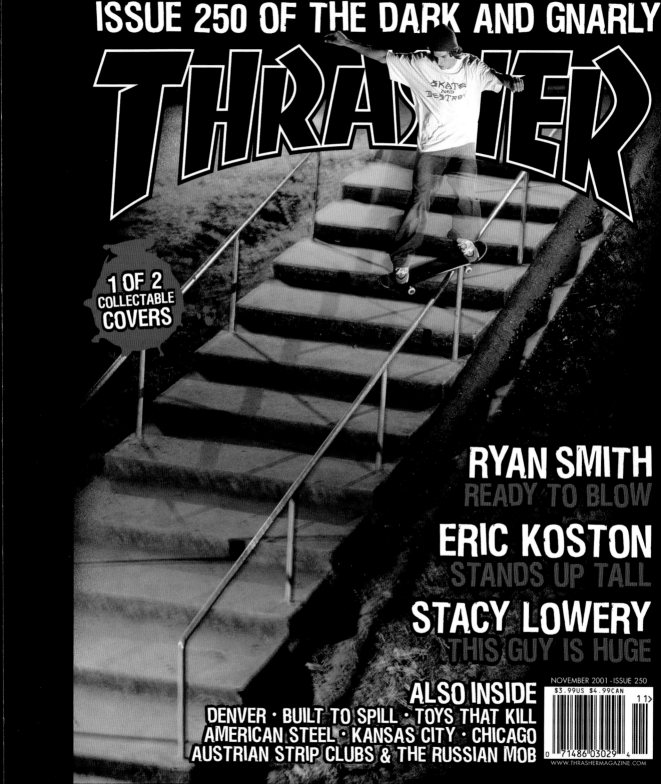

ISSUE 250 OF THE DARK AND GNARLY

THRASHER

1 OF 2 COLLECTABLE COVERS

RYAN SMITH
READY TO BLOW

ERIC KOSTON
STANDS UP TALL

STACY LOWERY
THIS GUY IS HUGE

ALSO INSIDE
DENVER · BUILT TO SPILL · TOYS THAT KILL
AMERICAN STEEL · KANSAS CITY · CHICAGO
AUSTRIAN STRIP CLUBS & THE RUSSIAN MOB

NOVEMBER 2001 · ISSUE 250
$3.99US $4.99CAN

11>

0 71486 03029 4

WWW.THRASHERMAGAZINE.COM

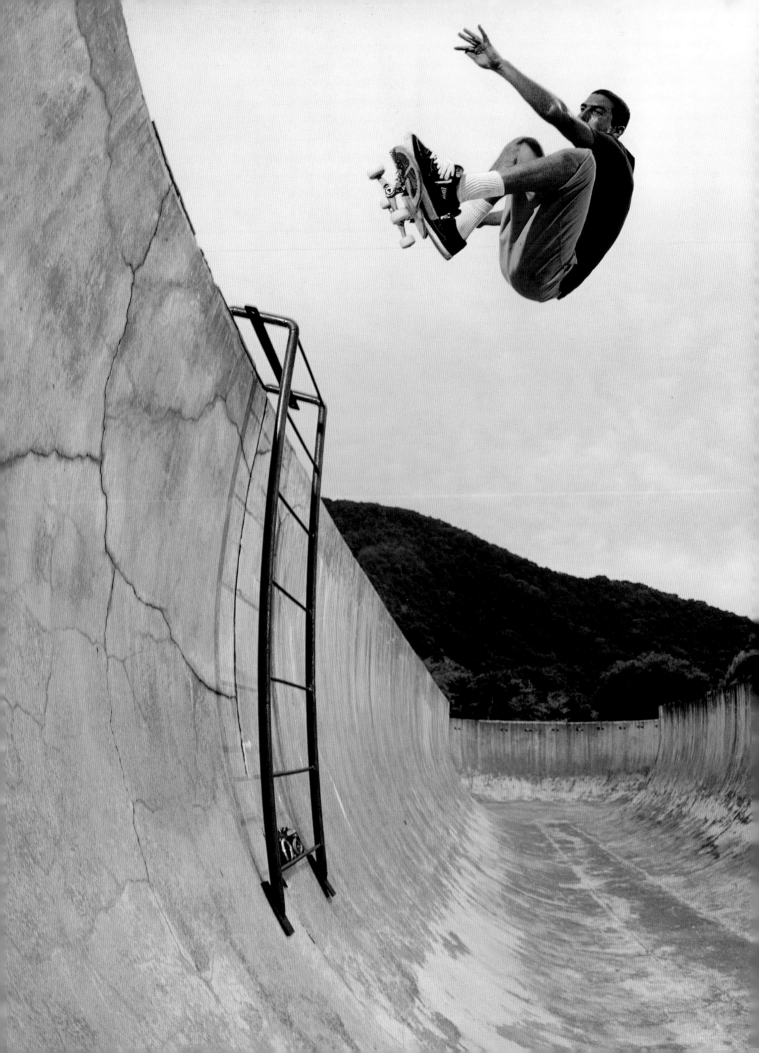

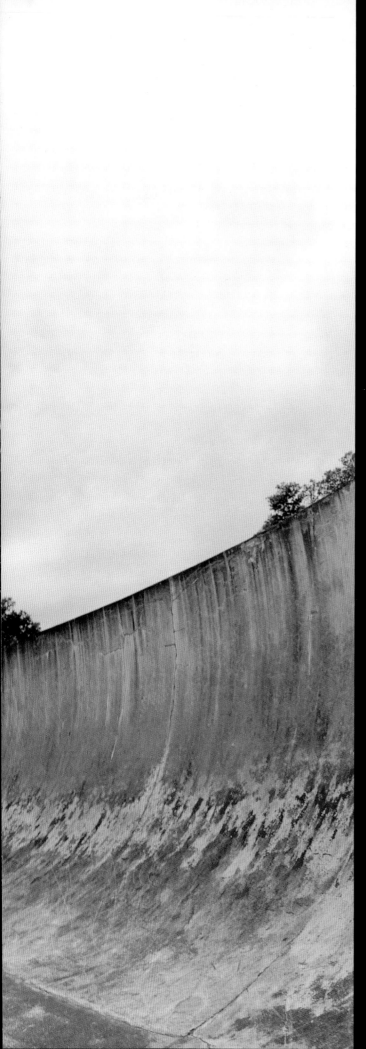

DECEMBER 2001: STEVE BAILEY

It was August 2001, right before September 11th. I first found out about this spot when I was in Japan on another trip. The people I was with said, "There's something to skate there—a cement park on the north island." That didn't mean anything to me. I thought it was probably shitty. But then I saw some video of the place: "Whoa, that looks insane!" I sent a photo of the view looking down the pipe to *Thrasher* and that set it off.

We had to take a 24-hour ferry ride with Tsuyoshi to get to the island. We sacrificed two days of our trip to ride a ferry up and back, and we were only on the island for 32 hours.

The night before, I was on hardly any sleep. It was hella cold and we were all on the floor, sleeping in the bottom of the halfpipe with only an airplane blanket, right on the ground. It was minimal, but rad. We barbequed a killer meal that night and started a fire. We only had one tape: Brujeria.

"WE HAD TO TAKE A 24-HOUR FERRY RIDE TO GET TO THE ISLAND"

I was pretty haggard the next morning, but we put the tunes on the radio and said "Gotta make this go." It was just a standard frontside ollie, dude. A little bit less flat than normal, but I was pretty hyped. The ladder's moveable. Where I ollied it was at the bottom of the pipe, at the steepest part. I pretty much got one kickturn on the flatwall and then ollied it.

People tripped on this cover, a lot. When people saw it they were telling Jake, "It's computer-generated. You can tell it's fake." And I always said, "Go there yourself. It's obviously fucking rad." There are other things out there like this, just tucked away. It's so epic to have the far corners of the skate world be put on the map.
—*Steve Bailey*

12/01 **Steve Bailey**
Photo: Luke Ogden
Trick: Ollie. Dude: Bailey.
Tunes: Brujeria. Spot: Never.

03/02 Bastien Salabanzi
Photo: Michael Burnett

Do you know what the sickest thing .
about this photo is? Check the arm.
That's how you know he's workin' for it.
Bastien Salabanzi, drifting kickflip fakie.

04/02 Arto Saari
Photo: Michael Burnett

20-year-old Arto Saari is one for
the ages. Fakie ollie back lip fakie.

MIKE WATT × **COMIX** × **CANVAS** × **GONZ**

THRASHER

IS AUSTIN STEPHENS **PRO**?
CAN JAMIE THOMAS **TOP HIMSELF**?
DOES PAUL MACHNAU **SLAUGHTER RAILS**?
ALL THIS ANSWERED AND EVEN MOSES TOO!

JANUARY 2002 · ISSUE 252
$3.99US $4.99CAN
01

WWW.THRASHERMAGAZINE.COM

ARTO SAARI'S HELSINKI SUMMER

THRASHER

ROB WELSH
DEMO GODS
CITIZEN FISH
EXHUMED

FEBRUARY 2002 · ISSUE 253
$3.99US $4.99CAN
02

WWW.THRASHERMAGAZINE.COM

S.O.T.Y. PARTY MAYHEM

THRASHER

¡PELIGRO
FANTASTICO!
TEMPLETON · CASWELL · STEPHENS

MALCOLM [MAKES IT]

STONED AGAIN
ROWLEY · APPLEYARD · SPAWN

ALIENATION VACATION
TIM O'CONNOR · JASON DILL

INSANE ZOUNDS
BUTTHOLE SURFERS
MERLE HAGGARD
FLOGGING MOLLY

MARCH 2002 · ISSUE 254
$3.99US $4.99CAN
03

WWW.THRASHERMAGAZINE.COM

ARTO SAARI × **SKATER OF THE YEAR**

THRASHER

2 FREE
POSTERS
INSIDE

ALSO: TRUJILLO / CARDIEL / McCRANK / SALABANZI
ROWLEY / BURNQUIST / FOWLER / KOSTON & MORE

+24 STARVING AMS
SNAPPING AT THE HEELS OF LAZY PROS
ZOUNDS: SLAYER / BILLY CHILDISH / SMOGTOWN

APRIL 2002 · ISSUE 255
$3.99US $4.99CAN
04

05/02 Jason Adams
Photo: Michael Burnett

Now that he works for Lucero, he's got
to make every skate mission count.
Jason Adams takes a break from his
cubicle to bust into the void.

06/02 Darrell Stanton
Photo: Gabe Morford

Stepping up to the mic in a rare show
of blowin' out the pros, Darrell Stanton
from Houston (by way of the LBC)
comes correct with the back noseblunt
on the Hubba for the new millennium:
Clipper. That must feel awful good.

07/02 Jamie Thomas
Photo: Michael Burnett

Flowers are real purty, but fuck that.
It's the Big Dog (Jamie Thomas) gettin'
all up in the out to crooks.

08/02 Tom Penny
Photo: Michael Burnett

Tom Penny has disappeared
and reappeared more times than
David Copperfield, but this switch
270 flip ain't no illusion.

Cover 1 (top left):

THRASHER

SALBA & MOUNTAIN
RETURN TO THE
PINK MOTEL

TAMPA AM
CASWELL TAKES IT
CARRIE GIVES IT

HEADS:
ETHAN FOWLER
NEIL HEDDINGS
CHET CHILDRESS

ZOUNDS:
HAR MAR SUPERSTAR
CONVERGE · DAG NASTY

MAY 2002 · ISSUE 256
$3.99US $4.99CAN
WWW.THRASHERMAGAZINE.COM

Cover 2 (top right):

THRASHER

TAMPA PRO
REYNOLDS · KOSTON · CARRIE

TEXAS PIPE
MISSIONS

ZOUNDS
REDMAN · THE STITCHES
SUPERCHUNK · THE HIVES

JUNE 2002 · ISSUE 257
$3.99US $4.99CAN
WWW.THRASHERMAGAZINE.COM

Cover 3 (bottom left):

THRASHER

RAZING ARIZONA
WITH ED TEMPLETON & THE MULE

TEXAS DAN'S COPING ROUNDUP

RKL CAPLETON MELVINS

JULY 2002 · ISSUE 258
$3.99US $4.99CAN
WWW.THRASHERMAGAZINE.COM

Cover 4 (bottom right):

THRASHER

TOM PENNY
LOST IN TRANSLATION

FOWLER & CO
ON THE ROAD TO RUIN

COREY DUFFEL
NO TALK, JUST HAMMERS

AUGUST 2002 · ISSUE 259
$3.99US $4.99CAN

THRASHER PRESENTS

TH1RT3EN

JOSH HARMONY N/SEGRIND PHOTOGRAPHED BY SCOTT POMMIER

FEATURING

JAMIE THOMAS / MARK APPLEYARD / ARTO SAARI
RYAN SMITH / MIKE CARROLL / PAUL MACHNAU
RICK McCRANK / CAIRO FOSTER / OMAR HASSAN
BRYAN HERMAN / COREY DUFFEL / PETER HEWITT
PAUL RODRIGUEZ / MARK GONZALES & MANY MORE

SUMMER 2002

THRASHER SPECIAL ISSUE #001

$4.99US $5.99CAN

0 09281 03029 4

MARSEILLE · DILLINGER FOUR · MARKOVICH

THRASHER®

Gosh That Looks Like Fun...

LIVIN' THE DREAM

Koston · Anderson · Carroll · McCrank

GIRL INVADES EUROPE

PLUS: ATMOSPHERE · PLANES MISTAKEN FOR STARS

SEPTEMBER 2002 · ISSUE 260
$3.99US $4.99CAN

0 71486 03029 4

09>

WWW.THRASHERMAGAZINE.COM

09/02 Alan Petersen
Photo: Luke Ogden

Don't think you can get more *Thrasher* gnar-dog than this boosted method in the Land of the Rising Sun. If he were Jerman, it would have been a Japan, but Al Petersen is from Fresno, and he don't do it like that.

SUMMER 2002 Photo Issue
Josh Harmony, nosegrind
Photo: Scott Pommier

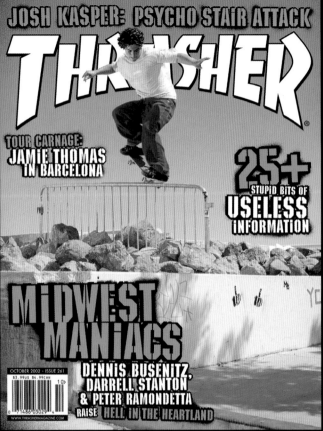

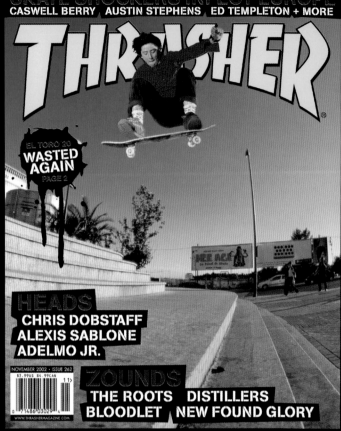

10/02 Jerry Smythe
Photo: Tony Vitello

Clueless to the cover possibilities,
Jerry Smythe skates upstream against
the New Spot wind tunnel and pilots a
frontside crooks over the rocks. SF, CA.

11/02 Dustin Dollin
Photo: Luke Ogden

The most slept-on part in Baker2G
was Dustin Dollin's. This fakie-flip
double-set in the heart of Spain is
another banger added to the legacy.

12/02 Andrew Reynolds
Photo: Luke Ogden

It was like three years ago when
'Drew frontside flipped the Wilshire 15.
After all the hi-jinx and madness around
him settled, he lives up to his early
promise by doing it over the Bernal 16.

ANDREW REYNOLDS FOREVER

THRASHER

ENDLESS SCUMMER

RAZORBLADES, VERT RAMPS,
BB GUNS, AND ROOT BEER

DECEMBER 2002 · ISSUE 263
$3.99US $4.99CAN

1 2>

WWW.THRASHERMAGAZINE.COM

01/03 Billy Marks
Photo: Michael Burnett

The usual gawk gang joins Laurence
Fishburne and the other Hollywood High
mural dwellers to bear witness to another
white rail milestone: Billy Marks, kickflip
frontside lipslide.

02/03 Ryan Smith
Photo: Michael Burnett

Out of spots and (maybe) his mind,
Ryan Smith lines up a noseblunt on the
steepest, sketchiest hubba in Southern
California. Things are gonna get a lot
harder before they get any easier.

03/03 Mark Appleyard
Photo: Luke Ogden

Second place in SOTY voting,
Mark Appleyard provides a new way
to look at skateboarding. Frontside
nosegrind on the outskirts of Sydney.

04/03 Bryan Herman
Photo: Michael Burnett

It's seen some big 180s and even
the 'hana, but it took Bryan Herman
to bust the kickflip at the Doctor's
Office double.

THRASHER

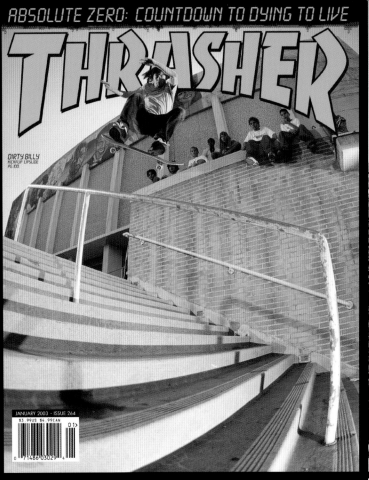

DIRTY BILLY
KICKFLIP LIPSLIDE
PG. 100

JANUARY 2003 · ISSUE 264
$3.99US $4.99CAN

0 71486 03029 4 01>

THRASHER

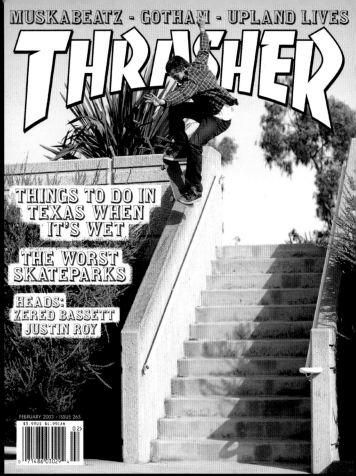

THINGS TO DO IN TEXAS WHEN IT'S WET

THE WORST SKATEPARKS

HEADS: ZERED BASSETT JUSTIN ROY

FEBRUARY 2003 · ISSUE 265
$3.99US $4.99CAN

0 71486 03029 4 02>

CARDIEL CONQUERS MEXICO CITY

THRASHER

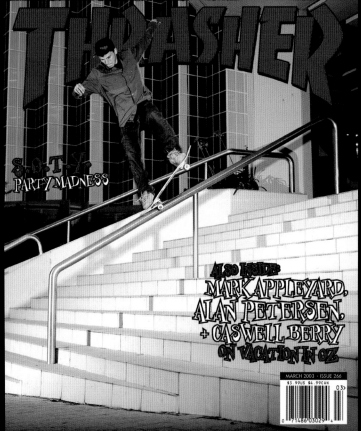

S.O.T.Y.
PARTY MADNESS

ALSO INSIDE:
MARK APPLEYARD,
ALAN PETERSEN,
+ CASWELL BERRY
ON VACATION IN OZ

MARCH 2003 · ISSUE 266
$3.99US $4.99CAN 03>

THRASHER

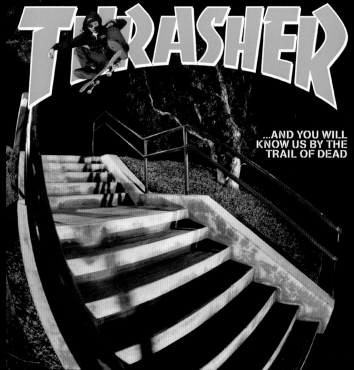

...AND YOU WILL KNOW US BY THE TRAIL OF DEAD

APRIL 2003 · ISSUE 267
$3.99US $4.99CAN 04>

DOUBLEROCK THROWDOWN

MARK APPLEYARD vs. CHRIS COLE

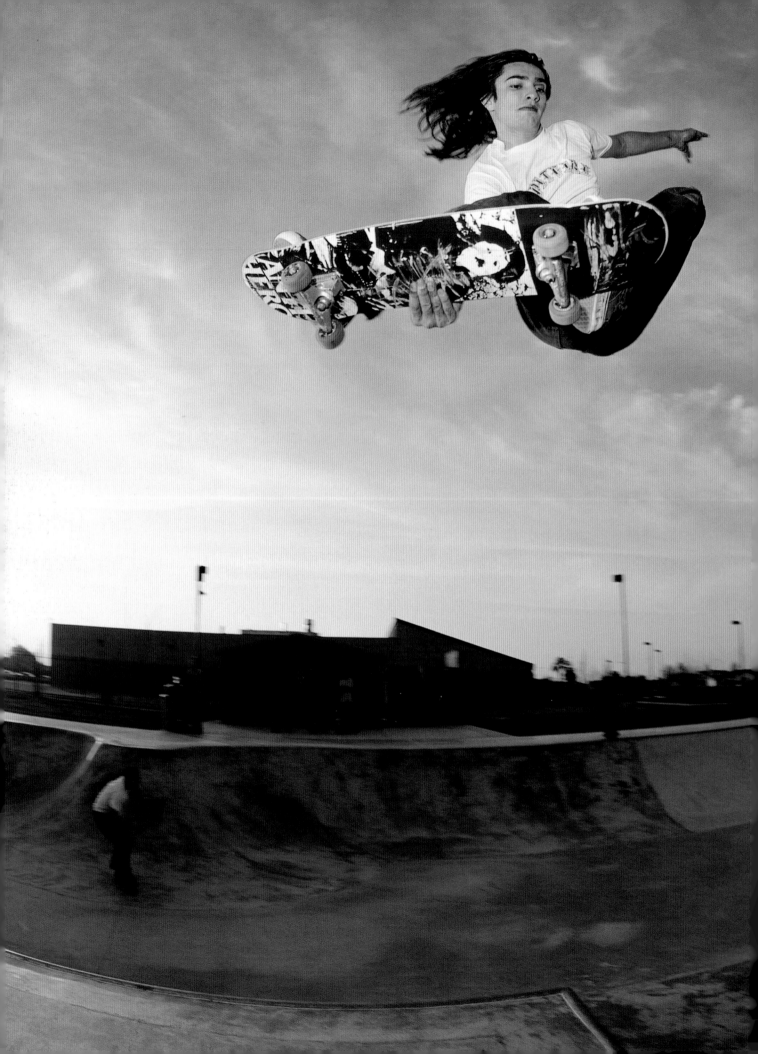

05/03 Tony Trujillo
Photo: Luke Ogden

How ever many hairdos you try on in adolescence,
look in the mirror and all you see is yourself.
Tony Trujillo grew into a man and now you have to deal with him.

06/03 Heath Kirchart
Photo: Scott Pommier

Three years ago: Heath Kirchart
"Won't do anything for the mag unless
it's a cover," OK? This second-set
back lip is just that. Glad we got this
straightened out.

07/03 John Rattray
Photo: Michael Burnett

The Pedro project's got a ways to go,
but John Rattray unlocked the speed
line to yank this invert on the extension...
shit. Brave Captain.

SUMMER 2003 Photo Issue
John Cardiel, frontside air
Photo: Gabe Morford

08/03 Tom Penny
Photo: Joe Krolick

Proud pop Tom Penny flips one to
fakie—on the over-vert, no less.

$KATE FOR MONEY, DIE FOR FAME

THRASHER

NO HOLIDAY IN THE SUN:
BAKER IN OZ

HEADS:
MATT DOVE
JAMES CRAIG
BRIAN SUMNER

RIDE OR DIE:

JUNE 2003 · ISSUE 269
$3.99US $4.99CAN

151 HEARSE TOUR
MIKE HASTIE · JAPANTHER · BUJU BANTON + MORE

HANDSOME MEN, UGLY TIMES IN SPAIN

THRASHER

HAVE A GO!
JOHN RATTRAY
DISCOVERS AMERICA

HEADS: VEGAS · CALES
BOULALA & ZITZER

YOU A WINNER!
SCORCHING AZ SUN, BEAT AZ LAGS

ZOUNDS: HATE ETERNAL
KNOCKOUT PILLS · GZA

JULY 2003 · ISSUE #270
$3.99US $5.99CAN

Thrasher PRESENTS # TH1RT3EN

PHOTO ISSUE 2003

A THRASHER MAGAZINE SPECIAL ISSUE
$4.99US $6.99CAN

FEATURING:
JOHN CARDIEL / GEOFF ROWLEY / BRYAN HERMAN
RUNE GLIFBERG / CHET CHILDRESS / VAN WASTELL
RYAN SMITH / SCOTT KANE / GREG LUTZKA / CHRIS COLE
MARK GONZALES / STEFAN JANOSKI / DANNY RENAUD + MORE

CARNAGE! SKATEBOARD INJURY BLOODFEST
SKATEBOARDING HURTS. A LOT. BRAIN DRAINS, WET NOODLES, ROAD RASH, BROKEN WINGS AND MORE IN THE HALL OF MEAT HALL OF FAME

THRASHER

THE HUNT FOR
HENSLEY
IN GOD'S LAND OF HOT DITCHES

EVERYBODY LOVES
LEO ROMERO

NORTHWESTERN
SLACKERS

HEADS:
NATE JONES
LINCOLN UEDA
JEREME ROGERS

AUGUST 2003 · ISSUE #271
$3.99US $5.99CAN

ZOUNDS:
AESOP & ELIGH
TURBONEGRO
(SMOG) IMMOLATION

09/03 Mark Gonzales
Photo: Gabe Morford

A backside 5-0 must feel pretty tight
for Mark Andrew Gonzales on the front
of The Mag.

10/03 Darren Navarrette
Photo: Luke Ogden

Tired of all the bogus tunes played at
contests, Darren Navarrette grabbed
his radio, cranked up the Molly Hatchet,
and torqued the fuck out of this lien air.
Boost this!

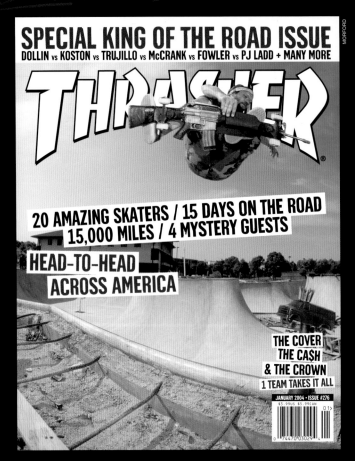

MORFORD

SPECIAL KING OF THE ROAD ISSUE
DOLLIN vs KOSTON vs TRUJILLO vs McCRANK vs FOWLER vs PJ LADD + MANY MORE

THRASHER

20 AMAZING SKATERS / 15 DAYS ON THE ROAD 15,000 MILES / 4 MYSTERY GUESTS

HEAD-TO-HEAD ACROSS AMERICA

THE COVER THE CA$H & THE CROWN
1 TEAM TAKES IT ALL

JANUARY 2004 • ISSUE #276
$3.99US $5.99CAN

0 74470 03029

JANUARY 2004: **DAN DREHOBL**

Guns are big in the USA. This photo said it all: AK frontside air at the most dangerous park in America, Edina, MN. King of the Road is about going McGuyver, and it was on that trip that Jasin Phares and Dan Drehobl hooked up this master work. Guns don't kill people; people kill people. This one was rejected by MAGAS: Mothers Against Guns As Skateboards. —*Jake Phelps*

11/03 Lance Mountain and Rick McCrank
Photo: Gabe Morford

Donald, Oregon gets a blast from the past and present when Lance lets Pops McCrank play over him in the deep end.

12/03 Bastien Salabanzi
Photo: Michael Burnett

So young and amazing, it's scary to think he's only 18. Bastien Salabanzi fakie flips a thick set.

01/04 Tony Trujillo
Photo: Gabe Morford

The only skater to have both King of the Road and Skater of the Year trophies, Tony Trujillo is definitely in it for the long haul. Frontside roll-in at the sea wall on the shores of Lake Michigan.

02/04 Josh Harmony
Photo: Michael Burnett

When schools look like prisons, it's hard to stay on the straight and narrow. Josh Harmony commits a first-degree nosegrind, knowing he's looking at a six-to-eight foot drop, and keeps cool as a cucumber.

GIRL GONE WILD / ANTI-HERO / ZOO YORK

THRASHER

**GREATEST
SKATE LIES
EVER TOLD**

**ZOUNDS:
BORED STIFF
THE SKULLS
AN ALBATROSS
THE FORGOTTEN
CACTI WIDDERS
+ MORE INSIDE**

NOVEMBER 2003 · ISSUE #274
$3.99US $5.99CAN

BASTIEN SALABANZI 22 PAGE BLOWOUT

THRASHER

**PARTY TIME!!!
SPRING
BREAK
FOREVER**

JAMIE THOMAS, CHRIS COLE,
JON ALLIE & THE ZERO POSSE
ROCK OUT ACROSS AMERICA

DECEMBER 2003 · ISSUE #275
$3.99US $5.99CAN

SPECIAL KING OF THE ROAD ISSUE
DOLLIN vs KOSTON vs TRUJILLO vs McCRANK vs FOWLER vs PJ LADD + MANY MORE

THRASHER

**20 AMAZING SKATERS / 15 DAYS ON THE ROAD
15,000 MILES / 4 MYSTERY GUESTS**

**HEAD-TO-HEAD
ACROSS AMERICA**

**THE COVER
THE CA$H
& THE CROWN
1 TEAM TAKES IT ALL**

JANUARY 2004 · ISSUE #276
$3.99US $5.99CAN

JOSH HARMONY FISCHERSPOONER BULGARIA

THRASHER

**15 THINGS
YOU COULDN'T CARE
LESS ABOUT INSIDE**

**HEADS
STEVE ROCHE
& AARON ARTIS**

**ZOUNDS
DEVIL MAKES THREE | SINCE BY MAN
NEW STRANGE | C-RAYZ WALZ | +MORE**

FEBRUARY 2004 · ISSUE #277
$3.99US $5.99CAN

THRASHER

HATE ON THIS
DOBSTAFF INTERVIEW
18-STAIR BLUNTSLIDES
HEELFLIP TAILSLIDES
TRIPLE-SET SWITCHFLIPS
& HELLA MORE INSIDE

MAY 2004 · ISSUE #280
$3.99US $5.99CAN

05>

0 74470 03029 4

THRASHERMAGAZINE.COM

MAY 2004: CHRIS DOBSTAFF

The first time I shot this trick, I was wearing a hat—but they wanted the photo to show my face. The second time, it was raining—I got the shot, but the photo was too dark. I had to go back three times to get it. Ridiculous. Who wants to jump on an 18-stair, let alone three times for the same trick? It's like giving away your chances of living.
—*Chris Dobstaff*

05/04 Chris Dobstaff
Photo: Nick Scurich

The last fire from East County, Chris Dobstaff bluntslides an 18-stair monster—not for God or Country. Congrats, Nick.

03/04 Matt Mumford
Photo: Michael Burnett

Bald, bowlbuster, Mister Matt Mumford creaking a crailer in Southern Oregon.

04/04 Mark Appleyard
Photo: Michael Burnett

On a rock thousands of miles out in the Pacific, Mark Appleyard caps a hell of a year with a torqued-out lien and a well-earned vacation.

THRASHER

JUNE 2004 · ISSUE #281
$3.99US $5.99CAN
06>
THRASHERMAGAZINE.COM

THRASHER PRESENTS PHOTO ISSUE 2004

TH1RT3EN

FEATURING:

JOHN CARDIEL / ANDREW REYNOLDS / ARTO SAARI
TOM KNOX / JOHNNY LAYTON / JIM GRECO / SAM HITZ
DUSTIN DOLLIN / PETER HEWITT / ALEX MOUL / JAMIE THOMAS
ERNIE TORRES / GARETH STEHR / RICK HOWARD + HELLA MORE

SUMMER 2004 · ISSUE #283
$4.99US $6.99CAN
13>

JULY 2004: ERNIE TORRES

I'd been waiting for this frontside flip to come out in the Photo
Feature section of *Thrasher*. I'd flipped through the issue before this
one, hoping to see my photo somewhere in there. When it wasn't
there, I thought, "Huh. I guess they weren't down to put it in. Oh well,
it didn't make the cut…whatever. Dangit!" Then, the next issue, it's on
the cover! I was so stoked and super excited. After that I became
a superstar and moved out to California.

Years later I was shooting pool with a couple friends at
Matt Hensley's bar. Some guy who must've been close to 30 came
up to me and said, "Hey, you're Ernie Torres, right? You've got a
mean frontside flip!" And then he added, "But you ain't no Koston or
Reynolds, bro." I was devastated. "Thanks, I know I'm not Koston or
Reynolds. I'm more like a Tom Penny, I guess." —*Ernie Torres*

06/04 Corey Duffel
Photo: Michael Burnett

Corey Duffel wanted a *Thrasher*
cover, we wanted a backside
lipslide…guess it worked out fine.

SUMMER 2004 Photo Issue
Tommy Sandoval, frontside flip
Photo: Michael Burnett

07/04 Ernie Torres
Photo: Michael Burnett

If you saw the King of The Road DVD,
you know that Ernie Torres ain't no joke.
Frontside flippin' double sets means
he knows what he's doin'.

MODEST MOUSE | MACHNAU GOES COCONUTS | PHX AM

THRASHER

GRINGOS EXTREMOS

SPANKY HEATH HERMAN & LEO IN COSTA RICA

JULY 2004 ▪ ISSUE #282

$3.99US $5.99CAN

07>

0 74470 03029 4

THRASHERMAGAZINE.COM

JAMIE THOMAS

THRASHER
1994 **10** 2004
YEARS OF THOMAS

The commemorative poster included with **Jamie Thomas**' August 2004 issue.

08/04 Jamie Thomas
Photo: Shigeo

Office politics mean nothing to
Jamie Thomas as he rides the glass
of a San Bernadino business complex.

09/04 Geoff Rowley
Photo: Michael Burnett

True skatespot, real street skater:
Geoff Rowley earned his 4th cover in
this disposable era. Geoff is the salt of
the earth; 50-50 while the world looks
the other way.

10/04 Austin Stephens
Photo: Michael Burnett

Too tan to slam, Austin coasts a killer
kickflip down a bent double.

11/04 Chad Bartie
Photo: Michael Burnett

Backside bluntin' one a long way from
the Gold Coast of OZ, Chad Bartie
dreams of Down Undah.

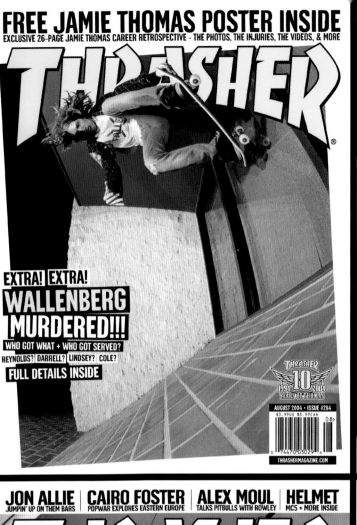

FREE JAMIE THOMAS POSTER INSIDE
EXCLUSIVE 26-PAGE JAMIE THOMAS CAREER RETROSPECTIVE - THE PHOTOS, THE INJURIES, THE VIDEOS, & MORE

THRASHER

EXTRA! EXTRA!
WALLENBERG MURDERED!!!
WHO GOT WHAT + WHO GOT SERVED?
REYNOLDS? DARRELL? LINDSEY? COLE?
FULL DETAILS INSIDE

THRASHER
10
1994 2004
YEARS OF THOMAS

AUGUST 2004 • ISSUE #284
$3.99US $5.99CAN
0 8>

THRASHERMAGAZINE.COM

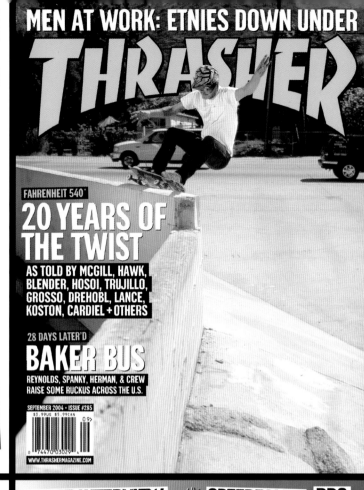

MEN AT WORK: ETNIES DOWN UNDER

THRASHER

FAHRENHEIT 540
20 YEARS OF THE TWIST
AS TOLD BY MCGILL, HAWK, BLENDER, HOSOI, TRUJILLO, GROSSO, DREHOBL, LANCE, KOSTON, CARDIEL + OTHERS

28 DAYS LATER'D
BAKER BUS
REYNOLDS, SPANKY, HERMAN, & CREW RAISE SOME RUCKUS ACROSS THE U.S.

SEPTEMBER 2004 • ISSUE #285
$3.99US $5.99CAN
0 9>

WWW.THRASHERMAGAZINE.COM

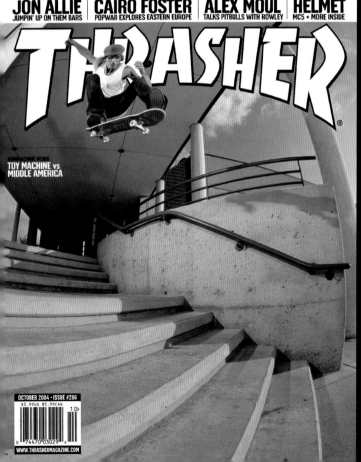

JON ALLIE JUMPIN' UP ON THEM BARS | **CAIRO FOSTER** POPWAR EXPLORES EASTERN EUROPE | **ALEX MOUL** TALKS PITBULLS WITH ROWLEY | **HELMET** MC5 + MORE INSIDE

THRASHER

TOY MACHINE vs
MIDDLE AMERICA

OCTOBER 2004 • ISSUE #286
$3.99US $5.99CAN
1 0>

WWW.THRASHERMAGAZINE.COM

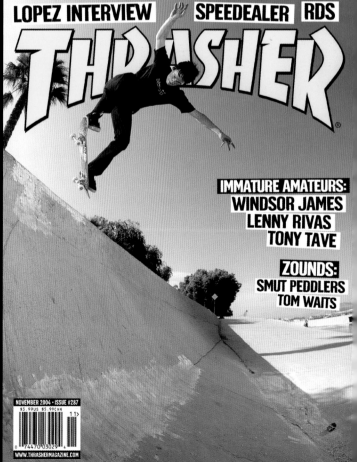

LOPEZ INTERVIEW | **SPEEDEALER** | **RDS**

THRASHER

IMMATURE AMATEURS:
WINDSOR JAMES
LENNY RIVAS
TONY TAVE

ZOUNDS:
SMUT PEDDLERS
TOM WAITS

NOVEMBER 2004 • ISSUE #287
$3.99US $5.99CAN
1 1>

WWW.THRASHERMAGAZINE.COM

12/04 Tommy Sandoval
Photo: Shigeo

While The Eagle shells out the cash,
Tommy Sandoval back lips a whopper.

Inset: "Kansas City in da house!"
Photo: Michael Burnett

02/05 Rune Glifberg
Photo: Michael Burnett

Off to Valhalla, Rune Glifberg glides
one into tranny BSO.

01/05 Jon Allie
Photo: Gabe Morford

September 18th, 2004. Jon Allie came
back for a little more of the famous
Noe Valley landmark by kickflip tailsliding
Clipper. He gets the front.

03/05 Paul Machnau
Photo: Nick Scurich

The clouds, the sky, Paul Machnau,
he's our guy! Five years later, he's back
in the saddle again. Back tail.

THRASHER
®

Daniel Harold Sturt © copyright 2004

APRIL 2005 · ISSUE #292
$3.99US $5.99CAN

04>

0 74470 03029 4

WWW.THRASHERMAGAZINE.COM

04/05 Geoff Rowley
Photo: Daniel Harold Sturt

Geoff Rowley is seriously parking all
the pros out there. 360 ollie off the
third turnbuckle into the bank; no
lazy foot here, kids.

05/05 Danny Way
Photo: Daniel Harold Sturt

He makes us all look like pussies.
Imagine going down that little ramp
backwards into a switch crooked grind.
Danny Way is Skate Rock.

06/05 Paul Rodriguez
Photo: Michael Burnett

Four years ago, Stefan Janoski opened
the door. Paul Rodriguez slams it shut
with a switch flip 50-50 in the '05.

07/05 Go Demon or Go Home
Artwork: Neck Face

Death always came with the territory…
Neck Face will skate your grave.
Art is for losers and rich kids.

SKATER OF THE YEAR DANNY WAY

THRASHER

YEAR IN REVIEW:
MARK APPLEYARD
ZERED BASSETT
DARRELL STANTON
CHRIS COLE
BASTIEN SALABANZI
PAUL RODRIGUEZ
MARK GONZALES
PAT DUFFY
CHAD MUSKA
JAMIE THOMAS
T-EDDY AWARDS
MEPHISTO PREDICTS
& TONS MORE

POINT X CAMP

MAY 2005 · ISSUE #293
$3.99US $5.99CAN
WWW.THRASHERMAGAZINE.COM

50 PAGES OF UNPAID BRUTALITY
THRASHER MAG 2005 AM HOTLIST

THRASHER

MAKING FRIENDS DOWN UNDAH
PAUL RODRIGUEZ
WIEGER REESE
SUPA & DOLLIN

JUNE 2005 · ISSUE #294
$3.99US $5.99CAN

BANANA FARM FREAKOUT
MINUTEMEN VALLEY 'CRETE
SHREDDING FOR HEDDINGS

WWW.THRASHERMAGAZINE.COM

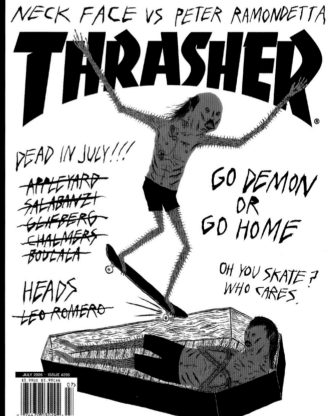

NECK FACE VS PETER RAMONDETTA

THRASHER

DEAD IN JULY!!!
~~APPLEYARD~~
~~SALABANZI~~
~~GLIFBERG~~
~~CHALMERS~~
~~BOULALA~~

HEADS
~~LEO ROMERO~~

GO DEMON
OR
GO HOME

OH YOU SKATE?
WHO CARES.

JULY 2005 · ISSUE #295
$3.99US $5.99CAN
WWW.THRASHERMAGAZINE.COM

SUMMER 2005 Photo Issue
Chet Childress, backside air
Photo: Joe Hammeke

08/05 Anthony Van Engelen
Photo: Mike Blabac

In The Lord's hands,
Anthony Van Engelen switch crooks
one for eternity.

09/05 Rick Howard
Photo: Gabe Morford

A symphony of sound plays through
Rick Howard's backside ollie off the
coast of China.

10/05 Erik Ellington
Photo: Michael Burnett

Double set back lip. Erik Ellington's
interview was two years' in the making.

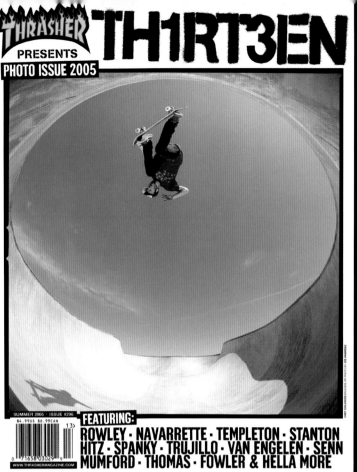

THRASHER PRESENTS PHOTO ISSUE 2005

TH1RT3EN

SUMMER 2005 · ISSUE #296
$4.99US $6.99CAN

FEATURING:
ROWLEY · NAVARRETTE · TEMPLETON · STANTON
HITZ · SPANKY · TRUJILLO · VAN ENGELEN · SENN
MUMFORD · THOMAS · FOWLER & HELLA MORE

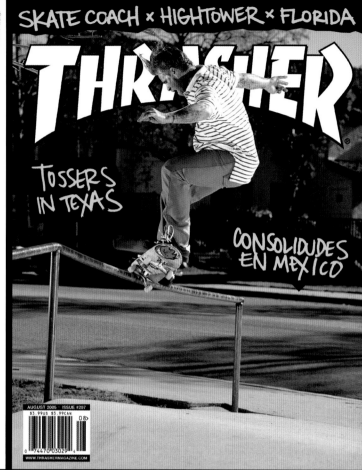

SKATE COACH × HIGHTOWER × FLORIDA

THRASHER

TOSSERS IN TEXAS

CONSOLIDUDES EN MEXICO

AUGUST 2005 · ISSUE #297
$3.99US $5.99CAN

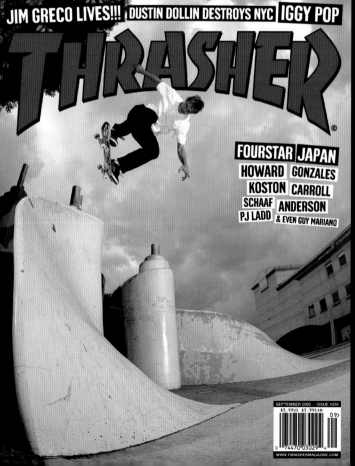

JIM GRECO LIVES!!! | DUSTIN DOLLIN DESTROYS NYC | IGGY POP

THRASHER

FOURSTAR	JAPAN
HOWARD	GONZALES
KOSTON	CARROLL
SCHAAF	ANDERSON
PJ LADD	& EVEN GUY MARIANO

SEPTEMBER 2005 · ISSUE #298
$3.99US $5.99CAN

★ DANNY WAY ★ MADE IN CHINA ★

THRASHER

LAKAI | RUSSIA

MARC JOHNSON
CAIRO FOSTER
MIKE CARROLL
RICK HOWARD
& JB GILLET

18-PAGE INTERVIEW
★ ERIK ELLINGTON

OCTOBER 2005 · ISSUE #299
$3.99US $5.99CAN

★★★ ALSO INSIDE:
ANTI-HERO BURNS EUROPE | UNSEEN
15 MORE THINGS YOU COULDN'T GIVE ANY LESS OF A CRAP ABOUT

11/05 Greg Lutzka
Photo: Nick Scurich

The Lutzka blindside flips way out West.

12/05 Chris Cole
and Team Zero
Photo: Shigeo

The Zero team killed the KOTR Book with hard work, but they still had time for a little fun. Cole wallrides while the gang posts up, and Knox gets another cover.

01/06 Mark Appleyard
Photo: Michael Burnett

Last-minute action, first-rate dude, Mark Appleyard goes Alice in Wonderland. Thanks, guys.

25 YEARS OF SKATE & DESTROY

THRASHER

SPECIAL ISSUE

OVER 50 PAGES OF RARE & NEVER SEEN PHOTOS FROM THE ARCHIVES OF THRASHER MAGAZINE

FEATURING:

HOSOI
HAWK
CABALLERO
BLENDER
GATOR
GONZ
NATAS
STRANGER
KOSTON
BURNQUIST
GRECO
CARDIEL
REYNOLDS
ROWLEY
MUSKA
& TONS MORE

JANUARY 2006 · ISSUE #302
$3.99US $5.99CAN

01>

0 74470 03029 4

WWW.THRASHERMAGAZINE.COM

1981 · T.F.F.Y. · 2006

02/06 Jon Ponts
Photo: Rhino

If you're going to a Neil Heddings spot, you better bust your best shit. Jon Ponts punches a chest-high kickflip to lien for the dark side.

03/06 Dustin Dollin
Photo: Lance Dawes

The last cover of Dustin Dollin wasn't a shaker, he rides for Baker, and this switch crooks is a maker.

04/06 Chris Cole
Photo: Shigeo

Power player Chris Cole was the money choice for SOTY 2005. Kickflip noseslide.

05/06 Jim Greco
Photo: Michael Burnett

The Fonz of skatin', Jim Greco 5-0s. Heeeeeey, sit on it.

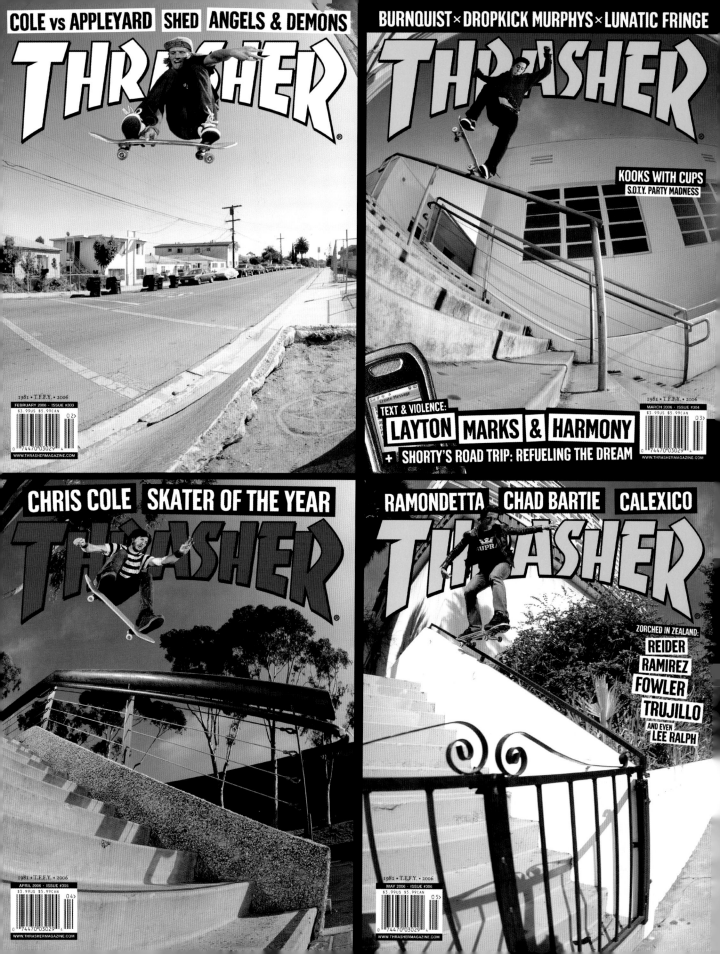

COLE vs APPLEYARD **SHED** **ANGELS & DEMONS**

THRASHER

1981 • T.F.Y. • 2006

FEBRUARY 2006 · ISSUE #303
$3.99US $5.99CAN

WWW.THRASHERMAGAZINE.COM

BURNQUIST × DROPKICK MURPHYS × LUNATIC FRINGE

THRASHER

KOOKS WITH CUPS
S.O.T.Y. PARTY MADNESS

1981 • T.F.Y. • 2006

MARCH 2006 · ISSUE #304
$3.99US $5.99CAN

TEXT & VIOLENCE:
LAYTON **MARKS & HARMONY**
+ **SHORTY'S ROAD TRIP: REFUELING THE DREAM**

WWW.THRASHERMAGAZINE.COM

CHRIS COLE **SKATER OF THE YEAR**

THRASHER

1981 • T.F.Y. • 2006

APRIL 2006 · ISSUE #305
$3.99US $5.99CAN

WWW.THRASHERMAGAZINE.COM

RAMONDETTA **CHAD BARTIE** **CALEXICO**

THRASHER

ZORCHED IN ZEALAND:
REIDER
RAMIREZ
FOWLER
TRUJILLO
AND EVEN
LEE RALPH

1981 • T.F.Y. • 2006

MAY 2006 · ISSUE #306
$3.99US $5.99CAN

WWW.THRASHERMAGAZINE.COM

06/06 Jon Goemann
Photo: Michael Burnett

Jon Goemann slangs a frontside 'cane.
Times are tough on the beaches of
Malaga, tio.

07/06 Nick Dompierre
Photo: Gabe Morford

This is in SD, but it took an East Coast
dude and a NorCal photographer to
make it happen. Nick Dompierre, this
shit is mega. In your backyard, bitch!

SUMMER 2006 Photo Issue
Cairo Foster, backside 5-0
Photo: Michael Burnett

08/06 Tony Tave
Photo: Michael Burnett

Tony Tave's almost better regular foot.
This proper switch heel is double-set thick.

DAEWON vs HASLAM · MISTAH F.A.B. · LIZARD OF OZ

THRASHER

EXCLUSIVE:
AN INSIDER'S GUIDE TO THE
WASHINGTON ST.
SKATEPARK

SPEAKING SPANISH
TO THE PORTUGESE:
GOEMANN
NESSER
SHETLER
WESTGATE
& SUSKI

1981 · T.F.F.Y. · 2006
JUNE 2006 · ISSUE #307
$3.99US $5.99CAN

GRINGOS FROM HELL

WWW.THRASHERMAGAZINE.COM

DITCH SKATING: ALIVE AND KICKING

18 PAGES OF ROUGH
& RUGGED TERRAIN

THRASHER

ANTI-HERO
TRUST EXERCISES
TRUJILLO
STRANGER
CARDIEL
HEWITT

AUSTRALIA IS UGLY
REYNOLDS
SZAFRANSKI
ROMERO
& SPANKY

1981 · T.F.F.Y. · 2006
JULY 2006 · ISSUE #308
$3.99US $5.99CAN

WWW.THRASHERMAGAZINE.COM

THRASHER PRESENTS
TH1RT3EN
PHOTO ISSUE 2006

SUMMER 2006 · ISSUE #309
$4.99US $6.99CAN

FEATURING:
SAARI · WAY · HASSAN · BARTIE · DREHOBL
GRAVETTE · HEWITT · GLIFBERG · MUMFORD
MARKS · RATTRAY · SANDOVAL & MORE...

WWW.THRASHERMAGAZINE.COM

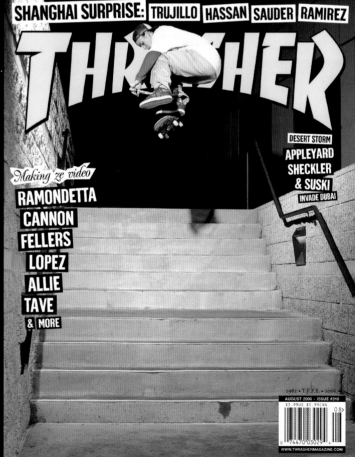

SHANGHAI SURPRISE: TRUJILLO · HASSAN · SAUDER · RAMIREZ

THRASHER

DESERT STORM
APPLEYARD
SHECKLER
& SUSKI
INVADE DUBAI

Making ze video
RAMONDETTA
CANNON
FELLERS
LOPEZ
ALLIE
TAVE
& MORE

1981 · T.F.F.Y. · 2006
AUGUST 2006 · ISSUE #310
$3.99US $5.99CAN

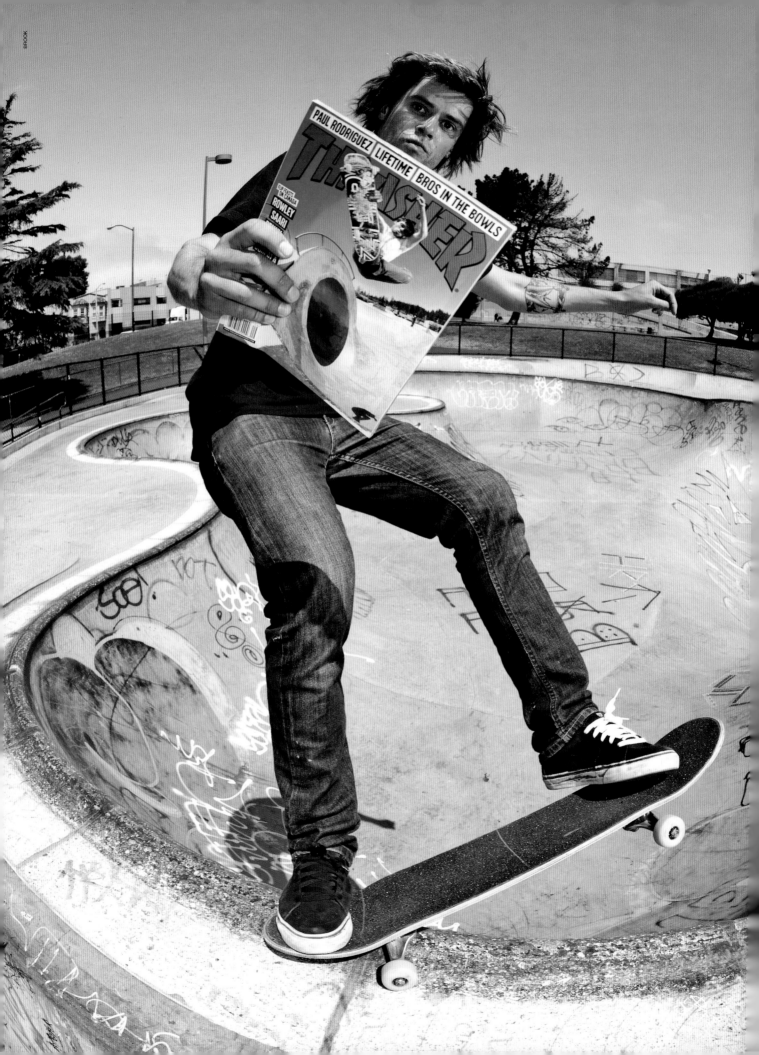

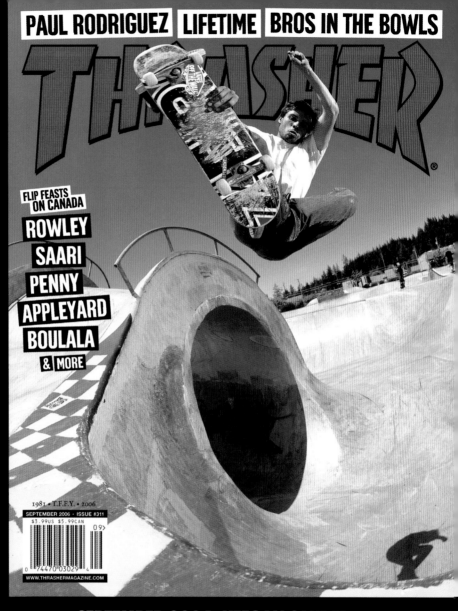

PAUL RODRIGUEZ | LIFETIME | BROS IN THE BOWLS

THRASHER®

FLIP FEASTS
ON CANADA
ROWLEY
SAARI
PENNY
APPLEYARD
BOULALA
& MORE

1981 • T.F.F.Y. • 2006
SEPTEMBER 2006 · ISSUE #311
$3.99US $5.99CAN

0 74470 03029 4

WWW.THRASHERMAGAZINE.COM

SEPTEMBER 2006: KEEGAN SAUDER

I never, ever, expected to get the cover of *Thrasher*—I was just
skating a park doing frontside airs, which I do all the time anyway.
The trip we were on was amazing because it was the first and only
trip I'd done with Jeff Grosso and Lance Mountain…*and* Stu Graham,
and John Rattray all at once. Just getting to hang out with them was
rad. I was stoked to think about how, "Damn, only 12 people a year

"ONLY 12 PEOPLE A YEAR GET TO BE ON THE COVER OF THRASHER"

get to be on the cover of *Thrasher*, and it's the sickest mag." And there
you are, on it, with pink fun all around. I didn't get paid much at the
time and I was kinda hurtin'; my dog had to go to the vet as soon as
I got home from that trip, so the photo incentive helped out a lot.
It was the most I've ever gotten in my life. So thanks Jamie, Robin,
Indy… Everyone. —*Keegan Sauder*

09/06 Keegan Sauder
Photo: Michael Burnett

Epic terrain and catchin' air will never go out of style.
Keegan Sauder torques a BK frontside in Reedsport, OR

10/06 Tommy Sandoval
Photo: Michael Burnett

Lock and load is all you need.
Tommy Sandoval nosegrinds a thick
set—'count em.

11/06 Leo Romero
Photo: Lance Dawes

Tall 50-50 by Leo Romero,
about to make it sing.

12/06 Jamie Thomas
Photo: Shigeo

Keen to contribute, the Eagle
(Jamie Thomas) takes on the Lee Ralph
challenge and wings a barefoot 50-50
down the City College 12.

01/07 Anthony Schultz
Photo: Michael Burnett

Burbling under current Anthony Schultz
chicken wings over the Denver Drains.

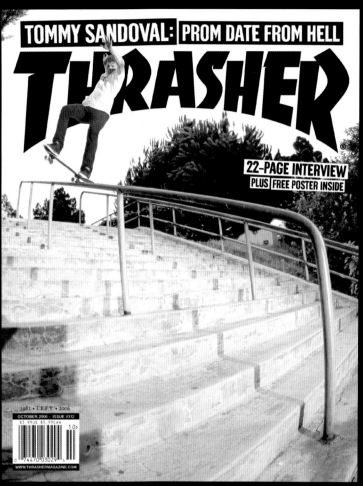

TOMMY SANDOVAL: PROM DATE FROM HELL

THRASHER

22-PAGE INTERVIEW
PLUS FREE POSTER INSIDE

1981 · T.F.F.Y. · 2006
OCTOBER 2006 · ISSUE #312
$3.99US $5.99CAN

WWW.THRASHERMAGAZINE.COM

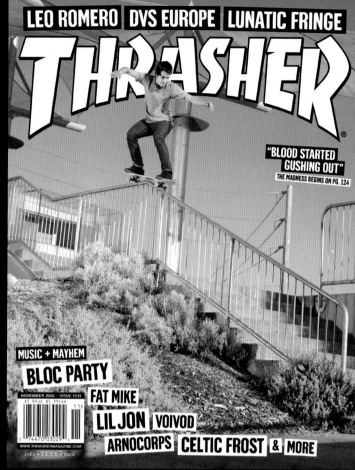

LEO ROMERO DVS EUROPE LUNATIC FRINGE

THRASHER

"BLOOD STARTED
GUSHING OUT"
THE MADNESS BEGINS ON PG. 124

MUSIC + MAYHEM
BLOC PARTY
NOVEMBER 2006 · ISSUE #313
$3.99US $5.99CAN
FAT MIKE
LIL JON VOIVOD
ARNOCORPS **CELTIC FROST** & **MORE**

WWW.THRASHERMAGAZINE.COM
1981 · T.F.F.Y. · 2006

SPECIAL KING OF THE ROAD SUPER ISSUE

THRASHER

TEAM ZERO
3x KOTR CHAMPS

4 SICK TEAMS
20 RIPPING SKATERS
HEAD-TO-HEAD
ACROSS AMERICA

DARKSTAR
vs **BAKER**
vs **TOY MACHINE**
vs **ZERO**
= 100+ PAGES OF
TOTAL INSANITY

PSYCHOS

PUNKS

SECURITY

JOCKS

COPS

BROADS

DECEMBER 2006 · ISSUE #314
$1.99US $5.99CAN

WWW.THRASHERMAGAZINE.COM
1981 · T.F.F.Y. · 2006

SABOTAGE **HURT FEELINGS** & **MUCH MORE**

APPLEYARD vs SCHROEDER HUBBA HIDEOUT

THRASHER

BLACK METAL:
CREATURE CONQUERS NORWAY
RVCA ITALY THE PACK
MY MORNING JACKET

JANUARY 2007 · ISSUE #315
$3.99US

WWW.THRASHERMAGAZINE.COM

MIKEY TAYLOR INTERVIEW · MASTODON · DAMN AM

THRASHER

STAKE
YOUR
CLAIM
ROWLEY, ARTO, & THE FLIP TEAM
GO RAMBO IN THE HIGH DESERT

FEBRUARY 2007 · ISSUE #316
$3.99US

DARK DAYS AT DUFFEL'S
ONE NIGHT OF VIOLENCE, CHAOS, AND IMMORALITY

WWW.THRASHERMAGAZINE.COM

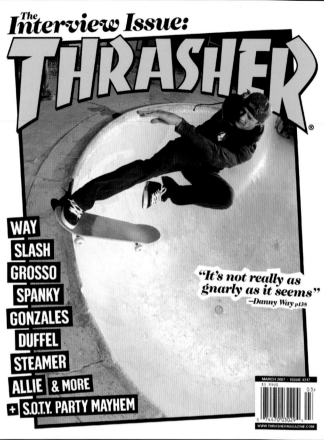

The
Interview Issue:
THRASHER

WAY
SLASH
GROSSO
SPANKY
GONZALES
DUFFEL
STEAMER
ALLIE & MORE
+ S.O.T.Y. PARTY MAYHEM

"It's not really as
gnarly as it seems"
—Danny Way p138

MARCH 2007 · ISSUE #317
$3.99US

WWW.THRASHERMAGAZINE.COM

APRIL 2007: DAEWON SONG

After years of table stacking and Mullen baiting, Daewon mixed it up hard in 2006, taking his tech-gnar to tranny and generally redefining what could be done on concrete curves. For his SOTY cover he got about as far away from a plastic bench as humanly possible—clicking out at 2:30 in the bowels of Baldy's famous pipeline. He did kickflips to fakie this high, too. —*Michael Burnett*

03/07 Danny Way
Photo: Mike Blabac

Mike Blabac was a couple beers deep when he nailed Danny Way getting back to his H-Street roots. Madollie tailslide sans-pads, Pala Pool. Surfers and snowdogs don't

02/07 Mikey Taylor
Photo: Giovanni Reda

Mikey Taylor—not quite Mike, but still old enough to nollie noseblunt the thing.

04/07 Daewon Song
Photo: Michael Burnett

From the manual pad to Mt Baldy, Daewon Song's concrete crusade is

DAEWON SONG SKATER OF THE YEAR

THRASHER

PASSING THE TORCH:
CHRIS COLE

ONE HELL OF A YEAR:
SANDOVAL
DOMPIERRE

WHAT HAPPENED TO
BASTIEN?

+ 19 GNARLY AMS

APRIL 2007 · ISSUE #318
$3.99US

04>

0 74470 03029 4

WWW.THRASHERMAGAZINE.COM

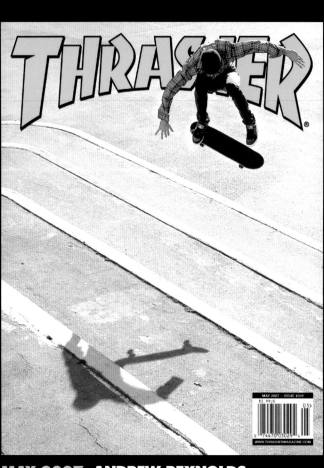

MAY 2007: ANDREW REYNOLDS

This backside flip at Wallenberg was one of the top-10 hardest tricks I've ever done. I jumped it maybe 40 times—slamming over and over and over. I didn't know I was shooting for a cover. I just thought I was shooting a sequence, 'cause I thought that was the best option. But there was this really nice still photo from a secret angle on the roof that I didn't know about.

Thrasher hooked it up, too. They gave me the sequence on the contents spread, and on the cover they didn't put any writing—just plain and classic. —*Andrew Reynolds*

05/07 Andrew Reynolds
Photo: Dan Zaslavsky

He said he was gonna do it, and he did.
Andrew Reynolds notches another milestone
and backside flips The 'Berg.

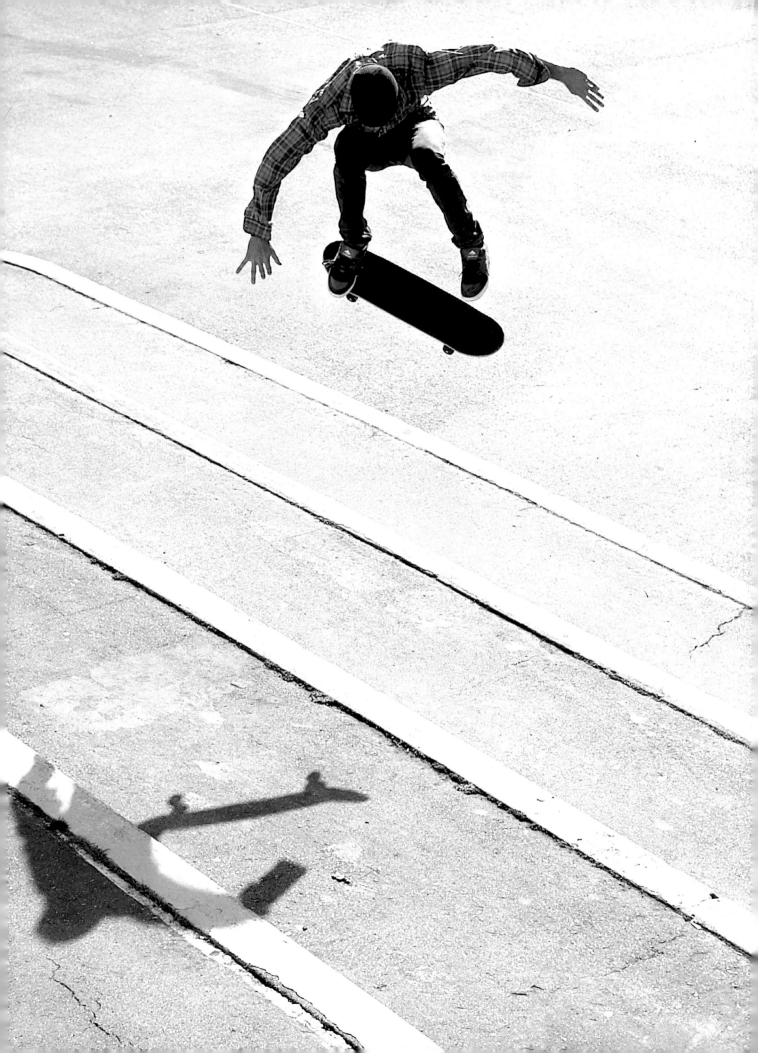

06/07 Shane Cross
Photo: Rhino
Rip In Peace: Shane Cross, back
noseblunt at Pizzey a week before he
died. Miss you.

07/07 Windsor James
Photo: Michael Burnett
Windsor James just goes for it.
Lonely front feeble, who knows where?

SUMMER 2007 Photo Issue
Peter Hewitt, lien air, Orcas Island
Photo: Joe Hammeke

08/07 Bob Burnquist
Photo: Michael Burnett
SMP Skatepark in Shanghai, China gets
Bob Burnquist's best. Why don't they
I-Max this guy?

SEPTEMBER 2007 · ISSUE #324
$5.99US
WWW.THRASHERMAGAZINE.COM

09/07 Sierra Fellers
Photo: David Broach

Kicky 50-50. Mr Sierra Fellers
tells you how.

10/07 Corey Duffel
Photo: Michael Burnett

Hazard colors are yellow and black, so
it makes sense that Corey Duffel rocks it
pretty tight out to backside 50-50.

11/07 Steve Nesser
Photo: Rhino

World Record 50-50: Steve Nesser
takes the cake.

12/07 Jake Duncombe
Photo: Michael Burnett

Jake Duncombe is one gnarly dude.
360 flip on a classic Gator board.

NOVEMBER 2007 · ISSUE #326
$1.99US
WWW.THRASHERMAGAZINE.COM

DECEMBER 2007 · ISSUE #327
$1.99US
WWW.THRASHERMAGAZINE.COM

COREY DUFFEL **AESOP ROCK** **EVIL TWIN PSYCHOS**

THRASHER

TWO FREE POSTERS INSIDE

OCTOBER 2007 · ISSUE #325
$3.99US

10>

0 74470 03029 4

WWW.THRASHERMAGAZINE.COM

01/08 Marc Johnson
Photo: Giovanni Reda

His last cover was in 1998.
Marc Johnson gets nosey in LA.

02/08 David Gonzalez
Photo: Ryan Allan

David Gonzalez had one of the best
quotes in recent memory: "I don't
care if I die." Keep it up kid; kicky
front board. Damn.

03/08 Terry Kennedy
Photo: Michael Burnett

When Terry Kennedy says, "Where's my
cover?", it better come. Thanks for the
wait. Front crooks.

04/08 Peter Watkins
Photo: Rhino

When it comes to skating everything,
Thrasher has it. Here, Peter Watkins split-
level bumps a line that most wouldn't see.

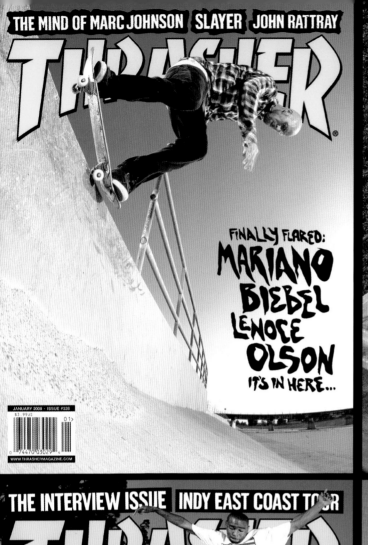

THRASHER

FINALLY FLARED:
MARIANO
BIEBEL
LENOCE
OLSON
IT'S IN HERE...

JANUARY 2008 • ISSUE #328
$3.99US

WWW.THRASHERMAGAZINE.COM

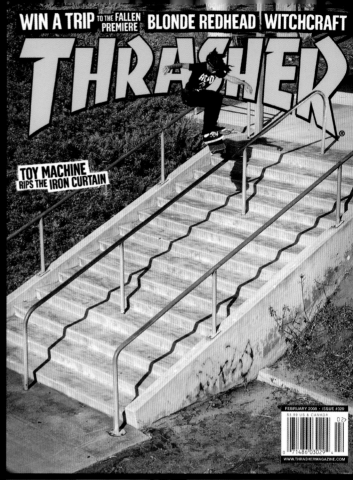

THRASHER

TOY MACHINE
RIPS THE IRON CURTAIN

FEBRUARY 2008 • ISSUE #329
$5.99 US & CANADA

WWW.THRASHERMAGAZINE.COM

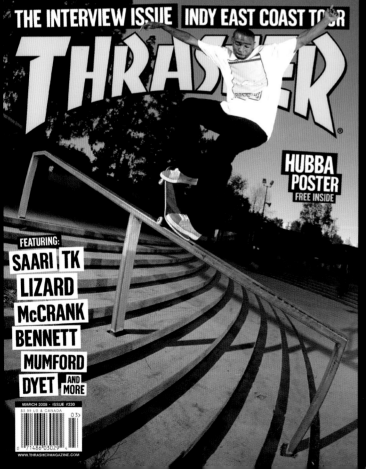

THRASHER

HUBBA
POSTER
FREE INSIDE

FEATURING:
SAARI TK
LIZARD
McCRANK
BENNETT
MUMFORD
DYET AND MORE

MARCH 2008 • ISSUE #330
$3.99 US & CANADA

WWW.THRASHERMAGAZINE.COM

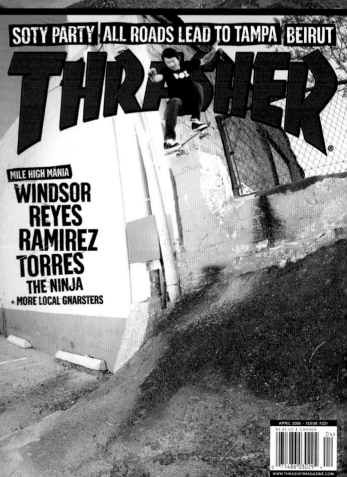

THRASHER

MILE HIGH MANIA
WINDSOR
REYES
RAMIREZ
TORRES
THE NINJA
+ MORE LOCAL GNARSTERS

APRIL 2008 • ISSUE #331
$3.99 US & CANADA

WWW.THRASHERMAGAZINE.COM

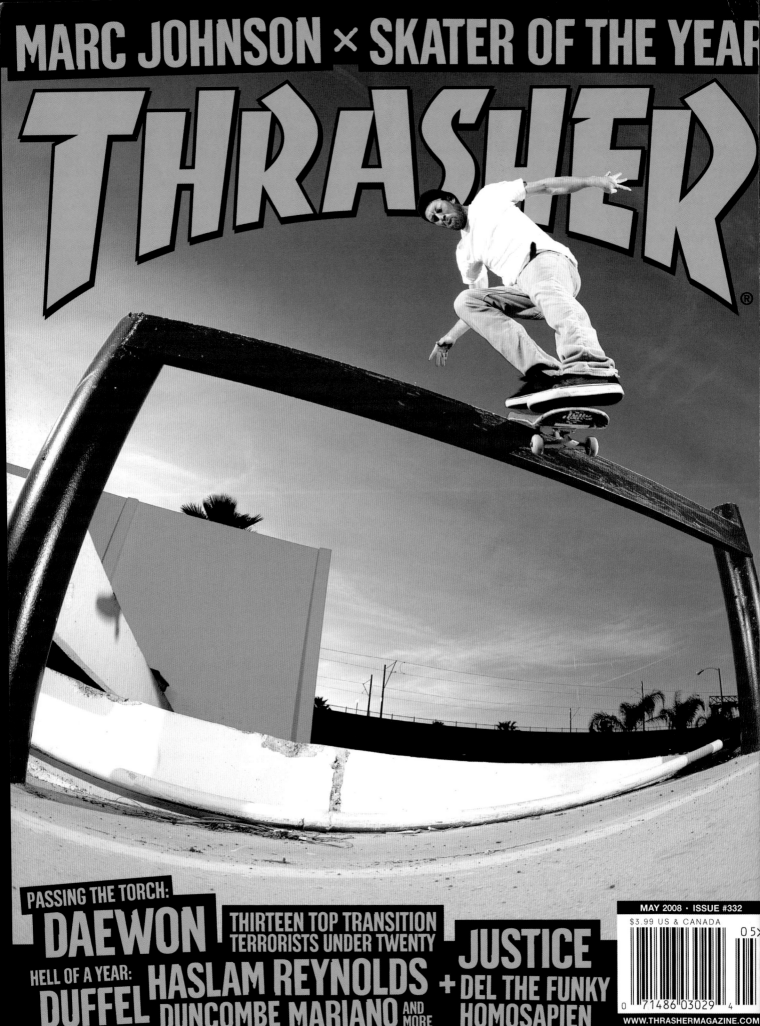

ANTI-HERO OFF RADAR BLACK LABEL GETS LOST

THRASHER

SLAUGHTER
AT THE OPERA
**APPLEYARD
MACHNAU
DUNCOMBE
DECENZO
LUTZKA
DYET** & MORE

CHRIS HASLAM, SWITCH CRAIL

JUNE 2008 · ISSUE #333
$3.99 US & CANADA

06

WWW.THRASHERMAGAZINE.COM

RUNE GOES RICHTER ZERO MESSES WITH TEXAS

THRASHER

JERKS IN ASIA:
**HARMONY
FOSTER
SPANKY
ROMERO
& FOWLER**

JULY 2008 · ISSUE #334
$3.99 US & CANADA

07

WWW.THRASHERMAGAZINE.COM

THRASHER
— presents —
PHOTO ISSUE 2008

TH1RT3EN

SUMMER 2008 · ISSUE #335
$4.99US

13

**BUSENITZ / JAWS / RAMONDETTA / LIZARD / GALL
TRAPASSO / MALTO / LAYTON / TANCOWNY / DYET
BACA / HEDDINGS / NUGE / KALIS / AULTZ** & MORE...

WWW.THRASHERMAGAZINE.COM

08/08 Jamie Tancowny
Photo: Michael Burnett

Old spot, new buck:
Jamie Tan-cow-ny, bigspin.

09/08 Mike Carroll
Photo: Gabe Morford

Mike Carroll, fourth cover, Japan grab.
Waldport, Oregon Coast. Damn.

10/08 Billy Marks
Photo: Shigeo

One of the sweetest kickflips in 'boarding.
Billy Marks sticks a fatty.

11/08 David Reyes
Photo: Michael Burnett

David Reyes, kickflip wallride.
Hey—Reyes in English means "King."

RYAN BOBIER INTERVIEW · SKATE ROCK: LIFE OF PAIN

THRASHER

SAUDER
TRAPASSO
DUFFEL
MARKS
LAYTON
NUGE AND MORE

JAMIE TANCOWNY, BIGSPIN
AUGUST 2008 · ISSUE #336
$3.99 US & CANADA 08>
0 71486 03029 9
WWW.THRASHERMAGAZINE.COM

SILAS INTERVIEW · RAVEONETTES · DIRT NASTY

THRASHER

UNCOVERED:
LANCE MOUNTAIN'S
PHOTO ARCHIVE
1977–2008

BEAUTY & THE BEAST

CARROLL · HEWITT · MALTO
KOSTON · SCHAAF · ANDERSON
TRUJILLO · HOWARD · McCRANK
& OTHER ROAD WIZARDS

SEPTEMBER 2008 · ISSUE #337
$3.99 US & CANADA 09>
0 71486 03029 9
WWW.THRASHERMAGAZINE.COM

BILLY INTERVIEW + POSTER · CREATURE JAPAN

THRASHER

ZOUNDS
NICKATINA
CRYSTAL CASTLES
HANK III
& MORE

HEADS
CROCKETT
& MONTOYA

VEGAS VACATION
RODRIGUEZ
ALFARO
JAWS & GALL

OCTOBER 2008 · ISSUE #338
$3.99 US & CANADA 10>
0 71486 03029 4
WWW.THRASHERMAGAZINE.COM

SHECKLER KILLS · LANCE'S SECRET POOL

THRASHER

HEADS
DAVID REYES
MIKE MO

HIJINX INC
GRECO
REYNOLDS
SPANKY
ANTWUAN
AND THE HOMIES...

NOVEMBER 2008 · ISSUE #329
$3.99 US & CANADA 11>
0 71486 03029 4
WWW.THRASHERMAGAZINE.COM

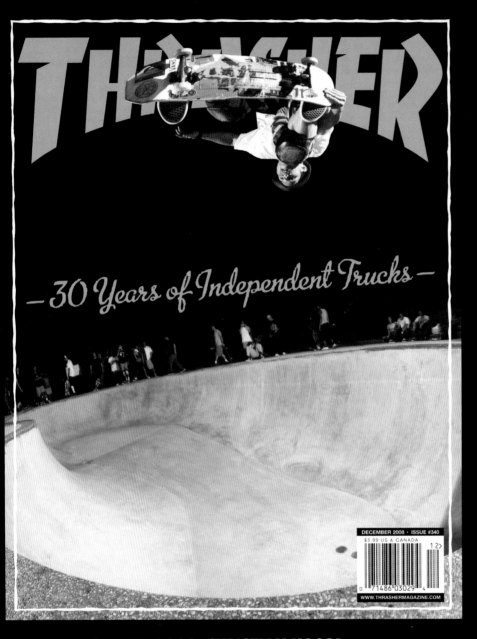

DECEMBER 2008: CHRISTIAN HOSOI

When I got out of prison I thought, "I can't wait to get another *Thrasher* cover." It's one of those things in skateboarding that has a reputation of being "it." I'd just started entering contests right around the time that this came out, and it was like icing on the cake for me upon my return to skateboarding.

I appreciated it and it made me feel good. I really didn't take into consideration how special the covers I had gotten before were. Any of the covers I got—the Europe cover, the mini-ramp cover where I'm wearing the "More Addictive Than Heroin, More Fun Than Crack" shirt—I just don't remember those being as special as this one. Thirty years of Independent trucks—and when that cover came out, I'd been riding Indys for 28 of those 30 years. It's awesome. I feel blessed. —*Christian Hosoi*

12/08 Christian Hosoi
Photo: Lance Dawes

He got a cover blasting over all of France,
so this tailgrab is nothin' for Christian Hosoi.

BURNETT

01/09 Tony Trujillo
Photo: Joe Hammeke

Israel has atomic supremacy in the
Middle East. TNT Trujillo starts WWIII
by dropping an indy to fakie bomb just
south of Heaven.

02/09 Cairo Foster
Photo: Joe Hammeke

It ain't spikes, but this crooks over
is the balls.

03/09 Omar Salazar
Photo: Joe Brook

He likes the name, so watch O-Zar
noseblunt some stairs and take the drop.

04/09 Silas Baxter-Neal
Photo: Michael Burnett

SBN, SOTY. Check this gritty back Smith
deep in the heart of Texas.

TNT MOTÖRHEAD GARRETT HILL

THRASHER

JUNKYARD DOGS
HOLMES **MAX**
NAVS DUANE
OMAR GROSSO
& MORE

JANUARY 2009 · ISSUE #341

$3.99 US & CANADA

01>

0 71486 03029 2

WWW.THRASHERMAGAZINE.COM

CURSES, LUNATICS, & SWITCHBLADES

THRASHER

RIPPERS & FREAKS:
REYNOLDS
THE NUGE
MACHNAU
DUFFEL
HARDY
LEO
+ MORE

FEBRUARY 2009 · ISSUE #342

$3.99 US & CANADA

02>

0 71486 03029 2

WWW.THRASHERMAGAZINE.COM

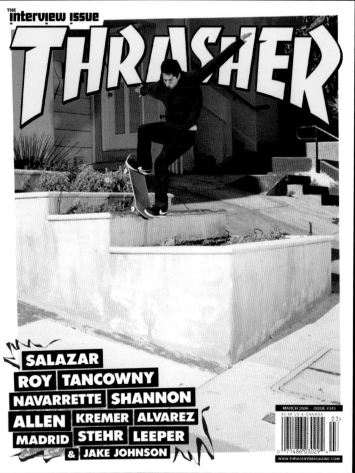

THE interview ISSUE

THRASHER

SALAZAR
ROY TANCOWNY
NAVARRETTE SHANNON
ALLEN KREMER ALVAREZ
MADRID STEHR LEEPER
& JAKE JOHNSON

MARCH 2009 · ISSUE #343

$3.99 US & CANADA

03>

0 71486 03029 2

WWW.THRASHERMAGAZINE.COM

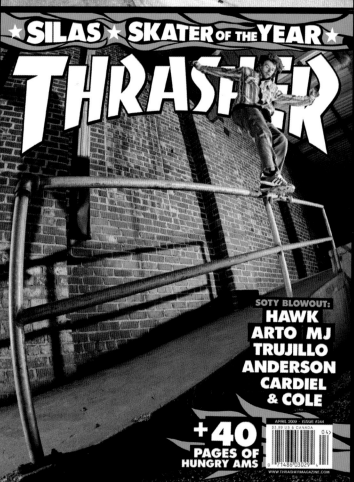

★ SILAS ★ SKATER OF THE YEAR ★

THRASHER

SOTY BLOWOUT:
HAWK
ARTO MJ
TRUJILLO
ANDERSON
CARDIEL
& COLE

+40
PAGES OF
HUNGRY AMS

APRIL 2009 · ISSUE #344

$3.99 US & CANADA

04>

0 71486 03029 2

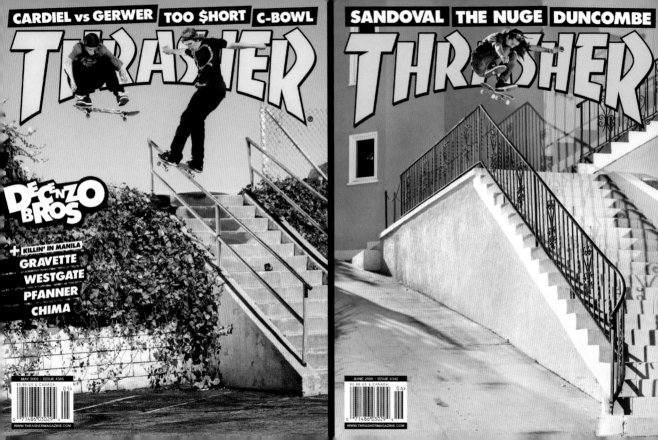

THRASHER

THRASHER

DECENZO BROS

+ KILLIN' IN MANILA
GRAVETTE
WESTGATE
PFANNER
CHIMA

MAY 2009 · ISSUE #345
$3.99 US & CANADA
05>
0 71486 03029
WWW.THRASHERMAGAZINE.COM

JUNE 2009 · ISSUE #346
$3.99 US & CANADA
06>
0 71486 03029
WWW.THRASHERMAGAZINE.COM

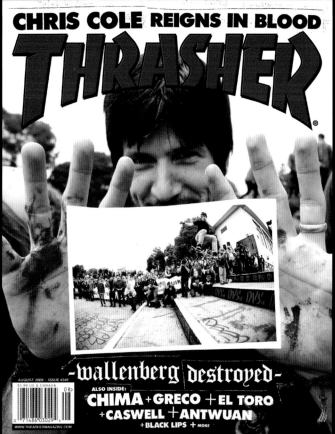

SUMMER 2009 Photo Issue
Antwuan Dixon has a Deathwish
Photo: David Broach

08/09 Chris Cole
Photo: Joe Brook
Inset: David Broach

He's got the whole world in his hands.
Chris Cole is the king of Wallenberg.

09/09 James Brockman
Photo: Rhino

Mad as a hatter, James Brockman
front blunts past the curb.

THRASHER

GONZ
ANDERSON
MARIANO
CARROLL
MALTO
SCHAAF
& MORE

OCTOBER 2009 • ISSUE #351
$5.99 US & CANADA
WWW.THRASHERMAGAZINE.COM

APPLEYARD | rowley | BURNQUIST

THRASHER

and the
WILDEST
confessions
OF
DAVID
GONZALEZ
+
LEMMY

NOVEMBER 2009 • ISSUE #352
$5.99 US & CANADA
WWW.THRASHERMAGAZINE.COM

GRAVETTE INTERVIEW | COLE | NAVARRETTE

THRASHER

SEASICK IN PARIS
ROMERO
SPANKY
TANCOWNY
HSU AND MORE...

DECEMBER 2009 • ISSUE #353
$5.99 US & CANADA
WWW.THRASHERMAGAZINE.COM

APPELO INTERVIEW | RUMBLE IN RAMONA | MURS

THRASHER

+BAKER/
DEATHWISH
LOW LIFE TOUR

JANUARY 2010 • ISSUE #354
$5.99 US & CANADA
WWW.THRASHERMAGAZINE.COM

Chris Cole, at the edge of a precipice.

02/10 Nick Trapasso
Photo: Michael Burnett

Six months of struggle end with a split
second of air time. Nick Trapasso caps
the Prevent This Tragedy video with a
lofty frontside 180 in Long Beach.

03/10 Chima Ferguson
Photo: Gabe Morford

While Koston's been doing them for
20 years, the switch back tail is still the
Holy Grail of ledge tricks. Chima Ferguson
got all of Clipper, thank you Jesus.

04/10 Chris Cole
Photo: Michael Burnett

Lightening strikes twice. Two-time Skater
of the Year, Chris Cole, brings the thunder
on a front blunt fakie down Rincon.

05/10 Justin Figueroa
Photo: Michael Burnett

Another handrail? Nah, this is big gnar.
Justin Figueroa, diesel back Smith.

PREVENT THIS TRAGEDY

THRASHER

starring —

**GUZMAN
TRAPASSO
ALLEN
GRAVETTE
MOLINAR
SLASH
APPELO
FOWLER
BACA**
& more

FEBRUARY 2010 · ISSUE #355
$3.99 US & CANADA
WWW.THRASHERMAGAZINE.COM

0 71486 03029 4 02>

RAMONDETTA NUGE TNT

THRASHER

**CHICO
GOEMANN
ABDIAS
GERWER**
& more

MARCH 2010 · ISSUE #356
$3.99 US & CANADA
WWW.THRASHERMAGAZINE.COM

0 71486 03029 4 03>

CHRIS COLE SKATER OF THE YEAR

THRASHER

FEATURING
**HAWK
ROWLEY
TRUJILLO
BURNQUIST
PUDWILL
ROMERO
MALTO**
AND MORE

APRIL 2010 · ISSUE #357
$3.99 US & CANADA
WWW.THRASHERMAGAZINE.COM

0 71486 03029 4 04>

LEO × SPANKY × JAWS × FELLERS × DECENZO × SHEFFEY

THRASHER

FIGGY'S BIG CRISIS

**SURFING
SAND DUNES
IN DUBAI**

DAVE DUNCAN
PARTIES ON

MAY 2010 · ISSUE #358
$3.99 US & CANADA

0 71486 03029 4 05>

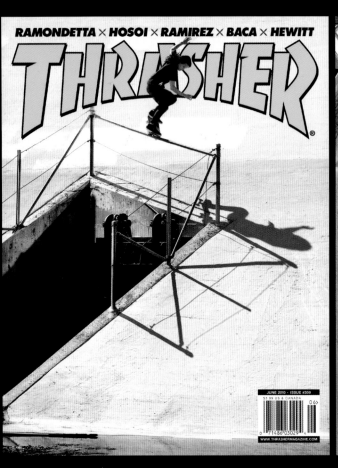

RAMONDETTA × HOSOI × RAMIREZ × BACA × HEWITT

THRASHER

JUNE 2010 · ISSUE #359
$3.99 US & CANADA 06>
WWW.THRASHERMAGAZINE.COM

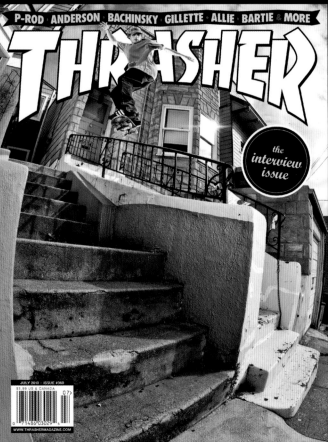

P-ROD · ANDERSON · BACHINSKY · GILLETTE · ALLIE · BARTIE & MORE

THRASHER

the
interview
issue

JULY 2010 · ISSUE #360
$3.99 US & CANADA 07>
WWW.THRASHERMAGAZINE.COM

06/10 David Gonzalez
Photo: Michael Burnett

07/10 Dave Bachinsky
Photo: Dan Zaslavsky
San Francisco stairways are quick

08/10 Eli Reed
Photo: Sean Cronan
Back East, hurricanes are called
blizzards. Eli Reed wasn't even born
yet when they started rippin' the

THRASHER

SEAN MALTO
— VS —
THE BLACK PEARL

HABITAT EN
GUADALAJARA

MORE ZOUNDS
THE GAME
HILLSTOMP
OFF!

— HOW TO —
RUIN
A SUMMER
ROAD TRIP

TOY MACHINE IN
CACKALACKA

AUGUST 2010 · ISSUE #361
$3.99 US & CANADA

08>

0 71486 03029 4

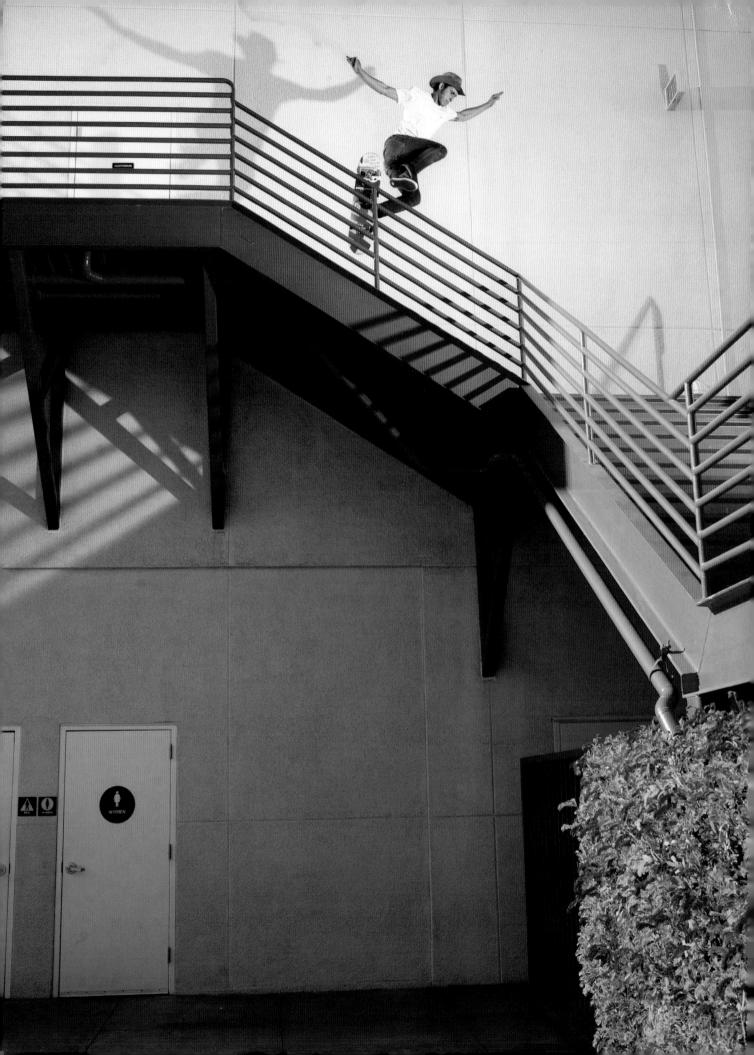

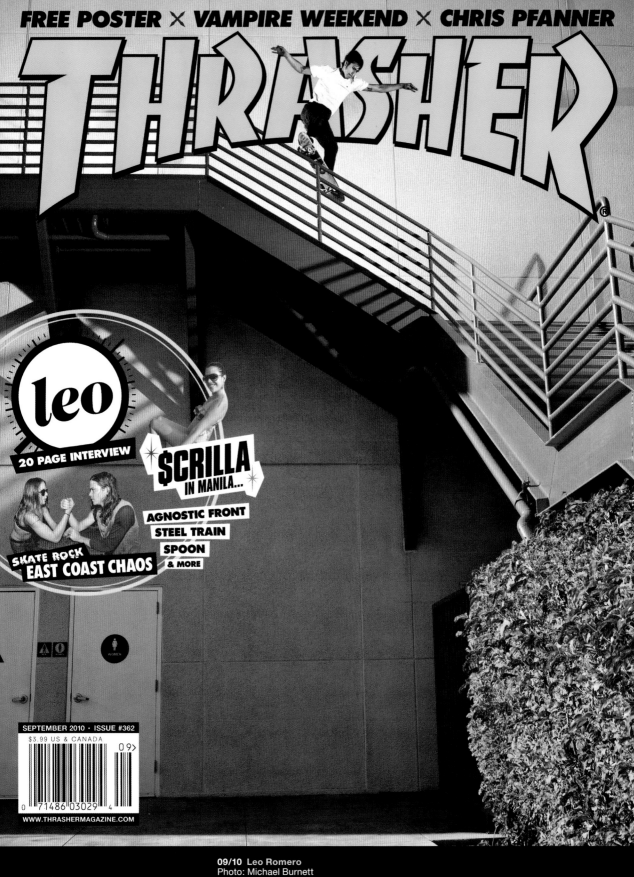

FREE POSTER ✕ **VAMPIRE WEEKEND** ✕ **CHRIS PFANNER**

THRASHER

leo

20 PAGE INTERVIEW

$CRILLA IN MANILA...

AGNOSTIC FRONT
STEEL TRAIN
SPOON **& MORE**

SKATE ROCK
EAST COAST CHAOS

SEPTEMBER 2010 · ISSUE #362
$3.99 US & CANADA

09>

0 71486 03029 4

WWW.THRASHERMAGAZINE.COM

09/10 Leo Romero
Photo: Michael Burnett

July 4th, 2010: 30 feet above the ground is no place to be.
Leo Romero Smiths behind the movie theater.

THRASHER

THE FINAL INTERVIEW
KIRCHART

NO GLASSES REQUIRED
GONZ
MANDERSON
WORREST

REAL HIGH VOLTAGE
BROCK
RAMONDETTA
FERGUSON
HARDY

Emerica strikes Gold

OCTOBER 2010 · ISSUE #363

$3.99 US & CANADA

10>

0 71486 03029 4

WWW.THRASHERMAGAZINE.COM

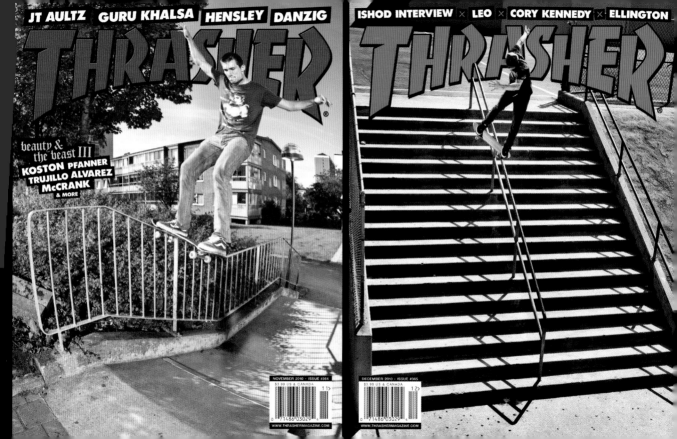

THRASHER

beauty &
the beast III

KOSTON PFANNER
TRUJILLO ALVAREZ
McCRANK & MORE

NOVEMBER 2010 · ISSUE #364
$3.99 US & CANADA
1 1>
0 71486 03025 2
WWW.THRASHERMAGAZINE.COM

THRASHER

DECEMBER 2010 · ISSUE #365
$3.99 US & CANADA
1 2>
0 71486 03025 2
WWW.THRASHERMAGAZINE.COM

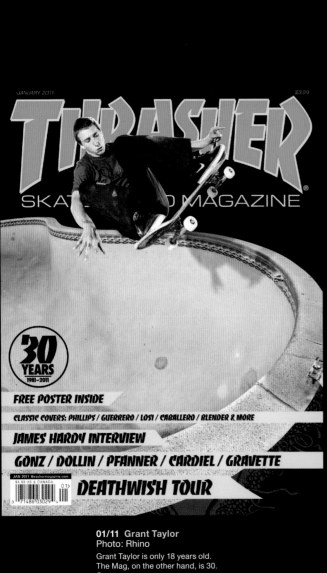

01/11 Grant Taylor
Photo: Rhino

Grant Taylor is only 18 years old.
The Mag, on the other hand, is 30.
Craze.

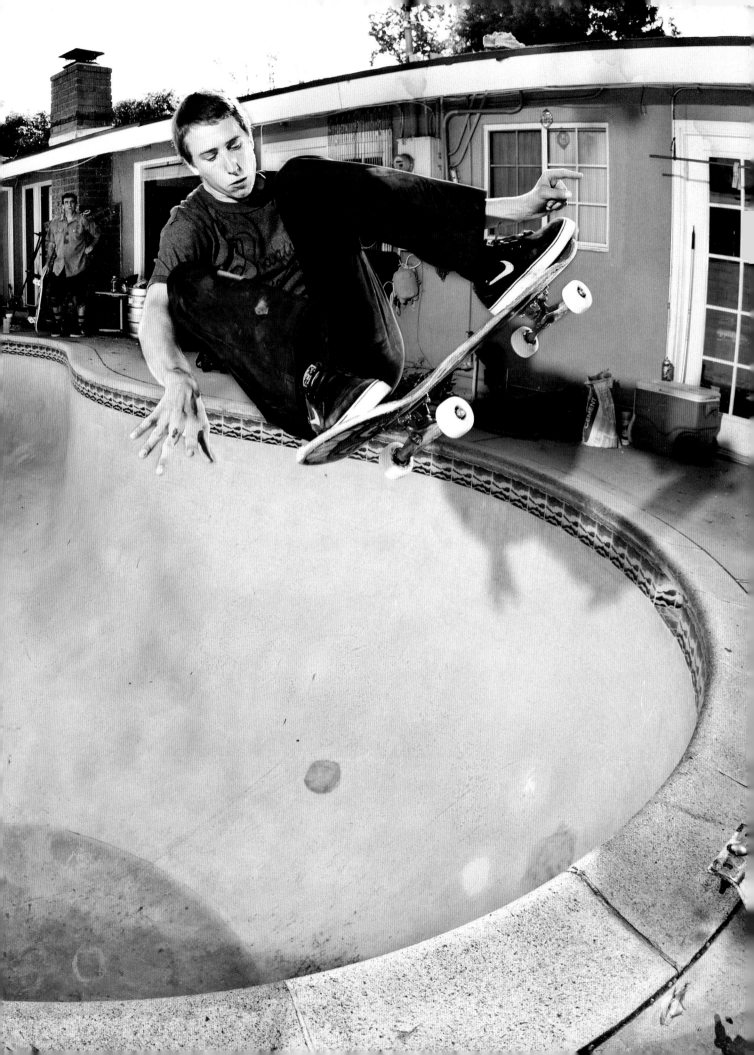

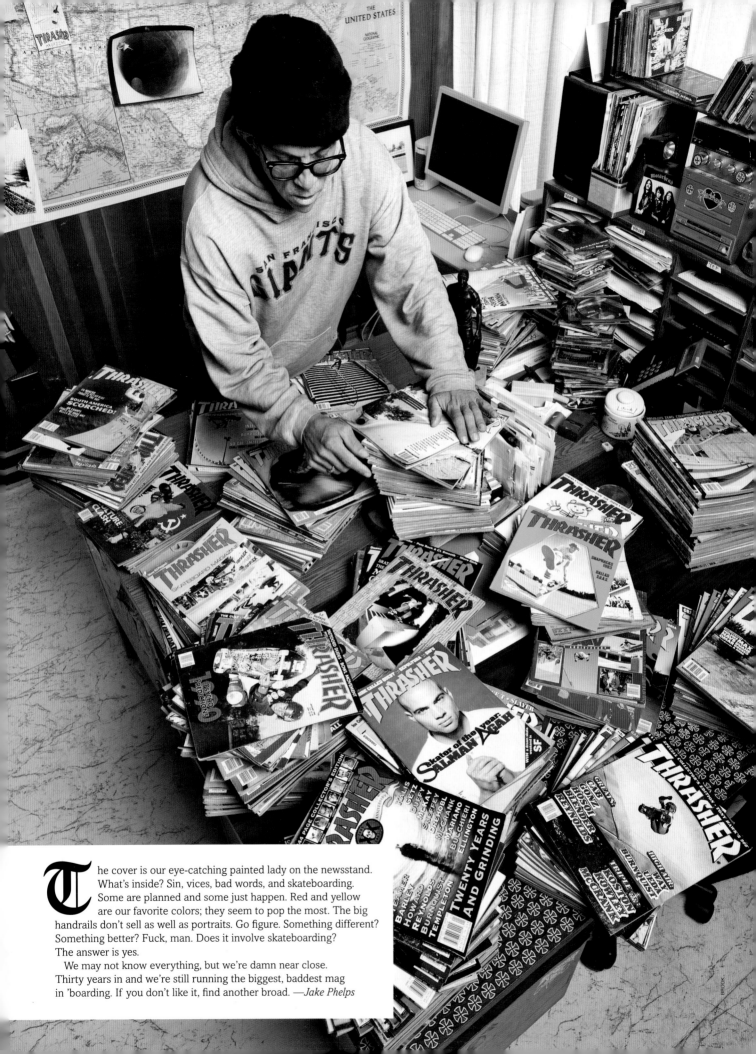

The cover is our eye-catching painted lady on the newsstand. What's inside? Sin, vices, bad words, and skateboarding. Some are planned and some just happen. Red and yellow are our favorite colors; they seem to pop the most. The big handrails don't sell as well as portraits. Go figure. Something different? Something better? Fuck, man. Does it involve skateboarding? The answer is yes.

We may not know everything, but we're damn near close. Thirty years in and we're still running the biggest, baddest mag in 'boarding. If you don't like it, find another broad. —*Jake Phelps*